THE LITTLE ICE AGE

HISTORICAL EVENTS

2000 —	
	World War II (1939-45)
1900 —	World War I (1914-18)
	Large scale European emigration
	Irish Potato Famine (1845-49)
1800 —	Napoleonic Wars (1798-1815)
	Industrial Revolution
	Great Storm of 1704
1700 —	Faeroes cod fisheries fail
	Thirty Years War (1618-1648)
	Jamestown Colony settled (1607)
1600 —	Spanish Armada (1588)
	Roanoke Colony (1587)
	All Saints Flood (1570)
	Spanish settlement at Santa Elena (1565)
1500 —	Columbus lands in the Bahamas (1492)
	Wine cultivation abandoned in England (1469)
1400 —	
	Norse Western Settlement in Greenland abandoned (c.1350)
	Black Death (1348)
	Hundred Years War (1337-1453)
1300 —	The Great Famine (1315-21)
	Hanseatic League rise to prominence
	Mongol Invasions
1200 —	Crusades in the Holy Land
	Cathedral building
1100 —	
	William the Conqueror invades England (1066)
1000 —	
	Norse settlement of Greenland (980s)

TEMPERATURE

CLIMATIC AND
NATURAL EVENTS

WARMING

Warming
Cooler (1960s)

Warming
Krakatau eruption (1883)
— Little Ice Age ends (?1850)
Tambora eruption (1816)

MEAN
1961
TO
1990

Glaciers advance in
Northern Hemisphere (1740–1760)
Warmer (1710–1740)
Coldest period of
the Little Ice Age (1670–1710)
Maunder Minimum (1645–1710)

LITTLE ICE AGE

Huanyaputina Eruption (1600)
Alpine glaciers advance
Cooler conditions after 1580

Greater storminess and
unpredictable climatic shifts

WARMER COLDER

— Little Ice Age begins (c. 1300)
Major volcanic eruption
generates a cold snap (1258)

MEDIEVAL WARM PERIOD

2000

1900

1800

1700

1600

1500

1400

1300

1200

1100

JS

1000

THE LITTLE ICE AGE

HOW CLIMATE MADE HISTORY 1300–1850

BRIAN FAGAN

BASIC
BOOKS A Member of the Perseus Books Group

Published by Basic Books,
A Member of the Perseus Books Group

Designed by Elizabeth Lahey

Library of Congress Cataloging-in-Publication Data
Fagan, Brian M.
The Little Ice Age: how climate made history, 1300–1850 / Brian Fagan.
Includes bibliographical references and index.
ISBN 0-465-02271-5
1. Climatic changes–Europe–History. I. Title.
QC989.A1 F34 2000
551.694–dc21 00-048627

00 01 02 / RRD 10 9 8 7 6 5 4 3 2 1

In memoriam
Professor Glyn Daniel and Ruth Daniel, archaeologists
Professor Hubert Lamb, climatologist

Contents

· PART FOUR ·
THE MODERN WARM PERIOD

PREFACE

We are in a raft, gliding down a river, toward a waterfall. We have a map but are uncertain of our location and hence are unsure of the distance to the waterfall. Some of us are getting nervous and wish to land immediately; others insist we can continue safely for several more hours. A few are enjoying the ride so much that they deny there is any immediate danger although the map clearly shows a waterfall. . . . How do we avoid a disaster?
—*George S. Philander,* Is the Temperature Rising?

April 1963: The waters of the Blackwater River in eastern England were pewter gray, riffled by an arctic northeasterly breeze. Thick snow clouds hovered over the North Sea. Heeling to the strengthening wind, we tacked downriver with the ebb tide, muffled to our ears in every stitch of clothing we had aboard. *Braseis* coursed into the short waves of the estuary, throwing chill spray that froze as it hit the deck. Within minutes, the decks were sheathed with a thin layer of ice. Thankfully, we turned upstream and found mooring in nearby Brightlingsea Creek. Thick snow began to fall as we thawed out with glasses of mulled rum. Next morning, we woke to an unfamiliar arctic world, cushioned with silent white. There was fifteen centimeters of snow on deck.

Thirty-five years later, I sailed down the Blackwater again, at almost the same time of year. The temperature was 18°C, the water a muddy green, glistening in the afternoon sunshine, skies pale blue overhead. We sailed before a mild southwesterly, tide underfoot, with only thin sweaters on. I shuddered at the memory of the chilly passage of three decades before as we lazed in the warmth, the sort of weather one would expect in a

California spring, not during April in northern Europe. I remarked to my shipmates that global warming has its benefits. They agreed. . . .

Humanity has been at the mercy of climate change for its entire existence. Infinitely ingenious, we have lived through at least eight, perhaps nine, glacial episodes in the past 730,000 years. Our ancestors adapted to the universal but irregular global warming since the end of the Ice Age with dazzling opportunism. They developed strategies for surviving harsh drought cycles, decades of heavy rainfall or unaccustomed cold; adopted agriculture and stock-raising, which revolutionized human life; founded the world's first preindustrial civilizations in Egypt, Mesopotamia, and the Americas. The price of sudden climate change, in famine, disease, and suffering, was often high.

The Little Ice Age survives only as a dim recollection: depictions in school textbooks of people dancing at fairs on a frozen River Thames in London in the jolly days of King Charles II; legends of George Washington's ragtag Continental Army wintering over at Valley Forge in 1777/78. We have forgotten that only two centuries ago Europe experienced a cycle of bitterly cold winters, mountain glaciers in the Swiss Alps were lower than in recorded memory, and pack ice surrounded Iceland for much of the year. Hundreds of poor died of hypothermia in London during the cold winters of the 1880s, and soldiers froze to death on the Western Front in 1916. Our memories of weather events, even of exceptional storms and unusual cold, fade quickly with the passing generations. The arid statistics of temperature and rainfall mean little without the chill of cold on one's skin, or mud clinging to one's boots in a field of ruined wheat flattened by rain.

We live in an era of global warming that has lasted longer than any such period over the past thousand years. For the first time, human beings with their promiscuous land clearance, industrial-scale agriculture, and use of coal, oil, and other fossil fuels have raised greenhouse gas levels in the atmosphere to record highs and are changing global climate. In an era so warm that sixty-five British bird species laid their eggs an average of 8.8 days earlier in 1995 than in 1971, when brushfires consumed over 500,000 hectares of drought-plagued Mexican forest in 1998 and when the sea level has risen in Fiji an average of 1.5 centimeters a year over the past nine decades—in such times, the weather extremes of the Little Ice

Age seem grotesquely remote. But we need to understand just how pro-
foundly the climatic events of the Little Ice Age rippled through Europe
over five hundred momentous years of history. These events did more
than help shape the modern world. They are the easily ignored, but
deeply important, context for the unprecedented global warming today.
They offer precedent as we look into the climatic future.

Speak the words "ice age," and the mind turns to Cro-Magnon mam-
moth hunters on windswept European plains devoid of trees. But the Lit-
tle Ice Age was far from a deep freeze. Think instead of an irregular see-
saw of rapid climatic shifts, driven by complex and still little understood
interactions between the atmosphere and the ocean. The seesaw brought
cycles of intensely cold winters and easterly winds, then switched
abruptly to years of heavy spring and early summer rains, mild winters,
and frequent Atlantic storms, or to periods of droughts, light northeaster-
lies, and summer heat waves that baked growing corn fields under a shim-
mering haze. The Little Ice Age was an endless zigzag of climatic shifts,
few lasting more than a quarter century. Today's prolonged warming is an
anomaly.

Reconstructing the climate changes of the past is extremely difficult,
because reliable instrument records are but a few centuries old, and even
these exist only in Europe and North America. Systematic weather obser-
vations began in India during the nineteenth century. Accurate meteoro-
logical records for tropical Africa are little more than three-quarters of a
century old. For earlier times, we have but what are called proxy records
reconstructed from incomplete written accounts, tree rings, and ice cores.
Country clergymen and gentleman scientists with time on their hands
sometimes kept weather records over long periods. Chronicles like those
of the eighteenth-century diarist John Evelyn or monastery scribes are in-
valuable for their remarks on unusual weather, but their usefulness in
making comparisons is limited. Remarks like "the worst rain storm in
memory," or "hundreds of fishing boats overwhelmed by mighty waves"
do not an accurate meteorological record make, even if they made a deep
impression at the time. The traumas of extreme weather events fade
rapidly from human consciousness. Many New Yorkers still vividly re-
member the great heat wave of Summer 1999, but it will soon fade from
collective memory, just like the great New York blizzard of 1888, which

stranded hundreds of people in Grand Central Station and froze dozens to death in deep snowdrifts.

A generation ago, we had a generalized impression of Little Ice Age climate compiled with painstaking care from a bewildering array of historical sources and a handful of tree-ring sequences. Today, the scatter of tree-ring records has become hundreds from throughout the Northern Hemisphere and many from south of the equator, too, amplified with a growing body of temperature data from ice cores drilled in Antarctica, Greenland, the Peruvian Andes, and other locations. We are close to a knowledge of annual summer and winter temperature variations over much of the Northern Hemisphere to as far back as A.D. 1400. Within a few years, these records will go back deep into the Middle Ages, perhaps to Roman times. We can now track the Little Ice Age as an intricate tapestry of short-term climatic shifts that rippled through European society during times of remarkable change—seven centuries that saw Europe emerge from medieval fiefdom and pass by stages through the Renaissance, the Age of Discovery, the Enlightenment, the French and Industrial revolutions, and the making of modern Europe.

To what extent did these climatic shifts alter the course of European history? Many archaeologists and historians are suspicious of the role of climate change in changing human societies—and with good reason. Environmental determinism, the notion that climate change was a primary cause of major developments like, say, agriculture, has been a dirty word in academia for generations. You certainly cannot argue that climate drove history in a direct and causative way to the point of toppling governments. Nor, however, can you contend that climate change is something that you can totally ignore. Throughout the Little Ice Age, and even as late as the nineteenth century, millions of European peasants lived at the subsistence level. Their survival depended on crop yields: cycles of good and poor harvests, of cooler and wetter spring weather, could make a crucial difference between hunger and plenty, life and death. The sufficiency or insufficiency of food was a powerful motivator of human action, sometimes on a national or even continent-wide scale, with consequences that could take decades to unfold. These same climatic verities still apply to millions of people living in less developed parts of the world.

In *The Little Ice Age* I argue that human relationships to the natural environment and short-term climate change have always been in a complex state of flux. To ignore them is to neglect one of the dynamic backdrops of the human experience. Consider, for instance, the food crises that engulfed Europe during the Little Ice Age—the great hunger of 1315 to 1319, which killed tens of thousands; the food dearths of 1741; and 1816, "the year without a summer"—to mention only a few. These crises in themselves did not threaten the continued existence of Western civilization, but they surely played an important role in the formation of modern Europe. We sometimes forget how little time has passed since Europeans went hungry because of harvest failure. Some of these crises resulted from climatic shifts, others from human ineptitude or disastrous economic or political policy; many, like the Irish potato famine of the 1840s, from a combination of all three—and a million people perished in that catastrophe. Its political consequences are still with us.

Environmental determinism may be intellectually bankrupt, but climate change is the ignored player on the historical stage. This is partly because of a long-held and erroneous assumption that there were few significant climatic shifts over the past millennium that could possibly have affected human societies, and also because few archaeologists or historians have followed the extraordinary revolution in paleoclimatology over the past quarter-century. Now we know that short-term climatic anomalies stressed northern European society during the Little Ice Age, and we can begin to correlate specific shifts with economic, social, and political changes, to try to assess what climate's true impact may be. (I focus on northern Europe in these pages, because this is the region that was most directly affected by atmospheric/ocean interactions during the Little Ice Age and where climatic data are most abundant. The effects on Mediterranean lands are still little understood.)

The Little Ice Age is a narrative history of climatic shifts during the past ten centuries and some of the ways in which people in Europe adapted to them.

The book is divided into four parts. Part One describes the Medieval Warm Period, roughly A.D. 900 to 1200. During these three centuries, Norse voyagers explored northern seas, settled Greenland, and visited North America. William the Conqueror invaded England and the pious

embarked on a frenzy of cathedral building. The Medieval Warm Period was not a time of uniform warmth, for then, as always since the Great Ice Age, there were constant shifts in rainfall and temperature, at least one caused by a great volcanic eruption in the tropics during the year 1258. Mean European temperatures were about the same as today, perhaps slightly cooler.

Tree rings and ice cores tell us that Little Ice Age cooling began in Greenland and the Arctic in about 1200. As the Arctic ice pack spread southward, Norse voyages to the west were rerouted into the open Atlantic, then ended altogether. Storminess increased in the North Atlantic and North Sea. Colder, much wetter weather descended on Europe between 1315 and 1319, when thousands perished in a continent-wide famine.

By 1400, the weather had become decidedly more unpredictable and stormier, with sudden shifts and lower temperatures that culminated in the cold decades of the late sixteenth century. Fish were a vital commodity in growing towns and cities where food supplies were a constant concern. Dried cod and herring were already the staples of the European fish trade, but changes in water temperatures forced fishing fleets to work further offshore. Part Two, "Cooling Begins," tells how the Basques, Dutch, and English developed the first offshore fishing boats adapted to a colder and stormier Atlantic, vessels like the English dogger, capable of venturing far offshore in the depths of February gales to catch fish near Iceland and eventually on Newfoundland's Grand Banks. The cod trade led fleets across the Atlantic and helped sustain the first North American colonists.

In the sixteenth century, Europe was still a rural continent, with the most rudimentary of infrastructures and a farming population that lived from harvest to harvest. Monarchs everywhere wrestled with the problem of feeding their people at a time when climatic misfortune was attributed to divine vengeance and human sin. The colder weather of the late sixteenth century particularly threatened communities in the Alps, where glaciers advancing down mountain valleys destroyed entire communities and overran their fields. Northern Europe suffered through exceptional storminess. The great gales of August 1588 destroyed more of the Spanish Armada fleet than the combined guns of English warships.

Part Three, "The End of the 'Full World'," tells the story of a gradual agricultural revolution in northern Europe that stemmed from concerns over food supplies at a time of rising populations. The revolution involved intensive commercial farming and the growing of animal fodder on previously fallowed land. It began in Flanders and the Netherlands in the fifteenth and sixteenth centuries, then spread to England in Stuart times—a period of constant climatic change and often intense cold. Many English landowners embraced the new agriculture as larger enclosed farms changed the face of the landscape and new crops like turnips provided protection for herds and people against winter hunger. The increased productivity from farmland made Britain self-sufficient in grain and livestock and offered effective protection against the famines of earlier times.

In France, however, the nobility had little concern for agricultural productivity. Despite some centers of innovation, France remained agriculturally backward in the midst of a deteriorating climate that made bad harvests more frequent. By the mid- to late eighteenth century, when much of Europe was growing larger quantities of produce, most French farmers were exceptionally vulnerable to food dearths resulting from short-term climatic shifts. Millions of poor farmers and city dwellers lived near the edge of starvation, as much at the mercy of the Little Ice Age as their medieval predecessors. But it was not until the politicization of the rural poor after the poor harvest of 1788 that reform began with the French Revolution.

When Mount Tambora in southeast Asia erupted in 1815, it created the famous "year without a summer" and widespread hunger. Cool, unpredictable weather continued into the 1820s and 1830s, when the first signs of agricultural problems surfaced in Ireland. During the seventeenth and eighteenth centuries, the Irish had embraced the potato as a dietary staple. By the early nineteenth century, Ireland exported her oats to England, and her poor lived almost exclusively on potatoes. With the inevitability of Greek tragedy, blight savaged the potato crop after 1845.

Part Four, "The Modern Warm Period," covers the end of the Little Ice Age and the sustained warming of modern times. The mass emigration fostered by the Irish famine was part of a vast migration from Europe by land-hungry farmers and others not only to North America but much

further afield, to Australia, New Zealand, and southern Africa. Millions of hectares of forest and woodland fell before the newcomers' axes between 1850 and 1890, as intensive European farming methods expanded across the world. The unprecedented land clearance released vast quantities of carbon dioxide into the atmosphere, triggering for the first time humanly caused global warming. Wood also fueled the early stages of the Industrial Revolution in the United States, adding to rising levels of greenhouse gases. Global temperatures began to rise slowly after 1850. They climbed more rapidly in the twentieth century as the use of fossil fuels proliferated and greenhouse gas levels continued to soar. The rise has been even steeper since the early 1980s, with record-breaking summer heat and mild winters during the 1990s. The Little Ice Age has given way to a new climatic regime, marked by prolonged and steady warming, with no signs of a downturn. At the same time, extreme weather events like Category 5 hurricanes and exceptionally strong El Niños are becoming more frequent.

The lessons of the Little Ice Age are twofold. First, climate change does not come in gentle, easy stages. It comes in sudden shifts from one regime to another—shifts whose causes are unknown to us and whose direction is beyond our control. Second, climate will have its sway in human events. Its influence may be profound, occasionally even decisive. The Little Ice Age is a chronicle of human vulnerability in the face of sudden climate change. In our own ways, despite our air-conditioned cars and computer-controlled irrigation systems, we are no less vulnerable today. There is no doubt that we will adapt again, or that the price, as always, will be high.

Acknowledgments

The great French historian Emmanuel Le Roy Ladurie once remarked that there were two kinds of historians: parachutists and truffle hunters. The parachutist observes the past from afar, slowly floating down to earth, while the truffle hunter, fascinated by treasures in the soil, keeps a nose close to the ground. Some of us are by temperament parachutists in everyday life. Many others are truffle hunters, with fine minds for detail. We bring this baggage with us when we study the past. I burden under the impedimenta of a parachutist in this book, which glosses over many passionate historical controversies. In writing it, I have relied on the advice of many colleagues, who are far more learned in the business of history than I. It is impossible to acknowledge everyone's help here. I hope that those not mentioned below will accept the homage of a neophyte historical parachutist.

The Little Ice Age has involved navigating a highly complex, diffuse literature in many disciplines and interviews with scholars with many specialties. I never expected to explore the esoteric byways of Hudson's Bay Company history, European oil paintings, the North Atlantic Oscillation, and Dutch sea defenses, but the journey has been exceptionally rewarding. My special thanks to my historian colleague at Santa Barbara, Sears McGhee, who jump-started me into the complex literature of European history and gave me much sage advice. Professor Theodore Rabb kindly read a rough draft of the book and made invaluable suggestions. I am grateful to David Anderson, William Calvin, Jan De Vries, Peter Gruntfuttock, John Hurst, Phil Jones, Terry Jones, William Chester Jordan, George Michaels, Tom Osborn, Christian Pfister, Prudence Rice, Chris Scarre, Alexa Schloe, Andrew Selkirk, Crispen Tickell, William Truckhouse, Richard Unger, Charlie Ward, and many others for advice, en-

couragement, and references. As always, Steve Cook and Shelly Lowenkopf were pillars of encouragement when the going got rough and I found myself batting my head against literary walls. Our weekly coffee drinking is a true learning experience.

My greatest debt is to my editor, William Frucht of Basic Books. He has been a wonderful sounding board, ruthless critic, and vital catalyst for what has turned out to be an engrossing and extremely demanding project. I am in awe of his perceptions and superb editorial skills. Jack Scott designed and drew the illustrations with his usual skill. My agent Susan Rabiner has encouraged me at every turn. And, finally, a word of thanks to my family for their patience, and to our cats, who have, as usual, sat on my keyboard with unerring accuracy at just the wrong moments. I fervently hope this is a sign of approval, even if flicking tails suggest otherwise.

Author's Note

All measurements in this book are given in metric units. A meter is slightly longer than a yard, and six kilometers is roughly ten miles. Water freezes at 0° Centigrade and boils at 100°C. An ideal temperature to be outdoors is about 25°C (77° Fahrenheit).

Place names are spelled according to the most common usages. Archaeological sites and historical places are spelled as they appear most commonly in the sources used to write this book.

Nonmeteorologists and nonsailors should note that wind directions are described, following common maritime convention, by the direction they are coming from. A westerly wind blows *from* the west. Ocean currents, however, are described by the direction they are flowing *toward*. Thus, a westerly wind and a westerly current flow in opposite directions.

WARMTH AND ITS AFTERMATH

When in April the sweet showers fall
And pierce the drought of March to the root, and all
The veins are bathed in liquor of such power
As brings the engendering of the flower . . .
Then people long to go on pilgrimages.

—*Geoffrey Chaucer,* Canterbury Tales

And what a wonder! Some knights who were sitting on a magnificently outfitted horse gave the horse and their weapons away for cheap wine; and they did so because they were so terribly hungry.

—*A German chronicler of 1315*

Major historical and climatic events, 950 to 1500

1500

 Wine cultivation abandoned in England

1400 Hundred Years War (1337–1453)

 Abandonment of Norse Western settlement,
 Greenland (c. 1350)

 Cool Black Death (c. 1348)
 and wet Great Famine (1315–21)

1300 Hanseatic League rises to prominence

 Large eruption causes cold summer (1258)

1200 Crusades

 Cathedral building

1100

 Medieval warm period

1050 William the Conqueror invades England

 Norse settlement of L'Anse Aux Meadolds

 Norse settlement of Greenland (980s)

900

 Climate Events

I

THE MEDIEVAL
WARM PERIOD

I beseech the immaculate Master of monks
To steer my journeys;
May the lord of the lofty heavens
Hold his strong hand over me.

—*Anonymous*, Hafgerdinga Lay
("The Lay of the Breakers")

The fog lies close to the oily, heaving water, swirling gently as a bitterly cold air wafts in from the north. You sit gazing at a featureless world, sails slatting helplessly. Water drips from the rigging. No horizon, no boundary between sea and sky: only the gray-shrouded bow points the way ahead. The compass tells you the boat is still pointing west, barely moving through the icy chill. This fog can hug the water for days, hiding icebergs and the signs of rapidly forming pack ice. Or a few hours later, a cold northeaster can fill in and sweep away the murk, blowing out of a brilliantly blue sky. Then the horizon is as hard as a salt-encrusted knife, the sea a deep blue frothing with white caps. Running easily under reduced sail, you sight snow-clad peaks far on the western horizon a half-day's run ahead—if the wind holds. As land approaches, the peaks cloud over, the wind drops, small ice floes dot the now-calm ocean. The wise mariner heaves to and waits for clearer weather and a breeze, lest ice block the way and crush the ship to matchwood.

Icebergs move haphazardly across the northern seas. Pack ice floes undulate in broken rows in the endless ocean swell. Far to the north, a ribbon of gray-white light shimmers above the horizon, the ice-blink of solid pack ice, the frontier of the Arctic world. To sail near the pack is to skirt the barrier between a familiar universe and oblivion. A brilliant clarity of land and sky fills you with keen awareness, with fear of the unknown.

For as long as Europeans can remember, the frozen bastions of the north have hovered on the margins of their world, a fearsome, unknown realm nurturing fantastic tales of terrible beasts and grotesque landscapes. The boreal oceans were a source of piercing winds, vicious storms and unimaginably cold winters with the ability to kill. At first, only a few Irish monks and the hardy Norse dared sail to the fringes of the ice. King Harald Hardråde of Norway and England is said to have explored "the expanse of the Northern Ocean" with a fleet of ships in about A.D. 1040, "beyond the limits of land" to a point so far north that he reached pack ice up to three meters thick. He wrote: "There lay before our eyes at length the darksome bounds of a failing world."[1] But by then, his fellow Norse had already ventured far over northern seas, to Iceland, Greenland and beyond. They had done so during some of the warmest summers of the previous 8,000 years.

I have sailed but rarely in the far north, but the experience, the sheer unpredictability of the weather, I find frightening. In the morning, your boat courses along under full sail in a moderate sea with unlimited visibility. You take off your foul-weather gear and bask in the bright sun with, perhaps, only one sweater on. By noon, the sky is gray, the wind up to 25 knots and rising, a line of dense fog to windward. The freshening breeze cuts to the skin and you huddle in your windproof foulies. By dusk you are hove-to, storm jib aback, main with three reefs, rising and falling to a howling gale. You lie in the darkening warmth belowdecks, listening to the endless shrieking of the southwester in the rigging, poised for disaster, vainly waiting for the lesser notes of a dying storm. A day later, no trace remains of the previous night's gale, but the still, gray water seems colder, about to ice over.

Only the toughest amateur sailors venture into Arctic waters in small craft, and then only when equipped with all the electronic wizardry of the industrial age. They rely on weather faxes, satellite images of ice condi-

tions, and constant radio forecasts. Even then, constantly changing ice conditions around Iceland and Greenland, and in the Davis Strait and along the Labrador coast, can alter your voyage plans in hours or cause you to spend days at sea searching for ice-free waters. In 1991, for example, ice along the Labrador coast was the worst of the twentieth century, making coastal voyages to the north in small craft impossible. Voyaging in the north depends on ice conditions and, when they are severe, small boat skippers stay on land. Electronics can tell you where you are and provide almost embarrassing amounts of information about what lies ahead and around you. But they are no substitute for sea sense, an intimate knowledge of the moody northern seas acquired over years of ocean sailing in small boats, which you encounter from time to time in truly great mariners, especially those who navigate close to the ocean.

The Norse had such a sense. They kept their sailing lore to themselves and passed their learning from family to family, father to son, from one generation to the next. Their maritime knowledge was never written down but memorized and refined by constant use. Norse navigators lived in intimate association with winds and waves, watching sea and sky, sighting high glaciers from afar by the characteristic ice-blink that reflects from them, predicting ice conditions from years of experience navigating near the pack. Every Norse skipper learned the currents that set ships off course or carried them on their way, the seasonal migrations of birds and sea mammals, the signs from sea and sky of impending bad weather, fog, or ice. Their bodies moved with swell and wind waves, detecting seemingly insignificant changes through their feet. The Norse were tough, hard-nosed seamen who combined bold opportunism with utterly realistic caution, a constant search for new trading opportunities with an abiding curiosity about what lay over the horizon. Always their curiosity was tempered with careful observations of currents, wind patterns, and ice-free passages that were preserved for generations as family secrets.

The Norse had enough to eat far from land. Their ancestors had learned centuries before how to catch cod in enormous numbers from open boats. They gutted and split the fish, then hung them by the thousands to dry in the frosty northern air until they lost most of their weight and became easily stored, woodlike planks. Cod became the Norse hardtack, broken off and chewed calmly in the roughest seas. It was no coinci-

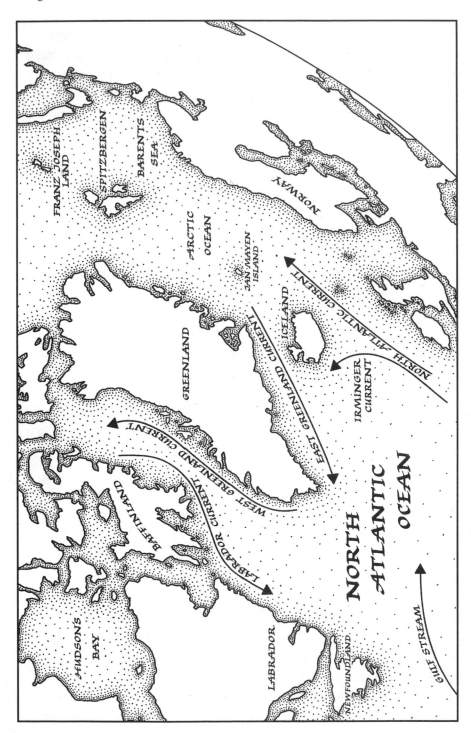

6

Major currents of the North Atlantic Ocean

dence Norse voyagers passed from Norway to Iceland, Greenland and North America, along the range of the Atlantic cod. Cod and the Norse were inextricably entwined.

The explorations of the Norse, otherwise known as Vikings or "Northmen," were a product of overpopulation, short growing seasons, and meager soils in remote Scandinavian fjords. Each summer, young "rowmen" left in their long ships in search of plunder, trading opportunities, and adventure. During the seventh century, they crossed the stormy North Sea with impressive confidence, raided towns and villages in eastern Britain, ransacked isolated Christian settlements, and returned home each winter laden with booty. Gradually, they expanded the tentacles of Norse contacts and trade over huge areas of the north. Norsemen also traveled far east, down the Vistula, Dnieper, and Volga rivers to the Black and Caspian seas, besieged Constantinople more than once and founded cities from Kiev to Dublin.

The tempo of their activity picked up after 800. More raiding led, inevitably, to permanent overseas settlements, like the Danish Viking camp at the mouth of the Seine in northern France, where a great army repeatedly looted defenseless cities. Danish attackers captured Rouen and Nantes and penetrated as far south as the Balearic Islands, Provence, and Tuscany. Marauding Danes invaded England in 851 and overran much of the eastern part of the country. By 866, much of England was under the Danelaw. Meanwhile, the Norwegian Vikings occupied the Orkney and Shetland Islands, then the Hebrides off northwestern Scotland. By 874, Norse colonists had taken advantage of favorable ice conditions in northern seas and settled permanently in Iceland, at the threshold of the Arctic.

The heyday of the Norse, which lasted roughly from A.D. 800 to about 1200, was not only a byproduct of such social factors as technology, overpopulation and opportunism. Their great conquests and explorations took place during a period of unusually mild and stable weather in northern Europe called the Medieval Warm Period—some of the warmest four centuries of the previous 8,000 years. The warmer conditions affected much of Europe and parts of North America, but just how global a phenomenon the Warm Period was is a matter for debate. The historical consequences of the warmer centuries were momentous in the north. Be-

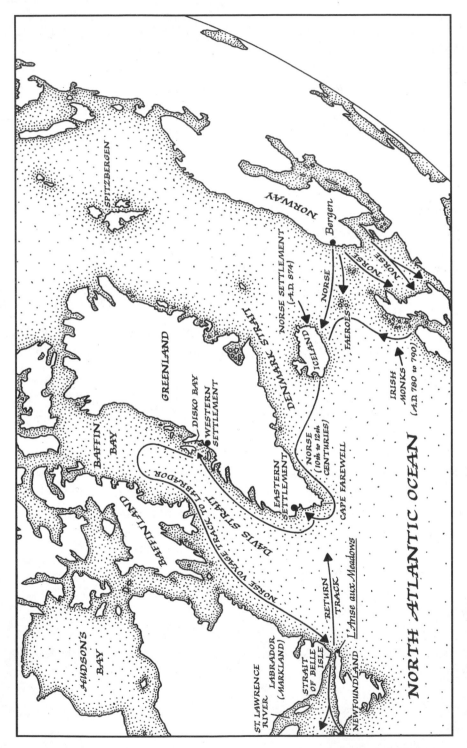

Early voyaging routes to Iceland, Greenland, and Vinland

tween 800 and 1200, warmer air and sea surface temperatures led to less pack ice than in earlier and later centuries. Ice conditions between Labrador and Iceland were unusually favorable for serious voyaging.

The Norse were not the first visitors to Iceland. Irish monks, seeking peaceful refuges far from the political and social turmoil at home, had preceded them. The oceangoing prelates settled the Faeroe Islands by A.D. 700 and sailed as far north as Iceland by 790. Legend has it they followed the spring migration of wild geese to land. But these remarkable seamen were unable to (or in any case did not) maintain a permanent settlement. Norse ships arrived three-quarters of a century later, at a time when January pack ice rarely reached the island's northern coast and both winter and summer temperatures were usually higher than today.

The ocean currents and atmospheric conditions near Iceland have an important bearing on temperature and rainfall throughout northwestern Europe. Warm water from the Atlantic and cold water from the Arctic converge on Iceland's shores. A branch of the cold East Greenland current sweeps along the north and east coasts of the island. The warmer Irminger current flows along the south shore and is an arm of the North Atlantic current, which, in turn, originates in the Gulf Stream deep in the North Atlantic Ocean. Today, in average years, the January to April pack ice edge lies about 90 to 100 kilometers off the northwestern corner of Iceland. In a mild year, the edge is 200 to 240 kilometers away, whereas an exceptionally cold season can bring pack right to the north coast and even around the eastern side of the island to the southern shore. An Irish monk named Dicuil, writing in A.D. 825, recorded that his brethren living in Iceland found no ice along the south coast but encountered it about a day's sail away from the north shore, the position the pack has occupied for most of the twentieth century. In contrast, during a period of great cold between 1350 and 1380, sea ice came so close to land that Greenland polar bears came ashore.

The new colony would never have survived had not the winters been milder than in earlier centuries. Even in good years, the Icelanders scrabbled for a living from thin soils and bitterly cold seas. In bad years they courted disaster. Oddur Einersson observed in 1580 that "the Icelanders who have settled on the northern coasts are never safe from this most terrible visitor. . . . Sometimes it is absent from the shores of Iceland for many

years at a time. . . . Sometimes it is scarcely to be seen for a whole decade or longer. . . . Sometimes it occurs almost every year." In a bad ice year, such as those of the 1180s or 1287, people starved, especially when several harsh winters followed one upon the next. In the extreme winter of 1695, ice blocked the entire coast in January and stayed until summer. A contemporary account tells us: "The same frosts and severe conditions came to most parts of the country; in most places sheep and horses perished in large numbers, and most people had to slaughter half their stock of cattle and sheep, both in order to save hay and for food since fishing could not be conducted because of the extensive ice cover."[2] Icelandic agriculture is vulnerable to harsh winters to this day. For example, intense icing and low temperatures during the severe winter of 1967 reduced farmers' productivity by about a fifth—this in an era of improved farming methods and livestock, indoor heating, and a sophisticated transport infrastructure.

The Norse brought with them a medieval dairying economy like that at home, which they combined with seal hunting and cod fishing. Warmer summer temperatures allowed them to obtain reasonably ample hay harvests for winter fodder and also to plant barley, even near the north coast, where it was cultivated until the twelfth century. After that, farmers could never grow barley in Iceland until the early 1900s.

Sometime in the late tenth century, Eirik the Red and his father Thorvald Asvaldsson left their home in southwestern Norway "because of some killings." They sailed westward to Iceland but had to make do with far-from-fertile land. Eirik was quarrelsome and endowed with a temper that matched his red hair. He married a well-connected Icelandic woman, there were more killings, and he was forced out to a farm on a windswept island. Even there he quarreled with a man named Thorgest to whom he had lent his ornamented high seat posts. The resulting bloodshed caused Eirik to be banished for three years. He took his ship and sailed boldly westward to explore some mysterious islands sighted by a drifting ship captained by a relative about a half-century earlier.

Armed with an invaluable body of sailing lore collected over generations by his kin, Eirik set off into unknown waters with a calm confidence that he would find new lands. Like other Norse skippers, he was an expert latitude sailor who used the sun and North Star to stay on course. He also carried a *sólarsteinn*, or "sun stone," a bearing dial or sun compass In stone or wood that allowed a ship's captain with a knowledge of the sun's positions to steer by a thin radial shadow cast on the disk when held level in his hand. Eirik sailed westward, steering for some snowy peaks that loomed over the horizon when the expedition was still not far from Iceland. The sailors approached land, then coasted southward and westward until they reached a deeply indented coastline dissected by deep fjords behind sheltering offshore islands. They had reached southwestern Greenland.

They had the land to themselves, a place where green summer pastures and thick willow scrub offered pasture and fuel. The summers were brief and fairly warm, with longer days than Iceland. The winters were long and harsh, but the Norse were accustomed to climatic extremes. They found much better grazing land than that at home, abundant fish and sea mammals, and edible birds aplenty. Eirik sailed back to Iceland with glowing reports of a land so fertile he named it Greenland, "for he said that people would be much more tempted to go there if it had an attractive name."[3]

He must have been a persuasive leader, for twenty-five ships of potential colonists sailed back to Greenland with him. Fourteen reached what was soon called the Eastern Settlement, in the sheltered waters of the southwest in what are now the Julianehåb and Narsaq districts. Eirik built his chieftain's seat at Brattahlid ("Steep Slope") in the heart of the richest farmland. At about the same time, another group of colonists pushed further north and founded the Western Settlement, centered around Sandnes Farm (Kilaarsarfik), in the modern-day Godthåb district at the head of the sheltered Ameralik fjord. Life in Greenland was easier than on the crowded, hardscrabble fields of Iceland, with, as yet, no competition from indigenous Inuit people, plenty to eat, and harsh but usually endurable conditions at sea.

The Norse soon explored the fjords and islands of the west coast. The shoreline was relatively ice-free most summers, thanks to the north-

flowing West Greenland current, which hugs the west coast and flows into Baffin Bay. The favorable current carried the colonists' ships into the heart of a land of islands and fjords around Disko Bay they called Nororseta, which teemed with cod, seals and walrus. Nororseta became an important hunting ground, where the colonists obtained food for the following winter and precious trade goods, especially narwhal and walrus tusks, which were much prized. For many years, the Greenland churches' tithes to the diocesan authorities in Norway were partly paid in walrus ivory.

Greenlanders sailing to Nororseta must have quickly become aware of lands to the west, if only because the prevailing currents in the northern hunting grounds carried them that way. The Davis Strait is little more than 325 kilometers across at its narrowest point. Even a modest journey offshore in good visibility would bring the high mountains of Baffinland into sight. The Norse found North America through a combination of accident and inevitability, having sighted the Arctic islands and mainland long before they set foot on western shores. They arrived in Nororseta at a time when summer ice conditions were usually less severe than in later centuries, which made it easier for them to take advantage of currents along the American side of the Strait.

The West Greenland current flows into Baffin Bay and the heart of Nororseta, where it gives way to much colder south-flowing currents. Much cooler water passes southward along Baffin Island, Labrador, and eastern Newfoundland. This circulation pattern affects ice formation. The Baffin/Labrador coast has heavier ice cover and a longer sea ice season, whereas Greenland coast sea ice forms late and disperses early. There is often a coastal belt of ice-free water all the way up to the Arctic Circle on the eastern side of the Davis Strait. The climate of the Medieval Warm Period may have permitted easier navigation between Baffinland and Labrador during many summers.

Yet the first documented sighting did not come from such a northern coasting voyage. Bjarni Herjolfsson, a young merchant shipowner and

"man of much promise" who dreamed of exploring foreign lands, arrived in Iceland from Norway in about 985 and was shocked to find that his father had emigrated to Greenland with Eirik the Red a short time before. Refusing to unload his ship, he set off for Greenland at once, taking advantage of a fair wind. The wind dropped. For days Bjarni and his men sailed in northerly winds and fog with no idea of their position. Eventually they sighted a flat, well-forested coastline quite unlike their destination, "for there are said to be huge glaciers in Greenland." Bjarni stayed offshore and coasted southward, sighting more land at intervals. Eventually a southwesterly gale carried them offshore for four days. They made land at dusk at a promontory that had a boat hauled up on it, and so finally reached their original destination.

The cautious Herjolfsson was criticized heartily for not setting foot on the mysterious coastline. Lief Eirikson, the son of Eirik the Red, bought Bjarni's ship, recruited a crew of thirty-five men, and sailed westward to Baffinland. Eirik himself reluctantly stayed behind after injuring himself on his way to the boat. Lief anchored off a rocky, glacier-bound coast, then cruised southward to a flat, well-wooded shore with sandy beaches, which he named *Markland* ("Forest Land") "for its advantages." He had reached part of modern-day Labrador, south of the northern limit of forests, somewhere near Hamilton Inlet. A favorable northeast wind carried them even further south, to the mouth of the Saint Lawrence River and to a region they called *Vinland* ("Wine Land"), perhaps after its wild grapes.

The famous L'Anse aux Meadows archaeological site, in extreme northern Newfoundland, may be where Lief Eirikson and his crew wintered over and founded a transhipment station, where timber and furs were processed before being carried on to Greenland. Archaeologists Helge Ingstad and Anne Stine unearthed eight sod-walled structures on a terrace overlooking a shallow bay. The settlement had a work shed, a smithy, also storage structures and four turf boat sheds. The Norse knew how to choose a winter settlement. L'Anse aux Meadows lies at a strategic point on the Strait of Belle Isle, at the mouth of the Saint Lawrence River, surrounded by water on three sides, with ample summer grazing for cattle. From L'Anse and perhaps other camps, the Norse ranged widely, but how far south they sailed along the mainland coast remains a matter of controversy.

All the information about Markland and Vinland was held by Green-land settler families with close-knit kin ties. They kept their informa-tion and sailing directions to themselves, just as fifteenth- and six-teenth-century Atlantic explorers did. Later expeditions encountered numerous indigenous people, who fought them so fiercely that the Norse never settled permanently in the western lands. But they visited regularly in search of timber, which was scarce in the Greenland settle-ments and easier to obtain from the west than from distant Norway. For two or more centuries, Greenland ships took passage to North America by sailing north and west and letting southerly ocean currents carry them to their destination. Then they sailed directly home on the prevailing southwesterly winds.

These voyages were wracked by human and natural dangers: hostile in-digenous people, polar bears, icebergs, sudden storms far offshore where rogue waves might swamp a laboring ship before the steersman could bear off before the menacing sea. But the greatest danger was suddenly massing sea ice, which could crush a stout Norse merchant ship in min-utes. Even in summer, crewmen kept axes handy, ready to chip mantles of ice off the rigging before the boat became top heavy. The prudent naviga-tor kept well clear of the ice margins, using word of mouth and years of experience to navigate Greenland waters. We know some of these verbal sailing directions from *Konungsskuggsjá (The King's Mirror),* a com-pendium of information about Greenland and adjacent lands written in the form of a sage's advice to his son in 1260. The anonymous author writes: "There is more ice to the northeast and north of . . . [Greenland] than to the south, southwest, and west; consequently, whoever wishes to make the land should sail around it to the southwest and west, till he has come past all those places where ice may be looked for, and approach the land on that side."[4]

Abundant cod and centuries of unusually mild conditions allowed the Greenlanders to voyage to North America and trade freely with Iceland and Norway in walrus ivory, wool, and even falcons. Their ships often carried exotic, valuable cargoes. In 1075, a merchant named Audun shipped a live polar bear from Greenland as a gift to King Ulfsson of Denmark. Four centuries later, no one would have dared carry such a cargo eastward. If not for the Medieval Warm Period, hundreds of years

might have passed before anyone colonized Greenland and voyaged be-
yond its fjords.

As the Medieval Warm Period dawned and the Vikings crossed to Green-
land and North America, Europe was a patchwork of feudal states and
warring lords, unified only by the Christian faith. King Charlemagne
founded his Frankish empire in 800. The Holy Roman Empire came into
being in 962 but offered little security. The Norsemen ravaged the north-
ern coasts for more than two hundred years, then acquired a veneer of
culture from the lands where they settled. Knut the Dane, or "Canute the
Great" (1016–35), famous for his attempts to control the tides, presided
over a North Sea empire that linked Britain and Denmark. William the
Bastard, Duke of Normandy, conquered the kingdom of England in
1066. He parceled out his new domains among his Norman lords and
created a feudal realm, a dense network of contractual relationships,
which connected the highest to the lowest in the land. Not that the va-
garies of the weather made William's task easier. Persistent northwesterly
winds delayed his Channel crossing until October. Furthermore, two cen-
turies of warm conditions had caused significant sea level rises. A shallow
fjord extended deep into eastern England as far as Norwich. The low-
lying English fenlands became a labyrinth of shallow channels and islands
so difficult of access for an invader that the Anglo-Danish inhabitants of
the city of Ely, led by Hereward the Wake, were able to hold off the Nor-
mans for a decade after 1066.

For all the conquest and adventuring, Europe was a rural continent.
Long before the Romans tamed Britain and Gaul two thousand years ago,
Europe's economy was anchored to the land and the sea, where the va-
garies of floods, droughts, and severe winters affected everyone's eco-
nomic fortunes. Several wet springs and cool summers in a row, a se-
quence of severe Atlantic winter storms and floods, a two-year
drought—such brief climatic variations were sufficient to put people's
lives at risk. The annual harvest drove everyone's fortunes, monarch and
baron, small-town artisan and peasant. The generally stable weather of

the Medieval Warm Period was an unqualified blessing for the rural poor and small farmers.[5]

Summer after summer, warm settled weather began in June, and extended into July and August and through the hectic days of late summer. Medieval paintings tell the story of bountiful harvest. A French book of the seasons shows men and women in the March fields, in the shadow of strongly fortified castle walls. The fields are small, often divided into strips. Women and children crouch over furrowed land, pulling weeds before planting begins. In the foreground, a bearded man with leather hat and leggings plows a furrow with an iron-tipped plow drawn by two patient oxen. A shepherd and his dog drive a flock of sheep across fallow land toward the castle, while the leafless vines in a walled field under the walls stand still in the early spring day. In the lower corner, a peasant pours seed for planting into a waiting sack.

The poor lived off the land, supplementing their harvests with fishing and hunting in dense forests. For the wealthy, hunting was a sport. Gaston Fébus's *Book of the Hunt*, written in France in 1387, proclaims the author's expertise at hunting stags with dogs. The pictures depict lords pursuing their prey through forests, their dogs leaping for the kill. Other illustrations show how Fébus used nets for trapping hares and foxes, with men hard at work spinning fine rope and fabricating nets of different grades, the finest being used for capturing pigeons, even songbirds. After the hunt, the hunters gathered for a fine feast in the open air, their horses grazing nearby, the dogs scavenging for scraps. The nobility had a passion for hunting with falcons. In a mid-thirteenth-century book on falconry published in Sicily, two falcon handlers with thick leather gauntlets display their birds, one of which is picking with its beak at its jess (tether).

Despite wars, Crusades, schism and other strife, the Medieval Warm Period was a bountiful time for Europe. In the deep countryside, the even tenor of rural existence unfolded year after year. Life centered on the endless processions of seasons, on the routines of planting and harvest, cycles of good years and bad, and on the timeless relations between lords and their serfs. Innumerable tiny, largely self-sufficient hamlets nestled in remote valleys and on the edges of thick woodlands, their inhabitants living close to the soil, where everything depended on the bounty of summer harvests and the living one could wrest from the land.

Most years passed with good harvests and enough to eat. Average summer temperatures were between 0.7 and 1.0°C above twentieth-century averages. Central European summers were even warmer, as much as 1.4°C higher than their modern averages. May frosts, always a hazard for warmth-loving crops, were virtually unknown between 1100 and 1300. The summer months were consistently sufficiently warm and dry for vineyards to spread across southern and central England, as far north as Hereford and the Welsh borders. Commercial vineyards flourished 300 to 500 kilometers north of their twentieth-century limits. During the height of the Warm Period, so many lords quaffed prime English wines that the French tried to negotiate trade agreements to exclude them from the Continent.

Rural and urban populations rose sharply during medieval times. New villages sprang up on hitherto uncleared lands. Thousands of hectares of woodland fell before farmers' axes in a medieval practice called *assarting*. Warmer summers and mild winters allowed small communities to grow crops on marginal soils and at higher altitudes than ever before—350 meters above sea level on the hills of Dartmoor in southwestern England, on the Pennine Moors in the northeast, where, in the thirteenth century, shepherds complained about the encroaching cultivation of prized grazing range, and on the summits of southeastern Scotland's Lammermuir Hills, 320 meters above sea level. Today, neither Dartmoor nor the Pennine Moors support crops and the upper limit of cereal growth in the Lammermuirs is well below that of 1250. In 1300, one farm owned by Kelso Abbey in southern Scotland had over 100 hectares of land under cultivation, supported 1,400 sheep and sixteen shepherds' households— all at 300 meters above sea level, well above today's limit. By the same year, thousands of farmers had settled on high ground and on marginal lands throughout England and Scotland, which placed them at risk of crop failure.

In Scandinavia, settlement, forest clearance, and farming spread 100 to 200 meters farther up valleys and hillsides in central Norway, from levels that had been static for more than 1,000 years. Wheat was grown around Trondheim and hardier grains such as oats as far north as Malagan, at latitude 62.5° north. The height change hints at a rise in summer temperatures of about a degree Centigrade, a similar increase to that across the

North Sea in Scotland. Farming became considerably easier in the Scottish highlands as a result, as forests spread outward into hitherto treeless environments. Far to the south in the Alps, tree levels rose sharply and farmers planted deeper and deeper into the mountains. During late prehistoric times, numerous copper mines had flourished in the Alps until advancing ice sealed them off. Late medieval miners reopened some of the workings when the ice retreated. Higher rainfall spread over much of southern Europe and the western Mediterranean. As a result, some Sicilian rivers were navigable in ways that would be impossible today. Medieval bridges, like the one in Palermo, still span them but are far longer than now necessary, simply because the rivers were wider nine hundred years ago.

In theory, European society was well ordered. "Every man should have a lord," proclaimed the Treaty of Verdun in 843. Only the Pope and the Holy Roman Emperor in Constantinople were exempt from this stricture, and they were vassals of the Lord. In practice, feudal society was intensely hierarchical, a confused mass of conflicting dependencies and loyalties, intersected by exceptions and exemptions and ridden with constant litigation. At the local level, the lord of a manor granted a plot of land to each of his serfs in exchange for service as unpaid laborers on his demesne. Enserfment implied a contract that traded land for service, protection for loyalty. Almost every rural European was conditioned by his or her position in a complex social order, hemmed in by legal and emotional ties of dependence that gave people some security but no personal freedom. But all on the land, lord and commoner alike, counted their blessings of fine weather and usually good harvests and attributed them to God's grace.

In that devout age, everyone's fate was in the hand of the Lord. People lived at God's mercy, with only their piety to intercede for them, expressed in prayer and mortar. Gratitude came from chant and prayer, from lavish offerings and, above all, from a surge of cathedral building.

The energetic Suger, Abbot of Saint Denis (d. 1151), was a shaper of European politics, an adviser to monarchs who even governed France when King Louis VII went on the Second Crusade. He found time to patronize the development of the soaring Gothic architectural style, where the skeletal structure of a cathedral held up a higher and lighter building, with more space for windows than earlier, more massive Norman churches.[6] Gothic churches were towering frameworks of masonry columns or pillars, supported on the outside by flying buttresses. Their architects made brilliant use of stained glass to tell stories, to depict the Christian cosmos, with a great rose window over the front wall of the cathedral. The stone tracery gave the appearance of a rose, the brightly colored glass set in lead in an ancient symbol of human love transcending passion. Sculptures on the external and internal walls of the cathedral represented biblical stories, the four Gospels, the Last Judgment, and other manifestations of Christian belief. Abbot Suger himself appears as a small figure kneeling in prayer in a small corner of one of the stained glass windows of his own abbey, itself a masterpiece of Gothic artistry.

The twelfth and thirteenth centuries were golden years of architects, masons, and carpenters, who moved from cathedral to cathedral, taking their evolving ideas with them. They created works of genius: Notre Dame, on the Ile de le Cité in the heart of Paris, commissioned by Bishop Maurice de Sully in 1159 and built over two centuries; the ethereal places of worship at Rheims and Sens; the choir of Canterbury Cathedral in southern England, erected in the 1170s, and Lincoln to the north, a triumph of vaulting, begun in 1192. The ultimate aesthetic effect came at the Sainte-Chapelle in Paris, completed on April 25, 1248, smaller than the great cathedrals and "an edifice of exquisite delicacy and light, its tall, slender windows filled with brilliant expanses of stained glass."[7] Cathedrals are never completed, for they are built, then rebuilt, restored, added to, and sometimes abandoned or damaged in war by later generations. But the surge in Gothic cathedral building, financed by an outpouring of surplus resources, labor, and wealth, was never emulated in later centuries.

Every civilization expresses itself through its great works. They are society's most tangible statement of what is important enough to have scarce resources lavished upon it. The Pyramids of Giza in Egypt were built at

enormous expense as symbolic ladders to heaven for the divine pharaohs who were buried in them 4,500 years ago. Aztec rulers of ancient Mexico laid out their fifteenth-century capital, Tenochtitlán, "the Place of the Prickly Pear Cactus," in the center of their vast empire as a depiction in stone and stucco of their cosmos. Our industrial and commercial age erects universities and museums, huge concert halls and stadiums, railroads, highways, and the World Wide Web. Medieval Europeans built cathedrals. The cathedral was an act of piety, a wondrous monument, a museum. Perhaps endowed with a sacred relic, a miraculous image, or a sign of martyrdom, a cathedral at Canterbury, York or Chartres was a tangible symbol of the imminent presence of God. Even in good years, medieval Christians worried about harvests, the fertility of the land, the continuity of life itself. Cathedrals were the Bible of the illiterate poor, built in an image of the cross and of the Body of Christ. Each represented a corner of God's kingdom. They were expensive outpourings of love for the Lord, sacrifices of stone and material goods offered in the expectation of divine favor.

In 1195, Notre Dame de Chartres cathedral rose in northern France on a sacred site occupied by six previous churches. Built in a mere quarter-century, Chartres is a masterpiece of Gothic architecture, where the Christian cosmos becomes a miracle in stone and glass. The cathedral is all windows, the great rose window of the western front symbolizing the Virgin Mary herself, evoking soul, eternity, the sun and cosmos. The other rose windows in the cathedral depict the Virgin and Child, the martyrs who spread the Word and the New Testament, and the wounded Christ at the center of the Last Judgment in the west window. Each window uses the same vocabulary of color, form, geometry and symbol. The gemlike transmutation of the light shining through Chartres's windows created transcendental effects that could heal and revivify the worshipers crowded in the soaring nave. On the floor of the nave, a circular tiled maze has a rose at the center, a labyrinth that depicts the path of the human soul through life on earth. There is only one maze path to the center. The confusion of the maze walker reflects the complex journey of life on earth, through the challenges of harvests good and bad, through war and pestilence, through youth, adulthood, and old age.

Like other cathedrals, Chartres was a magnet of medieval life. Only about 1,500 people lived in Chartres, except at major festivals, when as many as 10,000 visitors crowded the cathedral. The great bells tolled in times of joy and mourning. They sounded warnings and rang out with exultation and in crisis. Every Easter, a New Light was kindled to celebrate the Resurrection and the new farming year. The faithful lit a thousand tapers and carried them from village to village, household to household, as life was renewed. Come autumn, hundreds of heavily laden carts brought the fruits of a warm, bountiful summer as offerings to God. Like the Norse conquests, cathedrals too are a consequence of a global climatic phenomenon, an enduring legacy of the Medieval Warm Period.

For five centuries, Europe basked in warm, settled weather, with only the occasional bitter winters, cool summers and memorable storms, like the cold year of 1258 caused by a distant volcanic eruption that cooled the atmosphere with its fine dust. Summer after summer passed with long, dreamy days, golden sunlight, and bountiful harvests. Compared with what was to follow, these centuries were a climatic golden age. Local food shortages were not unknown, life expectancy in rural communities was short, and the routine of backbreaking labor never ended. Nevertheless, crop failures were sufficiently rare that peasant and lord alike might piously believe that God was smiling upon them.

Nothing prepared them for the catastrophe ahead. As they labored through the warm summers of the thirteenth century, temperatures were already cooling rapidly on the outer frontiers of the medieval world.

2

THE GREAT FAMINE

When the world was half a thousand years younger all events had much sharper outlines than now. The distance between sadness and joy, between good and bad fortune, seemed to be much greater than for us. . . . There was less relief available for misfortune and for sickness; they came in a more fearful and more painful way. Sickness contrasted more strongly with health. The cutting cold and the dreaded darkness of winter were more concrete evils. . . .

But one sound always rose above the clamor of busy life and, no matter how much of a tintinnabulation, was never confused with other noises, and for a moment, lifted everyone into an ordered sphere: that of the bells. The bells acted in daily life like concerned good spirits, who, with their familiar voices, proclaimed sadness or joy, calm or unrest, assembly or exhortation.

—Johan Huizinga
The Autumn of the Middle Ages

Complex interactions between the atmosphere and the ocean govern Europe's climate. A constantly changing pressure gradient reigns over the northern Atlantic and much of Europe's climate, its influence as pervasive in the north as the celebrated Southern Oscillation of the southwestern Pacific, which governs El Niños and much tropical weather. The North Atlantic Oscillation (NAO) is a seesaw of atmospheric pressure between a persistent high over the Azores and an equally prevalent low over Iceland.

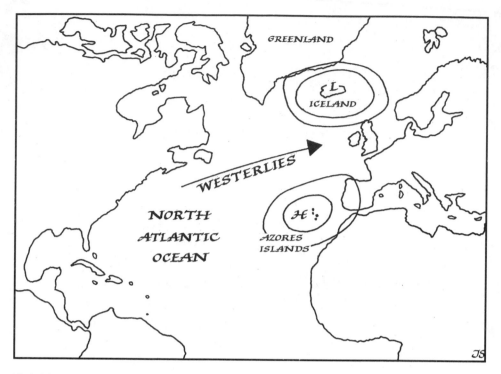

High North Atlantic Oscillation index

This seems like an arcane piece of scientific information until you understand that the NAO governs the position and strength of the North Atlantic storm track and thus the rain that falls on Europe, especially during winter.

The "NAO index" expresses the constant shifts in the oscillation from year to year and decade to decade. A high NAO index signals low pressure around Iceland and high pressure off Portugal and the Azores, a condition that gives rise to persistent westerly winds. These westerlies bring heat from the Atlantic's surface to the heart of Europe, together with powerful storms. The same winds keep winter temperatures mild, which makes northern European farmers happy and produces dry conditions in southern Europe. A low NAO index, in contrast, brings shallower pressure gradients, weaker westerlies, and much colder temperatures over Europe. Cold air from the north and east flows from the North Pole and Siberia, snow blankets Europe, and Alpine skiers have a wonderful time. NAO's winter oscillations account for about half the variability in winter temperatures in

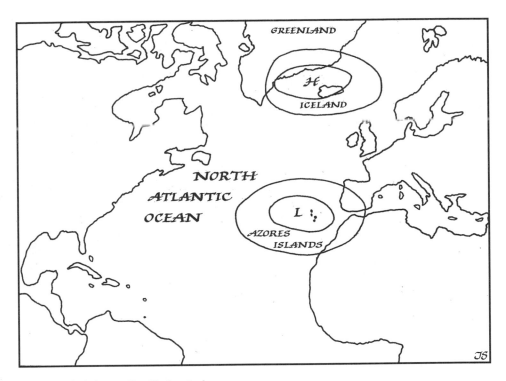

Low North Atlantic Oscillation index

northern Europe and also exercise an important effect on summer rainfall. A high NAO index brings more rain in the summer, as it did after 1314.

The seesaw swings unceasingly, in cycles that can last seven years or more, even decades, or sometimes much less. The swings are unpredictable and sudden. An extreme low NAO index causes a reversal of winter temperatures between Europe and Greenland. When pressure in Greenland is higher than in Europe—the "Greenland above" (GA) effect—persistent blocking high pressure systems form between Greenland and Scandinavia. Temperatures are above average in western Greenland and lower than usual in northwestern Europe (and also in eastern North America). Winter in western Europe is bitterly cold. When pressure over Greenland is lower than that in Europe—"Greenland below" (GB)—then temperatures are reversed and the European winter is milder than normal.

The extreme swings of the NAO are part of the complex atmospheric/ocean dynamics of the North Atlantic, which include sea-surface

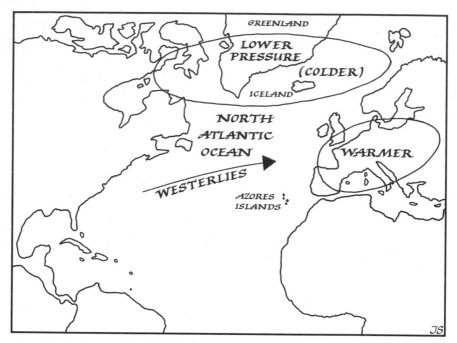

Greenland below effect

temperature anomalies, the strength of the Gulf Stream, atmospheric wave structure, and the distribution of sea ice and icebergs. These interactions are poorly understood, but there seems little doubt that many of the swings in the NAO result from changes in sea surface temperatures in the North Atlantic. One day, computer simulations of dynamic ocean temperatures and atmospheric relationships may allow meteorologists to predict winter rainfall in Europe several years in advance, a scientific breakthrough of momentous importance.

The chaotic atmosphere over the North Atlantic plays a major role in the NAO's unpredictable behavior. So do the mild waters of the Gulf Stream, which flow northeast off North America and then become the North Atlantic current, bringing warm water to the British Isles and adjacent coasts as far north as Iceland and Norway. The warmer surface waters of the north flush regularly, sinking toward the bottom, carrying atmospheric gases and excess salt. Two major downwelling sites are known, one just north of Iceland, the other in the Labrador Sea southwest of Greenland. At both these locations, vast quantities of heavier, salt-laden water sink far below the surface. Deep subsurface currents then carry the salt

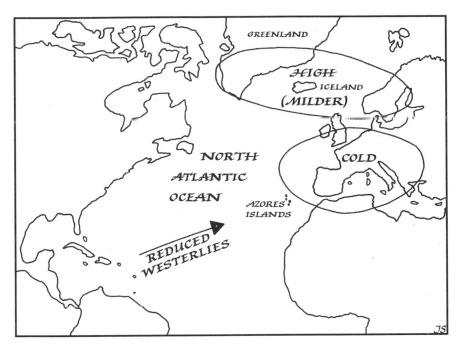

Greenland above effect

southward. So much salt sinks in the northern seas that a vast heat pump forms, caused by the constant influx of warmer water, which heats the ocean as much as 30 percent beyond the warmth provided by direct sunlight in the north. What happens if the flushing fails? The pump slows down, the warm North Atlantic current weakens, and temperatures fall rapidly in northwestern Europe. When downwelling resumes, the current accelerates and temperatures climb again. The effect is like a switch, triggered by the interaction of atmosphere and ocean. For example, in the early 1990s, the Labrador Sea experienced vigorous downwelling, which gave Europe mild winters. In 1995/96, the NAO index changed abruptly from high to low, bringing a cold winter in its wake.

The NAO has affected European climate for thousands of years. By piecing together information from tree rings, ice cores, historical records, and modern-day meteorological observations we now have a record of the North Atlantic Oscillation going back to at least 1675. Low NAO indices seem to coincide with known cold snaps in the late seventeenth century. Over the past two centuries, NAO extremes have produced memorable weather like the very cold winters of Victorian England in the 1880s. An-

other low index cycle in the 1940s enveloped Europe in savage cold as Hitler invaded Russia. The 1950s were somewhat kinder, but the 1960s brought the coldest winters since the 1880s. Over the past quarter-century, high NAO indices have brought the most pronounced anomalies ever recorded and warmed the Northern Hemisphere significantly, perhaps as a result of humanly caused global warming.

For many centuries, Europe's weather has been at the mercy of capricious swings of the NAO Index and of downwelling changes in the Arctic. We do not know what causes high and low indices, nor can we yet predict the sudden reversals that trigger traumatic extremes. But we can be certain that the NAO was a major player in the unpredictable, often extremely cold, highly varied weather that descended on Europe after 1300.

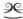

In the thirteenth century, Greenland and Iceland experienced increasing cold. Sea ice spread southward around Greenland and in the northernmost Atlantic, creating difficulties for Norse ships sailing from Iceland as early as 1203. Unusual cold brought early frosts and crop failures to Poland and the Russian plains in 1215, when famine caused people to sell their children and eat pine bark. During the thirteenth century, some Alpine glaciers advanced for the first time in centuries, destroying irrigation channels in high mountain valleys and overrunning larch forests.

While colder temperatures afflicted the north, Europe as a whole benefited from the change. The downturn of temperatures in the Arctic caused a persistent trough of low pressure over Greenland and enduring ridges of high pressure over northwestern Europe. A period of unusually warm, mostly dry summers between 1284 and 1311, in which May frosts were virtually unknown, encouraged many farmers to experiment with vineyards in England. After the turn of the fourteenth century, however, the weather turned unpredictable.

The year 1309/10 may have been a "Greenland above" year. The dry and exceptionally cold winter made the Thames ice over and disrupted shipping from the Baltic Sea to the English Channel. An anonymous chronicler wrote,

In the same year at the feast of the Lord's Nativity, a great frost and ice was massed together in the Thames and elsewhere, so that poor people were oppressed by the frost, and bread wrapped in straw or other covering was frozen and could not be eaten unless it was warmed: and such masses of encrusted ice were on the Thames that men took their way thereon from Greenhithe in Southark, and from Westminster, into London; and it lasted so long that the people indulged in dancing in the midst of it near a certain fire made on the same, and hunted a hare with dogs in the midst of the Thames.[1]

By 1312, the NAO Index was high, the Atlantic storm track shifted southward, and winters were mild again. Three years later, the rains began in earnest.

The deluge began in 1315, seven weeks after Easter. "During this season [spring 1315] it rained most marvellously and for so long," wrote a contemporary observer, Jean Désnouelles. Across northern Europe, sheets of rain spread in waves over the sodden countryside, dripping from thatched eaves, flowing in endless rivulets down muddy country lanes. Wrote chronicler Bernardo Guidonis: "Exceedingly great rains descended from the heavens, and they made huge and deep mud-pools on the land." Freshly plowed fields turned into shallow lakes. City streets and narrow alleys became jostling, slippery quagmires. June passed, then July with little break in the weather. Only occasionally did a watery sun break through the clouds, before the rain started again. "Throughout nearly all of May, July, and August, the rains did not cease," complained one writer.[2] An unseasonably cold August became an equally chilly September. Such corn and oats as survived were beaten down to the ground, heavy with moisture, the ears still soft and unripened. Hay lay flat in the fields. Oxen stood knee deep in thick mud under sheltering trees, their heads turned away from the rain. Dykes were washed away, royal manors inundated. In central Europe, floods swept away entire villages, drowning hundreds at a time. Deep erosion gullies tore through hillside fields where shallow clay soils could not absorb the endless water. Harvests had been less than usual in previous years, causing prices to rise, but that of 1315 was a disaster. The author of the *Chronicle of Malmesbury* wondered, like many others, if divine vengeance had come upon the land: "Therefore is the anger of the Lord kindled against his people, and he

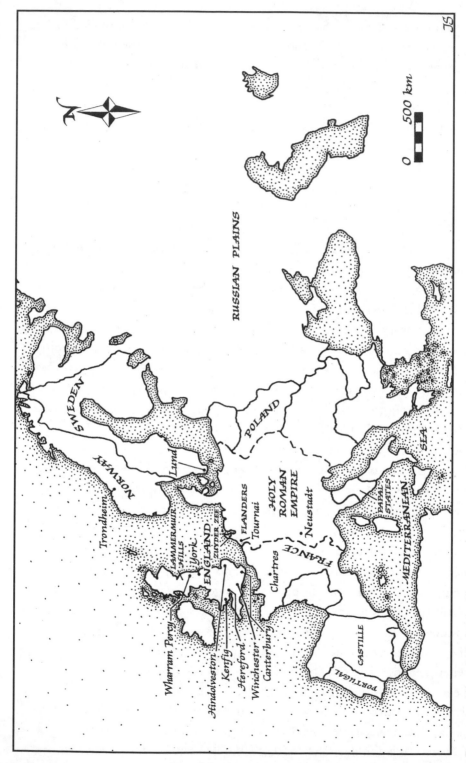

Europe in the early fourteenth century

hath stretched forth his hand against them, and hath smitten them."[3]
Tree rings from northern Ireland show that 1315 was a year of extraordinary growth for oak trees.

Europe was a continent of constant turmoil and minor wars, of endless killings, raids, and military expeditions. Many conflicts stemmed from succession disputes and personal rivalries, from sheer greed and reckless ambition. The wars continued whatever the weather, in blazing sunshine or torrential rain, armies feeding off villages, leaving empty granaries and despoiled crops in their train. War merely increased the suffering of the peasants, who lived close enough to the edge as it was. But the rains of 1315 stopped military campaigning in its tracks.

Trade and geography made Flanders one of the leading commercial centers of fourteenth-century Europe. Italian merchant bankers and moneylenders made their northern headquarters here, attracted by the great wealth of the Flemish weaving industry. Technically a fief of France, the country and its prosperous towns were more closely tied to England, whose wool formed the cloth woven across the North Sea. The quality and fine colors of Flemish fabrics were prized throughout Europe and as far afield as Constantinople, creating prosperity but a volatile political situation. Both England and France vied for control of the region. While the Flemish nobility kept French political interests and cultural ties dominant, the merchants and working classes favored England out of self-interest. In 1302, Flemish workers had risen in rebellion against their wealthy masters. The flower of French knighthood, riding north to crush the rebellion, had fallen victim to the swampy terrain, crisscrossed with canals, where bowmen and pikemen could pick off horsemen like helpless fish. Seven hundred knights perished in the Battle of Courtai and the defeat was not avenged for a quarter-century. The inevitable retaliation might have come much earlier had not the rain of 1315 intervened.

In early August of that year, French king Louis X planned a military campaign into Flanders, to isolate the rebellious Flemings from their North Sea ports and lucrative export trade. His invasion force was poised at the border before the Flemish army, ready to advance in the heavy rain. But as the French cavalry trotted onto the saturated plain, their horses sank into the ground up to their saddle girths. Wagons bogged down in the mire so deeply that even seven horses could not move them. The infantry stood knee-deep in boggy fields and shivered in their rain-flooded

tents. Food ran short, so Louis X retreated ignominiously. The thankful Flemings wondered if the floods were a divine miracle. Their thankfulness did not last long, for famine soon proved more deadly than the French.

The catastrophic rains affected an enormous area of northern Europe, from Ireland to Germany and north into Scandinavia. Incessant rain drenched farmlands long cleared of woods or reclaimed from marsh by countless small villages. The farmers had plowed heavy soils with long furrows, creating fields that absorbed many millimeters of rain without serious drainage problems. Now they became muddy wildernesses, the crops flattened where they grew. Clayey subsoils became so waterlogged in many areas that the fertility of the topsoil was reduced drastically for years afterward.

As rural populations grew during the thirteenth century, many communities had moved onto lighter, often sandy soils, more marginal farming land that was incapable of absorbing sustained rainfall. Deep erosion gullies channeled running water through ravaged fields, leaving little more than patches of cultivable land. In parts of southern Yorkshire in northern England, thousands of acres of arable land lost their thin topsoil to deep gullies, leaving the underlying rock exposed. As much as half the arable land vanished in some places. Inevitably, crop yields plummeted. Such grain as could be harvested was soft and had to be dried before it could be ground into flour. The cold weather and torrential rains of late summer 1315 prevented thousands of hectares of cereals from ripening fully. Fall plantings of wheat and rye failed completely. Hay could not be cured properly.

Hunger began within months. "There began a dearness of wheat. . . . From day to day the price increased," lamented a chronicler in Flanders.[4] By Christmas 1315, many communities throughout northwestern Europe were already desperate.

Few people understood how extensive the famine was until pilgrims, traders, and government messengers brought tales of similar misfortune from all parts. "The whole world was troubled," wrote a chronicler at Salzburg, which lay at the southern margins of the affected region.[5] King Edward II of England attempted to impose price controls on livestock, but without success. After the hunger grew worse, he tried again, placing restrictions on the manufacture of ale and other products made from

grain. The king urged his bishops to exhort hoarders to offer their surplus grain for sale "with efficacious words" and also offered incentives for the importation of grain. At a time when no one had enough to eat, none of these measures worked.

The hunger was made worse by the previous century's population growth. Late eleventh-century England's population of about 1.4 million had risen to 5 million by 1300. France's inhabitants (that is, that part of Europe now lying within the country's modern boundaries) increased from about 6.2 million in the late eleventh century to about 17.6 million or even higher. By 1300, with the help of cereal cultivation at unprecedented altitudes and latitudes, Norway supported half a million people. Yet economic growth had not kept pace with population. There was already some sluggishness in local economies by 1250, and very slow growth everywhere after 1285. With growing rural and urban populations, high transportation costs, and very limited communication networks, the gap between production and demand was gradually widening throughout northern Europe. Many towns and cities, especially those away from the coast or major waterways, were very vulnerable to food shortages.

In the countryside, many rural communities survived at near-subsistence levels, with only enough grain to get through one bad harvest and plant for the next year. Even in good years, small farmers endured the constant specter of winter famine. All it took was a breakdown in supply lines caused by iced-in shipping, bridges damaged by floods, an epidemic of cattle disease that decimated breeding stock and draught animals, or too much or too little rainfall, and people went hungry.

Even in the best of times, rural life was unrelentingly harsh. Six decades earlier, in 1245, a Winchester farm worker who survived childhood diseases had an average life expectancy of twenty-four years. Excavations in medieval cemeteries paint a horrifying picture of health problems resulting from brutal work regimes. Spinal deformations from the hard labor of plowing, hefting heavy grain bags, and scything the harvest are commonplace. Arthritis affected nearly all adults. Most adult fisherfolk suffered agonizing osteoarthritis of the spine from years of heavy boatwork and hard work ashore. The working routines of fourteenth-century villagers revolved around the never-changing rhythm of the seasons, of planting and harvest. The heat and long dry spells of summer

were a constant struggle against weeds that threatened to choke off the growing crops. The frantically busy weeks of harvest time saw villagers bent to the scythe and sickle and teams of threshers winnowing the precious grain. The endless round of medieval household and village never ceased, and the human cost in constant, slow-moving toil was enormous. Yet despite the unending work, village diets were never quite adequate, and malnutrition was commonplace. Local food shortages were a reality of life, assuaged by reliance on relatives and manorial lords or on the charity of religious houses. Most farmers lived from harvest to harvest on crop yields that at the best of times were far below modern levels.

Both archaeology and historical records provide portraits of medieval village life, but few are as complete as that from Wharram Percy, a deserted village in northeast England. Forty years of research have revealed a long-established settlement that mirrors many villages of the day. Iron Age farmers lived at Wharram Percy more than 2,000 years ago. At least five Roman farms flourished here. By the sixth century, Saxon families dwelt in their place. Scattered farming settlements gave way to a more compact village between the ninth and twelfth centuries, which was replanned at least twice. The Medieval Warm Period was good to Wharram Percy, when the settlement entered its heyday. The population grew considerably, the hectarage under cultivation expanded dramatically. The compact village became a large settlement with its own church, two manor houses and three rows of peasant houses, each with its own croft (enclosure) built around a central, wedge-shaped green. The peasants lived in thatched long houses, their roofs supported by pairs of timbers known as crucks, with flimsy walls that were replaced at regular intervals. Each building had three parts: an inner room for sleeping, sometimes used as a dairy, a main living area with central hearth, and a third space used as a cattle byre, or for some other farming purpose. (Long houses were common in Medieval villages everywhere, although architecture and village layout varied greatly between Scandinavia and the Alps.) Wharram Percy was largely self-sufficient, a prosperous community in its heyday. But the bountiful days of the thirteenth century were long fled from memory when the village was finally abandoned in the sixteenth century.

The self-sufficiency of European villages extends deep into the past, to long before the Romans imposed the *Pax Romana* on Gaul and Britannia

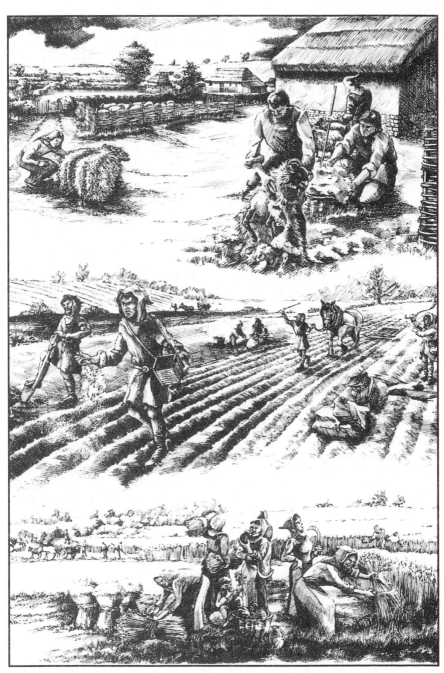

Medieval farming: sheep shearing sowing, and the harvest. Reconstruction based on Wharram Percy, England. Reprinted with permission of English Heritage.

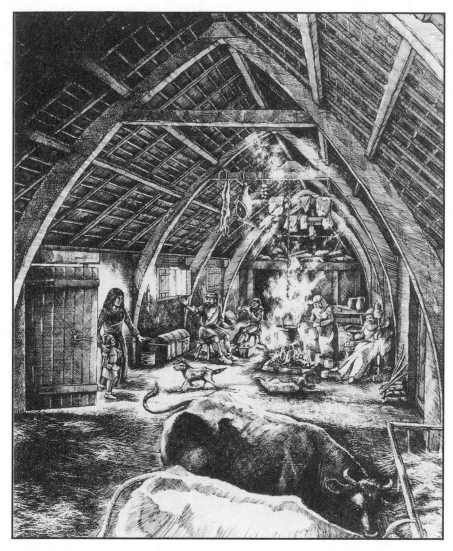

Medieval farming: interior of a long house with its crucks (timber beams). Reconstruction based on Wharram Percy, England. Reprinted with permission of English Heritage.

just before the time of Christ. A millennium later, life still revolved around the manor house and the farm, the monastery and small market towns. Tens of thousands of parish churches formed a network of territorial authority at the village level, where, for all the political changes and land ownership controversies, the parish priest remained a figure of respect. But times were changing as new commercial and political interests emerged. By 1250, a tapestry of growing cities and towns linked by tracks, water-

ways and trade routes lay superimposed on the rural landscape. Walled castles and cities rose at strategic locations, creating oases of safety in troubled lands where barons fought with barons at the slightest provocation. Towns and cities, a few with as many as 50,000 inhabitants, were places somewhat apart, striving for their own social and political identity, peopled by a growing class of merchants and burghers, who were outside the feudal system. Many of these towns lay at key ports and estuaries, at important river crossings, or around the residences of important lords and bishops. But poor communications, especially on land, meant that most communities were largely self-sufficient, as they had always been. The parish always remained the cornerstone of the ordered life of the countryside through famine, plague, and war, long after nation states and powerful commercial associations transformed the European economy.

Europe's commerce was still based on trade routes well known to the Romans. Wool flowed across the North Sea and English Channel, Mediterranean goods up major waterways like the Rhine and overland, along routes between Lombardy, Genoa, and Venice, important centers of trade with eastern Mediterranean lands. The Hanseatic League, a powerful commercial association based in Scandinavia, Germany, and the Low Countries, was still in its infancy. Europe's rudimentary infrastructure still depended on slow, unreliable communications across potentially stormy seas, on rivers and inland waterways, and the most rudimentary rural tracks. The amount of grain imported from the Baltic and Mediterranean lands was still minuscule compared with later centuries. In the final analysis, every community, every town, was on its own.

Medieval farmers had few options for dealing with rainfall and cold. They could diversify their crops, planting some drought-resistant strains and others that thrived in wetter conditions. As a precaution, they could sow their crops on a mosaic of different soils, hoping for better yields from some of them. In earlier centuries they could perhaps move to richer areas, but by 1300 most of Europe's best farmland was occupied. Storage was all important. Enough grain had to be kept on hand to tide the community over from one harvest to the next and beyond, and to even out the good and bad years. Even with barns stuffed to the eaves, however, few medieval villages could endure two bad harvests, even if wealthy lords or religious foundations with their large granaries had such a capacity. The villagers' best recourse was the ability to exchange grain and other vi-

tal commodities with relatives and neighbors living close or afar. This form of famine relief could be highly effective on a small scale, but not when an entire continent suffered the same disaster.

Most close-knit farming communities endured the shortages of 1315 and hoped for a better harvest the following year. Then the spring rains in 1316 prevented proper sowing of oats, barley, and spelt. The harvest failed again and the rains continued. Complained a Salzburg chronicler of 1316: "There was such an inundation of waters that it seemed as though it was THE FLOOD."[6] Intense gales battered Channel and North Sea. Storm-force winds piled huge sand dunes over a flourishing port at Kenfig near Port Talbot in south Wales, causing its abandonment. Villages throughout northern Europe paid the price for two centuries of extensive land clearance. Flocks and herds withered, crops failed, prices rose, and people contemplated the wrath of God. The agony was slow: famine weakens rural populations and makes them vulnerable to disease, which follows almost inevitably in its train. The prolonged disaster is familiar from modern-day famines in Africa and India. People first turned to relatives and neighbors, invoking the ties of kin and community that had bound them for generations. Then many families abandoned their land, seeking charity from relatives or aimlessly wandering the countryside in search of food and relief. Rural beggars roamed from village to village and town to town, telling (often false) stories of entire communities abandoned or of deserted meadows and hillsides.

By the end of 1316, many peasants and laborers were reduced to penury. Paupers ate dead bodies of diseased cattle and scavenged growing grasses in fields. Villagers in northern France are said to have eaten cats, dogs, and the dung of pigeons. In the English countryside, peasants lived off foods that they would not normally consume, many of them of dubious nutritional value. They were weakened by diarrhea and dehydration, became more susceptible to diseases of all kinds, were overcome by lethargy, and did little work. The newborn and the aged died fastest.

Community after community despaired and slowly dissolved. Thousands of acres of farmland were abandoned due to a shortage of seed corn

and draught oxen, and to falling village populations. Huge areas of the
Low Countries, inundated by the sea after major storms and prolonged
rains, were so difficult to reclaim that major landowners could hardly per-
suade farmers to resettle their flooded lands. Across the North Sea, in the
Bilsdale area of northeast Yorkshire, late thirteenth-century homesteaders
had cleared hundreds of acres of higher ground for new villages. A couple
of generations later, knots of hamlets, each with its own carpenters,
foresters, and tanners, flourished on the newly cleared land. But climatic
and economic deterioration, the 1316 famine, disease, and Scottish raids
caused all of them to be abandoned by the 1330s. The hamlets became
tiny single-family holdings, and the communities dispersed. Throughout
northern Europe, small farming communities on marginal land were
abandoned, or shrunk until their holdings were confined to the most fer-
tile and least flood-prone lands.

The cold and wet conditions brought profound hardship to home-
steads almost everywhere. Many free landowners, forced to sell or mort-
gage their farms, were reduced to the basest poverty. Thousands of farm-
ers became laborers, especially in areas around London and other large
cities, where there was much demand for food and such tasks as plowing
were made more laborious by the wet, clogged soils. Real estate records
and rent lists reveal a dramatic increase in land transactions, as richer
landowners exploited their poorer neighbors and families deeded fields to
their children to enable them to survive. Compared with 1315, for exam-
ple, the manor of Hindolveston in Norfolk witnessed a 160 percent in-
crease in surrenders of property by tenants in 1316, and a 70 percent
overage in 1317. In most cases, a handful of rich farmers bought out their
poorer colleagues. One Adam Carpenter acquired five parcels of land in
1315 alone. By the time the rush of transactions abated, he had acquired
forty-seven.

The year 1316 was the worst for cereal crops throughout the entire
Middle Ages. In many places, the crops simply did not ripen. Where
wheat could be harvested, the plants were stunted, the yields pitiful.
Throughout the thirteenth century, the Winchester manors in southern
England had enjoyed more or less constant yields of about three bushels
for every one sown. The 1316 crop was only 55.9 percent of normal, the
lowest between 1271 and 1410. The estate's income accounts record
"from lamb's wool nothing this year, because they were not shorn on ac-

count of the great inconsistency of the weather in the summer." "From the sale of hay in the meadow, nothing on account of the abundance of rain in the summer." The Bishop of Winchester's mill made no profit "because the mill did not grind for half the year on account of the flood."[7] Not only wheat but barley, beans, oats, and peas yielded crops that were 15 to 20 percent lower than normal. Northern Europe generally experienced comparable shortfalls.

Salt and wine production plummeted. Downy mildew attacked French grapes, so vines never reached their proper maturity and "there was a great failure of wine in the whole kingdom of France." Chroniclers complained of shortages and harsh taste. The vineyards of Neustadt in Germany were hard hit: 1316, "a trifling quantity of wine"; 1317, "very little wine." That of 1319 was "sour," while the cold in 1323 was so extreme that the root stocks died. Not until 1328, six years after the famine ended, was there "very much and exceptionally good wine."[8]

The weather attacked not only crops but animals. Just feeding them in winter became a serious headache. The fields were so damp that, even if hay could be mowed, the crops could not dry in the open. Stored in a barn, uncured hay rots, builds up heat and methane gas, and can burst into flames unless turned regularly. What drying ovens and kilns were available were used to dry unripened grain for human consumption. The worst for animals came later in the famine years. The bitterly cold winter of 1317/18 used up the already depleted fodder stocks. When these ran out, farmers had to turn their animals out to forage for themselves in short-lived warmer spells. Thousands of head starved or froze to death in their pastures. Sheep suffered especially badly from the cold, for prolonged snow and frost early in the year make lambing a risky proposition. The raw summer brought virulent rinderpest, which attacked cattle with diarrhea, dehydration, and intestinal failure. Thousands of putrefying carcasses were burnt or buried in mass graves. A parasitic worm infection called liver fluke reduced sheep and goat flocks by as much as 70 percent in some places.

"The great dying of beasts" continued into the early 1320s, bringing severe shortages not only of livestock but of manure for the fields. The impact was felt immediately. Oxen and horses lay at the heart of the rural economy, the former used extensively for plowing. Teams of oxen, often owned jointly by several families, plowed heavier soils for entire communi-

ties and were heavily used by medieval manors. Inevitably, the stock shortage translated into fewer hectares plowed, abandoned fields, and lower crop yields. Only pigs were relatively unaffected. Fast-breeding swine were abundant until the shortfall in bread, beef, and mutton caused people to increase the amount of pork in their diet and herds were decimated.

In the towns, the urban poor ate less bread. Wrote a Flemish observer in 1316: "The people were in such great need that it cannot be expressed. For the cries that were heard from the poor would move a stone, as they lay in the street with woe and great complain, swollen with hunger."[9] In Flanders, bread was no longer made from wheat but from anything that was available. Sixteen Parisian bakers were caught putting hog dung and wine dregs in their loaves. They were placed on punishment wheels in public squares and forced to hold fragments of the rotten bread in their hands. People went days without eating and assuaged hunger pangs by eating leaves, roots, and the occasional fish taken from a stream. Even King Edward II of England had trouble finding bread for his court. Famine was often more severe in cities and towns than in the countryside, with widespread diarrhea and lethargy resulting from "strange diets." The hungry suffered greatly from the intense winter cold. There had not been so many deaths from disease or such instability in towns within living memory. Robbery with assault became commonplace as thieves stole anything that could be eaten or sold for food, be it hay, timber, or church roof lead. Piracy flourished as desperate locals preyed on fishing boats and grain vessels.

Grave robbing had always been a fact of life, especially in times of scarcity, when thieves would dig for coins, clothing, and fine objects buried with the dead that could be pawned. Towns like Marburg in Germany maintained faint lights in their cemeteries, which may have prevented some looting, but no one protected rural burial grounds. One can imagine the surreptitious gleam of candle lanterns in country graveyards in the small hours of the night, the stealthy digging into a fresh grave, the quick stripping of the corpse of its shroud and silver ornaments. By morning, there would be only scattered bones, perhaps a grinning skull and dismembered finger bones, their rings torn away. From there, it was but a short step to rumors of secret cannibalism, of people eating their children. London taverns bred tales of hungry villagers seen eating their kin and of famished prisoners in jail consuming fellow inmates, but no chronicler ever wrote of a specific instance.

Beggars flocked to the cities from the countryside. In the Low Countries, they gathered in large groups, scavenged the middens that lay outside town walls or "grazed like cattle" in the fields. Bodies littered cultivated land and were buried in mass graves. The mendicants spread disease. In the town of Tournai in modern-day Belgium, 1316 was "the year of the mortality." Gilles de Muisit, abbot of Saint-Martin de Tournai, wrote: "men and women from among the powerful, the middling, and the lowly, old and young, rich and poor, perished daily in such numbers that the air was fetid with the stench."[10] Huge communal cemeteries entombed the previously segregated dead, rich and poor alike. In Louvain, a wagon from the hospital "loaded with six or eight corpses twice or thrice a day continuously carried pitiable little bodies to the new cemetery outside the town." Between 5 and 10 percent of Flanders's urban population perished in the Great Famine.

By 1317, as the rains continued through another wet summer, people everywhere despaired. The church performed complex rogation ceremonies to pray for divine intervention. Guilds and religious orders in Paris processed barefoot through the streets. In the dioceses of Chartres and Rouen, chronicler Guillaume de Nangis saw "a large number of both sexes, not only from nearby places but from places as much as five leagues away, barefooted, and many even, excepting the women, in a completely nude condition, with their priests, coming together in procession at the church of the holy martyr, and they devoutly carried bodies of the saints and other relics to be adored."[11] After generations of generally good harvests and settled weather, they believed divine retribution was at hand for a Europe divided by wars. Rich and poor alike endured the punishment of God.

The famine brought an outpouring of religious fervor and, for some, profit. Canterbury Cathedral with its wealthy priory attracted streams of pilgrims, many of them poor travelers in holy orders. The priory had an honorable tradition for charity. Its budget had run at a deficit because of its generosity, showing only four years with modest surpluses between 1303 and 1314. In 1315, the monks made an unexpected profit of £534, despite the famine. Their wheat yields were as bad as anyone else's, but they were able to sell considerable amounts of oats. Their real profit came from £500 worth of offerings to the priory by pilgrims praying for better weather. In 1316, the monks found themselves in the same position as everyone else, with significant grain shortfalls and a need to pay much

higher prices for anything they could not produce for themselves. They also faced a moral dilemma. The priory was besieged by poor pilgrims seeking relief. Yet offerings were off by 50 percent. Rents from the priory estates had declined by nearly half, but the house could not reduce its level of relief without affecting its good reputation among the devout. At the same time, consumption of communion wine had increased twofold owing to the increased level of devotions. The monks resorted to cost-cutting measures reminiscent of modern times. They curtailed pensions, delayed essential maintenance on buildings, and postponed costly lawsuits.

The priory's problems were compounded by increased royal taxation to pay for wars with the Scots. King Edward I had conquered Wales between 1277 and 1301 and secured it with a line of castles from Harlech to Conway. He had also invaded Scotland unsuccessfully to intervene in a succession dispute. Edward's poorly timed intervention provoked a Scottish bid for total independence. He was succeeded by Edward II in 1307, whose army was defeated by Robert the Bruce at the Battle of Bannockburn in 1314. Warfare continued until 1328, when the Scots prevailed. The cost for the English was enormous, at a time of great suffering. Royal taxation fell heavily on a hungry populace and on Canterbury priory. The monks still managed to produce plenty of high-priced oats, but most of their carefully thought out savings were eaten up not by pilgrims but by the new taxation for Scottish wars. However, the priory's refusal to cut relief soon rebounded in its favor. When the harvest improved in 1319, offerings promptly skyrocketed to a record £577. The monks received so many sacred relics for a cathedral already well endowed with such artifacts that they sold them off for over £426. It was well they had plenty of money in hand, for cattle disease struck in 1320, with devastating effects on the surrounding area. Fortunately, offerings reached over £670, as people prayed for relief, and the priory weathered the crisis.

The suffering lasted for seven years before more normal harvests brought a measure of relief. Horrendous weather continued through 1318, with extensive flooding in the Low Countries in 1320 and 1322. The cycle ended in 1322 with a reversal of the NAO, which brought a bone-chilling winter

that immobilized shipping over a wide area while thousands more perished from hunger and disease. The settled climate of earlier years gave way to unpredictable, often wild weather, marked by warm and very dry summers in the late 1320s and 1330s and by a notable increase in storminess and wind strengths in the English Channel and North Sea. The moist, mild westerlies that had nourished Europe throughout the Medieval Warm Period turned rapidly on and off as the NAO oscillated from one extreme to the other. The Little Ice Age had begun.

COOLING BEGINS

Lord, thyse weders ar spytus and the weders full kene
And the frostys so hydus they water myn eeyne
No ly.
Now in dry, now in wete,
Now in snaw, now in slete,
When my shone freys to my fete,
It is not all esy.

—*Second shepherd,* Second Towneley Shepherd's Play,
part of the Wakefield Cycle, c. 1450

Through climatic history, economic history, or at least agrarian
history, is reduced to being 'one damn thing after another.'
—*Jan de Vries*
"Measuring the Impact of Climate on History," 1981

3

THE CLIMATIC SEESAW

> Glacier oscillations of the last few centuries have been among the greatest that have occurred during the last 4,000 years perhaps . . . the greatest since the end of the Pleistocene ice age.
> —François Matthes
> "Report of Committee on Glaciers," 1940

Fifteen thousand years have passed since the end of the last glacial episode of the Great Ice Age. Since then, through the Holocene (Greek: recent) era, the world has experienced global warming on a massive scale—a rapid warming at first, then an equally dramatic, thousand-year cold snap some 12,000 years ago, and since then warmer conditions, culminating in a period of somewhat higher temperatures than today, about 6,000 years before present. The past 6,000 years have seen near-modern climatic conditions on earth.

Like the Ice Age that preceded it, the Holocene has been an endless seesaw of short-term climate change caused by little-understood interactions between the atmosphere and the oceans. The last 6,000 years have been no exception. In Roman times, European weather was somewhat cooler than today, whereas the height of the Medieval Warm Period saw long successions of warm, settled summers. Then, starting in about 1310 and continuing for five and a half centuries, the climate became more unpredictable, cooler, occasionally stormy, and subject to sporadic extremes—the Little Ice Age.

"Little Ice Age" is one of those scientific labels that came into use almost by default. A celebrated glacial geologist named François Matthes

first used the phrase in 1939. In a survey on behalf of a Committee on Glaciers of the American Geophysical Union, he wrote : "We are living in an epoch of renewed but moderate glaciation—a 'little ice age' that already has lasted about 4,000 years."[1] Matthes used the term in a very informal way, did not even capitalize the words and had no intention of separating the colder centuries of recent times from a much longer cooler and wetter period that began in about 2000 B.C., known to European climatologists as the Sub-Atlantic. He was absolutely correct. The Little Ice Age of 1300 to about 1850 is part of a much longer sequence of short-term changes from colder to warmer and back again, which began millennia earlier.

The harsh cold of Little Ice Age winters lives on in artistic master-pieces. Peter Breughel the Elder's *Hunters in the Snow*, painted during the first great winter of the Little Ice Age in 1565, shows three hunters and their dogs setting out from a snowbound village, while the villagers skate on nearby ponds. Memories of this bitter winter lingered in Breughel's mind, as we see in his 1567 painting of the three kings visiting the infant Jesus. Snow is falling. The monarchs and their entourage trudge through the blizzard amidst a frozen landscape. In December 1676, artist Abraham Hondius painted hunters chasing a fox on the frozen Thames in London. Only eight years later, a large fair complete with merchants' booths, sleds, even ice boats, flourished at the same ice-bound location for weeks. Such carnivals were a regular London phenomenon until the mid-nineteenth century. But there was much more to the Little Ice Age than freezing cold, and it was framed by two distinctly warmer periods.

A modern European transported to the height of the Little Ice Age would not find the climate very different, even if winters were sometimes colder than today and summers very warm on occasion, too. There was never a monolithic deep freeze, rather a climatic seesaw that swung constantly backwards and forwards, in volatile and sometimes disastrous shifts. There were arctic winters, blazing summers, serious droughts, torrential rain years, often bountiful harvests, and long periods of mild winters and warm summers. Cycles of excessive cold and unusual rainfall could last a decade, a few years, or just a single season. The pendulum of climate change rarely paused for more than a generation.

Scientists disagree profoundly on the dates when the Little Ice Age first began, when it ended, and on what precise climatic phenomena are

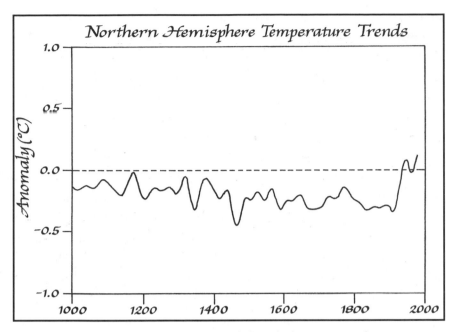

Northern Hemisphere temperature trends based on ice-core and tree-ring records, also instrument readings after c. 1750. This is a generalized compilation obtained from several statistically derived curves.

to be associated with it. Many authorities place the beginning around 1300, the end around 1850. This long chronology makes sense, for we now know that the first glacial advances began around Greenland in the early thirteenth century, while countries to the south were still basking in warm summers and settled weather. The heavy rains and great famines in 1315–16 marked the beginning of centuries of unpredictability throughout Europe. Britain and the Continent suffered through greater storminess and more frequent shifts from extreme cold to much warmer conditions. But we still do not know to what extent these early fluctuations were purely local and connected with constantly changing pressure gradients in the North Atlantic, rather than part of a global climatic shift.

Other authorities restrict the term "Little Ice Age" to a period of much cooler conditions over much of the world between the late seventeenth and mid-nineteenth centuries. For more than two hundred years, mountain glaciers advanced far beyond their modern limits in the Alps, Iceland and Scandinavia, Alaska, China, the southern Andes and New Zealand.

Mountain snow lines descended at least 100 meters below modern levels (compared with about 350 meters during the height of the late Ice Age 18,000 years ago). Then the glaciers began retreating in the mid- to late nineteenth century as the world warmed up significantly, the warming accelerated in part by the carbon dioxides pumped into the atmosphere by large-scale forest clearance and the burgeoning Industrial Revolution—the first anthropogenic global warming.

Climate change varied not only from year to year but from place to place. The coldest decades in northern Europe did not necessarily coincide with those in, say, Russia or the American West. For example, eastern North America had its coldest weather of the Little Ice Age in the nineteenth century, but the western United States was warmer than in the twentieth. In Asia, serious economic disruption, far more threatening than any contemporary disorders in Europe, occurred throughout much of the continent during the seventeenth century. From the 1630s, China's Ming empire faced widespread drought. The government's draconian response caused widespread revolt, and Manchu attacks from the north increased in intensity. By the 1640s, even the fertile Yangtze River Valley of the south suffered from serious drought, then catastrophic floods, epidemics, and famine. Millions of people died from hunger and the internecine wars that resulted in the fall of the Ming dynasty to the Manchus in 1644. Hunger and malnutrition brought catastrophic epidemics that killed thousands of people throughout Japan in the early 1640s. The same severe weather conditions affected the fertile rice lands of southern Korea. Again, epidemics killed hundreds of thousands.

Only a few short cool cycles, like the two unusually cold decades between 1590 and 1610, appear to have been synchronous on the hemispheric and global scale.

Unfortunately, scientifically recorded temperature and rainfall observations do not extend back far into history—a mere two hundred years or less in Europe and parts of eastern North America. While these incomplete readings take us back through recent warming into the coldest part

Some methods used to study the Little Ice Age

Ice Cores →

Tree Rings →

Volcanic Eruptions (irregular)

Historical Accounts (Impressionistic)

Wine Harvests

Instrument Records

A.D.	1900	1800	1700	1600	1500	1400	1300	1200	1100	1000	900

(Vertical axis label: Method)

of the Little Ice Age, they tell us nothing of the unpredictable climatic change that descended on northern Europe after 1300.

Reconstructing earlier climatic records requires meticulous detective work, considerable ingenuity, and, increasingly, the use of statistical methods. At best, they provide but general impressions, for, in the absence of instrument readings, statements like "the worst winter ever recorded" mean little except in the context of the writer's lifetime and local memory. Climatic historians and meteorologists have spent many years trying to extrapolate annual temperature and rainfall figures from the observations of country clergymen and scientifically inclined landowners from many parts of Europe. Extreme storms offer unusual opportunities for climatic reconstruction. On February 27, 1791, Parson Woodforde at Weston Longville, near Norwich in eastern England, recorded : "A very cold, wet windy day almost as bad as any day this winter." Synoptic weather charts reconstructed from observations like Woodforde's reveal a depression that brought fierce northeasterly winds of between 70 and 75 knots along the eastern England coast for three days. The gale brought the tides on the Thames "to such an amazing height that in the neighborhood of Whitehall most of the cellars were underwater. The parade in St. James's Park was overflowed." Thames-side corn fields suffered at least £20,000 worth of damage.[2]

Fluctuating grain prices are another barometer of changing temperatures, in the sense that they can be used to identify cycles of unusually

wet or dry weather that brought poor harvest in their train. Economic historians like W. G. Hoskins have tracked grain prices over many centuries and chronicled rises of 55 percent to as much as 88 percent above normal at times of scarcity, when hoarders and merchants stockpiled grain with an eye to a windfall profit or cereals were just in short supply. In countries like Britain or France, where bread was a staple, such rises could be catastrophic, especially for the poor. In the social disorders that usually followed, farmers lived in fear of their crops being pillaged before they were ripe, and mobs descended on markets to force bakers to sell bread at what they considered to be fair prices. Monastery records and the archives of large estates are a mine of information about harvests good and bad, about prices and yields, but, like most early historical sources, they lack the precision of a tree-ring sequence or an ice core. Annalists would write of heavy rain storms that "in many places, as happens in a flood, buildings, walls, and keeps were undermined," but such vivid descriptions are no substitute for reliable daily temperature readings.[3]

The dates of wine harvests, derived from municipal and tithe records, also vineyard archives, provide a general impression of cooler and warmer summers, with the best results coming from linking such information with readings from tree rings and other scientific sources. The climate historian Christian Pfister focuses on two crucial months that stand out in colder periods: cold Marches and cool and wet Julys. Such conditions marked 1570 to 1600, the 1690s, and the 1810s, probably the coldest decades of the Little Ice Age.[4]

Climatic historians are ingenious scholars. For instance the Hudson's Bay Company insisted that its captains and factors in the Canadian Arctic keep weather records on a daily basis even at its most remote stations. Since the same employees often worked for the company for many years, the records of ice conditions and of the first thaw and snowfall are remarkably accurate for the late eighteenth and early nineteenth centuries, to the point that you can track annual fluctuations in first snowfall and the beginning of the spring thaw to within a week, even a few days, over long periods of years. Spanish scholars are using the records of rogation ceremonies performed to pray for rain or an end to a deluge. Rogation rituals were rigorously controlled by the church and unfolded at various levels, culminating in years of crisis in formal processions and pilgrimages. Thus, they provide a crude barometer of climatic fluctuations.

Historical records like these clearly display minor fluctuations between decades, but how they relate to broader climate change is a matter for future research. In recent years, statistical methods are being used to test indices developed from historical sources against tree-ring and other scientific climatic data. From such tests we learn, for example, that sixteenth century central Europe was cooler at all seasons than the period 1901 to 1960, and that winters and springs were about 0.5° cooler, with autumn rainfall about 5 percent higher. Almost uninterrupted cold winters settled over the area between 1586 and 1595, with temperatures about 2°C cooler than the early twentieth-century mean. The same indices proclaim 1691–1700 and 1886–95 as the coldest decades in Switzerland over the past five centuries.

For all the richness and diversity of archival records, we have to rely in large part on scientific sources for year-by-year climatic information on the Little Ice Age. This record comes in part from ice cores, sunk deep into the Greenland ice cap, into Antarctic ice sheets, including one at the South Pole, and into mountain glaciers like that at Quelccaya in the southern Andes of Peru. Ice-core research bristles with highly technical difficulties, many of them resulting from the complex processes by which annual snowfall layers are buried deeper and deeper in a glacier until they are finally compressed into ice. Scientists have had to learn the different textures characteristic of summer and winter ice, so they can assemble a long record of precipitation that goes back deep into the past. Snowfall changes are especially important because they provide vital evidence on the rate of warming and cooling during sudden climatic changes.

Two cores from the Greenland ice cap, known as GISP-1 and 2, are of particular interest for the Little Ice Age. GISP-2 has an accuracy in calendar years of ±1 percent, which makes it exceptionally useful for dating temperature changes, themselves identified by changes in the isotopic signal of deuterium (D) from year to year, even season to season. Lower isotopic excursions signal low temperatures, such as those in Greenland during the fourteenth century, where winters were the coldest they have been over the past seven hundred years. Ice-core climatic reconstructions offer great promise for studying the short-term cycles of warmer and colder conditions that affected the medieval Norse settlements in Greenland.

Until the 1960s, tree-ring research was largely confined to the Southwestern United States, where astronomer Andrew Douglass achieved sci-

entific immortality by dating ancient Indian pueblos from the annual growth rings in desiccated wooden lintel beams. Since then, thousands of tree-ring sequences have come from the Southwest, to the point that experts can trace the year-by-year progression of serious droughts across the region 1,000 years ago. Originally, tree-ring dating was applied only in areas with markedly seasonal rainfall, but the science is now so refined that we have highly accurate sequences from German and Irish oaks going back at least 8,000 years.

Tree-ring temperature reconstructions now span the entire Northern Hemisphere and come from over 380 locations. We have the first interannual and interdecadal temperature variability curves as far back as A.D. 1400 or earlier, with very reliable data for the years after 1600.[5] Such temperature estimates, acquired by statistical regression analyses from modern instrument records or by proxies from historical records and other sources, are vital to establishing just how warm the late twentieth century has been in comparison with earlier times.

Major volcanic eruptions, like that which destroyed Roman Herculaneum and Pompeii in A.D. 79, are spectacular, often catastrophic events. The greatest of them can be detected in tree-ring sequences and through fine dust in ice cores. Eruptions have important climatic consequences because of the fine dust they throw out, which can linger in the atmosphere for years on end. Hypotheses linking eruptions and weather have been around a long time. Benjamin Franklin theorized that volcanic dust could lower temperatures on earth. In 1913, a U.S. Weather Bureau scientist named William Humphreys used data from the spectacular Krakatau eruption in Southeast Asia in 1883 to document the correlation between historic volcanic eruptions and worldwide temperature changes. Volcanic dust is some thirty times more effective in shielding the earth from solar radiation than it is in preventing the earth's heat from escaping. During the three years it may take for the dust from a large eruption to settle out, the average temperature of much of the globe may drop as much as a degree, perhaps even more. The effects tend to be most marked during the summer following a major volcanic event.

The provisional temperature curves for the Little Ice Age display some conspicuous downward spikes, when a single year was unusually cold. Almost invariably, these are associated with major eruptions, such as that of

Mount Tambora in southeast Asia in 1815, the most spectacular eruption of the past 15,000 years. Over the next few years, Tambora's ash drifted through the atmosphere and dimmed the sun. The year 1816 appears as a sharp cold spike in the climatologists' temperature diagrams, the "year without a summer" when snow fell in New England in June and Europe shivered through a frigid September. Major volcanic eruptions almost invariably brought colder summers and bad harvests, natural phenomena unconnected with the endless perturbations of the Little Ice Age. During the seventeenth century, an unusual frequency of volcanic events contributed to the volatility of climate change.

What caused the Little Ice Age? Did small changes in the earth's axis affect global temperatures for five centuries? Or did cyclical fluctuations in solar radiation lead to greater cooling? The answer still eludes us, largely because we have barely begun to understand the global climatic system and the interactions between atmosphere and ocean that drive it. There are few certainties. One is that we still live in the Great Ice Age, somewhere near the midpoint of an interglacial, one of the many that have developed over the past three-quarters of a million years. In the fullness of time—according to some estimates, in the next 23,000 years—the world will most likely return to another glacial cycle, with temperatures as extreme as those of 18,000 years ago, when much of Europe really was in a deep freeze.

Slow, cyclical changes in the eccentricity of the earth's orbit and in the tilt and orientation of its spin axis have constantly changed patterns of evaporation and rainfall and the intensity of the passing seasons over the past 730,000 years. As a result, the world has shifted constantly between extreme cold and short warmer periods. The geochemist Wallace Broecker believes these changes caused the entire ocean-atmosphere system to flip suddenly from one mode during glacial episodes to an entirely different one during warmer periods. He argues that each flip of the "switch" changed ocean circulation profoundly, so that heat was carried around the world differently. In other words, Ice Age climatic patterns were very different from those of the past 10,000 years.

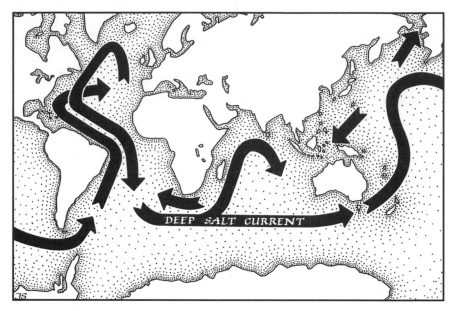

The Great Ocean Conveyor Belt, which circulates saltwater deep below the surface of the world's oceans. Salt downwelling in the North Atlantic Ocean plays a vital part in this circulation.

If Broecker is correct, then today's climatic mode results from what he calls the "Great Ocean Conveyor Belt."[6] Giant, conveyor-like cells circulate water through the world's oceans. In the Atlantic, warm, upper-level water flows northward until it reaches the vicinity of Greenland. Cooled by Arctic air, the surface waters sink and form a current that covers enormous distances at great depths, to the South Atlantic and Antarctica, and from there into the Pacific and Indian Oceans. A southward movement of surface waters in these oceans counters the northward flow of cold bottom water. In the Atlantic the northward counterflow is sucked along by the faster southward conveyor belt, which is fed by salt-dense water downwelling from the surface in northern seas. The Atlantic conveyor circulation has power equivalent to one hundred Amazon Rivers. Vast amounts of heat flow northward and rise into the Arctic air masses over the North Atlantic. This heat transfer accounts for Europe's relatively warm oceanic climate, which has persisted, with vicissitudes, through ten millennia of the Holocene.

We understand the Great Ocean Conveyor Belt in only the most general terms, but enough to know that circulation changes in the upper

ocean have a profound effect on global climatic events like El Niños. We know, also, that the chaotic equations of the atmosphere and ocean exercise a powerful influence on the swirling atmospheric streams, surface downwelling, and shifting currents of the North Atlantic. Broecker and others have recently turned their attention to the deep sea, to changes in the thermohaline circulation (marine circulation caused by differences in the temperature and salinity of sea water).[7]

Since it was discovered in the 1980s, we have assumed that the ocean conveyor belt has operated smoothly throughout the Holocene. Under this scenario, nearly equal amounts of deep ocean water originate in the North Atlantic and around the perimeter of the Antarctic and are thoroughly mixed during their northward and southward passages. This mixing occurs when surface water exposed to atmospheric gases descends into the deep ocean. This long-held assumption may be wrong, for we now know something is different in today's Southern Ocean. The Weddell Sea in Antarctica has produced much smaller quantities of mixed deep water than expected over the decades since scientific observations began. In contrast, the North Atlantic is now producing deep water at a rate consistent with that needed to maintain its natural carbon 14 (14C) level. Broecker theorizes that Southern Ocean deep water production was much greater during the Little Ice Age than today, just as it was during the last glacial maximum of the Ice Age and during the short-lived and cold Younger Dryas period of 11,500 years ago.

Antarctic deep-water production may have increased about eight hundred years ago during the fourteenth century, precisely when Europe experienced its first significant cooling, then slackened off as conditions warmed again after 1850. The end of the Little Ice Age saw two warming stages, one from the late nineteenth century to about 1945, the other from after 1975 to the present. Scientific observations over the past quarter-century display no signs of higher production, so most likely the deep-water production rate slowed well before the 1940s.

There are no easy answers to the conundrum of the Little Ice Age, but we can be certain that such minor "ice ages" occurred many times earlier in the Holocene, even if we still lack the tools to identify them. We would logically expect another such episode to descend on the earth in the natural, and cyclical, order of climate change, were it not for increasingly

compelling evidence that humans have altered the climatic equation irrevocably through their promiscuous use of fossil fuels since the Industrial Revolution. We may be in the process of creating an entirely new era in global climate, which makes an understanding of the Little Ice Age a high scientific priority.

Climate has never been a fashionable topic in historical circles, largely because, until recently, paleoclimatology was a crude and infant science. Only a handful of scholars, among them the French scholar Le Roy Ladurie, Swiss climatic historian Christian Pfister, and the late British climatologist Hubert Lamb have paid careful attention to the social effects of volatile climatic shifts in the Little Ice Age. Most historians discount the importance of climate in shaping the events of the recent past, reacting, quite rightly, against the notion that climate change was a primary and simple trigger for major historical events. No one would argue today that climate change "caused" the French Revolution or that the bitter cold of twelfth century Greenland "caused" the medieval Norse to abandon their northernmost farms. This kind of environmental determinism, with its simple cause-and-effect arguments, is long vanished from serious discussion and with good reason.

The historian's caution was entirely appropriate in an era before tree-ring networks, ice cores, and sophisticated statistical treatments of historical data. Today, a climatologist's portrait of the annual fluctuations of the Little Ice Age looks like a fine-toothed comb gone mad—a graph of sharp-edged spikes of cold and warm, of cycles of cooler and warmer conditions plotted above and below a benchmark for today's climate. The curve never stays still, but moves up and down, sometimes sharply and without warning, at other times trending more gently. It is as if we have set sail on a climatic sea, tossed to-and-fro from the moment we set out on our journey through time. We will rarely experience true stability, just the occasional calm spot: a decade of settled, warmer weather or more intense cold. The constant reality is unpredictable change fueled by complex interactions between atmosphere and ocean, by pressure swings on the other side of the world.

For the first time, we place a detailed graph of changing climate alongside the momentous historical events of the Little Ice Age, not as a remote backdrop but as a critical, and long neglected, factor in a complex equation of harvests, subsistence crises, and economic, political and social changes. We can see how cycles of cold or of excessive rainfall rippled across Europe, affecting monarch, noble, and commoner in different ways, changing the course of wars and the prosperity of fisheries, and fostering agricultural innovation. Climate change was a subtle catalyst, not a cause, of profound change in a European world where everyone lived at the complete mercy of a subsistence farming economy, where the ripple effects of poor wine harvests could affect the economic welfare of the Hapsburg empire. The Little Ice Age is the story of Europeans' struggle against the most fundamental of all human vulnerabilities.

4

STORMS, COD
AND DOGGERS

As soon as the great ocean has been traversed there is such a great superfluity of ice on the sea that nothing like it is known anywhere else in the whole world and it lies so far out from the land that there is no less than four or more days journey thereunto on the ice.

—Konungsskuggsjá *(The King's Mirror), c. 1250*

Sailors on the northern reaches of the medieval world began to experience the effects of increasing cold a century before the great famine of 1315–21. The cooling first intensified in the northeast, around Franz Josef Land and Spitzbergen, and then spread westward across the Arctic. Many winters, thick pack ice moved further south than it had for centuries, then lingered in the stormy waters between Iceland and Greenland through early summer, hampering an already tricky ocean passage. Not every winter was exceptionally cold, but harsh conditions, freezing late spring temperatures and persistent pack ice more frequently compounded sailors' difficulties.

In Eirik the Red's day, Norse merchant ships (*knarrs*) had taken the most direct route from Iceland to East Greenland, along Latitude 65° north, then coasted south and west round Cape Farewell to the Eastern Settlement. Even in those warmer times, ships foundered in offshore gales, were dashed to pieces against the rugged Greenland and Icelandic coasts, capsized when overloaded, or were simply blown off course never

to be seen again. Only a few of these maritime tragedies have left a record in history. In about 1190, a Norwegian *knarr* named *Stangarfóli* was set off course by a gale while bound from Bergen to Iceland and wrecked on the east coast of Greenland. A decade later, some hunters found the wreck, the skeletons of six men, and the perfectly preserved, frozen body of Icelandic priest Ingimund Thorgeirsson. Beside him lay wax tablets inscribed with crabbed runes that recorded his death from starvation.[1]

By 1250, many fewer ships made the crossing to the Norse colonies. Those that dared traveled a much more hazardous route, far from land in the open Atlantic. A skipper now sailed a day and a night due west from Iceland, then altered course southwestward to avoid the pack ice off southeastern Greenland. The new routing involved more time out of sight of land and a higher risk of foundering in the savage westerly gales that can blow in this part of the North Atlantic even in high summer. Inevitably, Greenland became more isolated from Norway and Iceland. Two and a half centuries later, in 1492, Pope Alexander VI remarked in a letter that "shipping to that country [Greenland] is very infrequent because of the extensive freezing of the waters—no ship having put into shore, it is believed, for eighty years."[2] Alexander suggested that voyages might be possible in August. Political ties between the ancient Norse homeland and its western colonies loosened, and, in the case of Greenland, became almost nonexistent. However, the Pope was misinformed. Where the Norse no longer sailed, others now voyaged, among them Basque and English mariners in new designs of sailing vessels equipped to handle the roughest of winter weather. Ironically, they traveled to Iceland, Greenland, and beyond because the Church had declared fish a legal food on religious holidays.

In northwestern Europe at the end of the thirteenth century, few noticed that the spikes of colder, more stormy years were coming closer together. Those who suffered through cold winters and increasingly frequent sea floods perhaps thought of these occasional catastrophes of extreme cold or storm as manifestations of divine vengeance. At a distance of eight hundred years, we can discern a different pattern: the first signs of climatic deterioration. The winter of 1215 in particular was exceptionally cold in eastern Europe and caused widespread famine. Thousands of hungry Polish farmers headed in desperation for the Baltic coast,

where they vainly believed fish were to be found. While hunger was rarer in the west, the swings of the North Atlantic Oscillation were growing wider and faster.

Making landfall on the eastern shores of the North Sea is always dangerous, especially in the narrows leading to the English Channel. Ever shifting sandbanks protect the low-lying shore with its endless beaches and narrow creeks. Even in good weather with a commanding breeze, the sailor approaches carefully, chart in hand, eyeing the featureless coast in search of rare conspicuous landmarks such as a tall church spire or a lighthouse. The shallows usually lie far offshore, ready to take off one's keel in a few catastrophic poundings from the short, steep seas. Heaven help the skipper who is caught close to land when a howling northwester makes the coast a dangerous lee shore. He tries to claw offshore, hard on the wind, pounding against steep seas that break over the bow as the stomach churns—partly from the motion, partly from fear. Thousands of sailors have perished in these violent waters over the centuries.

Ten thousand years ago, the southern North Sea was a marshy plain where elk and deer wandered and Stone Age foragers hunted and fished. England was part of the Continent until as recently as 6000 B.C., when rising sea levels caused by post–Ice Age warming filled the North Sea. By 3000 B.C., the ocean was at near-modern levels. Sea levels fluctuated continually through late prehistoric and Roman times but rose significantly after A.D. 1000. Over the next two centuries, the North Sea rose as much as forty to fifty centimeters above today's height in the Low Countries, then slowly retreated again as temperatures fell gradually in the north. The North Sea was brimful on the calmest days. When exceptionally high tides coincided with gale-force winds, raging waters surged over thousands of hectares of coastal farmland in a few short hours. The fourteenth and fifteenth centuries had more than their share of such catastrophes.

Seven centuries ago, the North Sea washed coastlines very different from those of today. For instance, a now-vanished shallow estuary extended deep into East Anglia, making Norwich and Ely important ports. Countless narrow creeks and channels penetrated into the farmlands, harboring thousands of small craft, traders, and fishermen. The lumbering grain ships and cargo vessels that plied these waters went well armed, for pirates would pounce on them from muddy hiding places deep in the

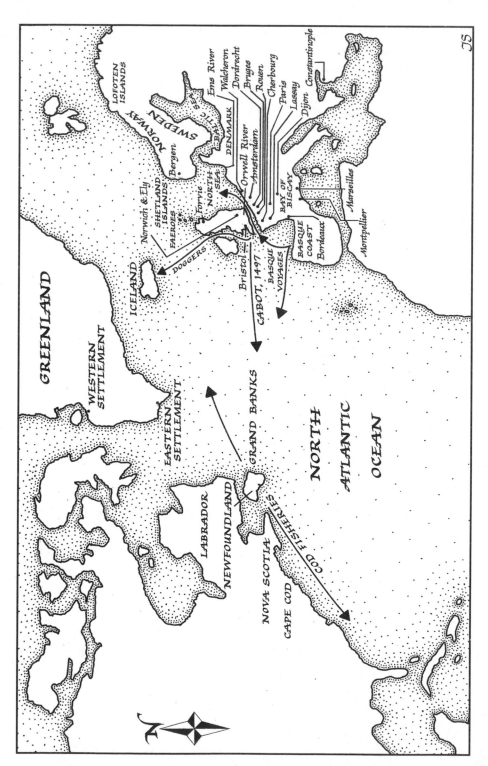

North Atlantic locations, fourteenth and fifteenth centuries, mentioned in Chapters 4 and 5.

coastal marshlands and sandy islands of the low shorelines between the Baltic and the English Channel. The same infiltrating creeks made the surrounding low-lying coastlines vulnerable to unpredictable storm surges, which would sweep up the narrow defiles and flood the land on either side, forcing entire villages to evacuate or drowning them almost without warning. We can imagine the scene, repeated so many times over the generations. Huge waves of muddy water attacked the shore, spray blowing horizontally in the dark mist masking the ground. The relentless ocean cascaded up beaches and into narrow inlets, devouring everything before it. Thatched farmhouses tumbled end-for-end in the waves; pigs and cattle rolled like dice across inundated fields. Bedraggled families clung to one another in trees or on rooftops until the boiling waters swept them away. The only sound was the shrieking wind, which drowned out everything—the growl of shifting gravel beaches, the desperate cries of drowning victims, the groaning branches of tree lashed by the gale. When the sky cleared, the sun shone on an enormous muddy lake as far as the eye could see, a desolate landscape devoid of human life.

No one could resist the onslaught of an angry North Sea, which contemptuously cast aside the crude earthen dikes of the day. The hydrological and technological know-how to erect truly permanent coastal fortifications did not yet exist. The first serious and lasting coast works date to after 1500, but even they were usually inadequate in the face of savage hundred-year storms. Small wonder the authorities often had trouble persuading peasants to settle on easily flooded lands.

At least 100,000 people died along the Dutch and German coasts in four fierce storm surges in about 1200, 1212–19, 1287, and 1362, in long-forgotten disasters that rivaled the worst in modern-day Bangladesh. The Zuider Zee in the northern Netherlands formed during the fourteenth century, when storms carved a huge inland sea from prime farming land that was not reclaimed until this century. The greatest fourteenth-century storm, that of January 1362, went down in history as the *Grote Mandrenke,* the "Great Drowning of Men."[3] A fierce southwesterly gale swept across southern England and the English Channel, then into the North Sea. Hurricane-force winds collapsed church towers at Bury St. Edmunds and Norwich in East Anglia. Busy ports at Ravenspur near Hull in Yorkshire and Dunwich on the Suffolk shore suffered severe damage in the first of a series of catastrophes that

eventually destroyed them. Huge waves swept ashore in the Low Countries. A contemporary chronicler reported that sixty parishes in the Danish diocese of Slesvig were "swallowed by the salt sea." At least 25,000 people perished in this disaster, maybe many more: no one made accurate estimates. The fourteenth century's increased storminess and strong winds formed huge dunes along the present-day Dutch coastline. Amsterdam harbor, already an important trading port, experienced continual problems with silting caused by strong winds cascading sand from a nearby dune into the entrance.

In the early 1400s, more damaging storm surges attacked densely populated shorelines. On August 19, 1413, a great southerly storm at extreme low tide buried the small town of Forvie, near Aberdeen in northeastern Scotland, under a thirty-meter sand dune. More than 100,000 people are said to have died in the great storms of 1421 and 1446.

Judging from North Atlantic Oscillation readings for later centuries, the great storms of the fourteenth and fifteenth centuries were the result of cycles of vigorous depressions that flowed across northwestern Europe after years of more northerly passage when the NAO Index was low. The changing signals of hydrogen isotopes from a two-hundred-meter section of Greenland ice core GISP-2 tell us summer and winter temperatures for the fourteenth century. This hundred-year period saw several well-marked cycles of much colder conditions, among them 1308 to 1318, the time of Europe's massive rains and the Great Famine; 1324 to 1329, another period of unsettled weather; and especially 1343 to 1362, when stormy conditions in the North Sea culminated in the "Great Drowning" and the Norse Western Settlement struggled through its exceptionally cold winters.

Sometime between 1341 and 1363 (the date is uncertain), Norwegian church official Ivar Bárdarson sailed northward with a party of Norse along the western Greenland coast from the Eastern to the Western Settlement, charged by local lawmen to drive away hostile *skraelings* who were rumored to be attacking the farms. He found the Western Settlement deserted, a large church standing empty and no traces of any

colonists. "They found nobody, either Christians or heathens, only some wild cattle and sheep, and they slaughtered the wild cattle and sheep for food, as much as the ships would carry."[4] While Bárdarson blamed elusive Inuit, whom he never encountered, his account is puzzling, for one would assume that the marauding hunters would have killed the livestock. Bárdarson seems to have visited a ghost town abandoned without apparent reason. But modern archaeological excavations reveal a settlement that was dying on its feet from the cold.

Ever since Eirik the Red's time, the Greenlanders had lived off a medieval dairying economy just like those in their homelands. Even in good years with warm summers and a good hay crop, they lived close to the edge. Their survival depended on storing enough hay, dried sea mammal flesh, and fish to tide humans and beasts over the winter months. The Norse could usually survive one bad summer by using up the last of their surplus the following winter. But two successive poor hay crops placed both the animals and their owners at high risk, especially if lingering ice restricted summer hunting and fishing. The ice-core analyses for 1343 to 1362 reveal two decades of much colder summers than usual. Such a stretch, year after year, spelled disaster.[5]

The main house block of a small manor farm called Nipaatsoq tells a grim story of the final months of its occupation. Animals and people lived in separate rooms linked by interconnecting passages. Each spring, the owners swept out the reeds and grass that covered the floors and emptied dung from the byres, yet the archaeologists found the debris of the very last winter's occupation intact. No one had been left to clean up in the spring.

Five dairy cows once occupied the manor's byre. The hooves of these five beasts, the only part of a cow that has no food value whatsoever, were scattered among other food remains across the lower layer of one room. The owners had butchered the dead animals so completely that only the hooves remained. They did this in direct violation of ancient Norse law, which for obvious reasons prohibited the slaughter of dairy cows. In desperation, they put themselves out of the dairy business by eating their breeding stock.

The house's main hall, with its benches and hearths, yielded numerous arctic hare feet and ptarmigan claws, animals often hunted in winter. The larder contained the semi-articulated bones of a lamb and a newborn calf,

and the skull of a large hunting dog resembling an elkhound. The limb bones of the same animal lay in the passageway between the hall and sleeping chamber. All the dog bones at the manor farm came from the final occupation layer and displayed the butchery marks of carcasses cut up for human consumption. Having first eaten their cows and then as much small game as they could take, the Nipaatsoq families finally consumed their prized hunting dogs.

The houseflies tell a similar tale. Centuries before, the Norse accidentally introduced a fly, *Telomerina flavipes,* which flourishes in dark, warm conditions where feces are present. *Telomerina* could only have survived in the warmth of the fouled floors of the main hall and sleeping quarters, where their carcasses duly abounded. Quite different, cold-tolerant carrion fly species lived in the cool larder. Once the house was abandoned, the cold-loving flies swarmed into the now empty living quarters as the fires went out. *Telomerina* vanishes. The uppermost layer of all, accumulated after the house was empty, contains species from outside, as if the roof had caved in.

There were no human skeletons in the house—no remains of dead the survivors were too weak to bury, no last survivor whom no one was left to bury. With but a few seals for the larder, the Nipaatsoq farmers may have simply decided to leave. Where and how they ended up is anybody's guess. Had they adopted toggling harpoons and other traditional ice-hunting technology from their Inuit neighbors a few kilometers away, they could have taken ring seal year round and perhaps avoided the late spring crises that could envelop them even in good years. Perhaps they had an aversion to the Inuits' pagan ways, or their cultural roots and ideologies were simply too grounded in Europe to permit them to adapt.

Another isolated Norse settlement, known to archaeologists as Gård Under Sandet (Farm Beneath the Sand) lay inland, close to what was once fertile, rich meadowland just ten kilometers from Greenland's ice cap. Farm Beneath the Sand began as a long house used first as a human dwelling, then as an animal shed. In about 1200 the hall burnt down. Several sheep perished in the blaze. The farmers now built a centralized farmhouse, like that at Nipaatsoq, with constantly changing rooms, not all of them in use at one time, as the stone-and-turf farm changed over more than two centuries. Late in the 1200s, the climate deteriorated, local glaci-

ers advanced and the pastures sanded up. Farming became impossible and the settlement was abandoned. After abandonment, sheep that were left behind continued to shelter in the empty houses, as did overnighting Thule hunters.[6]

The Norse kept a foothold at the warmer Eastern Settlement for another 150 years. Here they lay close to the open North Atlantic, where changing fish distributions, southern spikes of pack ice, and new economic conditions brought new explorers instead of the traditional *knarrs*. Basques and Englishmen paused to fish and to trade for falcons, ivory, and other exotic goods. But above all, they pursued whales and cod.

In the eighth century, the Catholic Church created a huge market for salted cod and herring by allowing the devout to consume fish on Fridays, the day of Christ's crucifixion, during the forty days of Lent and on major feast days. The ecclesiastical authorities still encouraged fasting and forbade sexual intercourse on such occasions, also the eating of red meat, on the grounds it was a hot food. Fish and whale meat were "cold" foods, as they came from the water, and were thus appropriate nourishment for holy days. But fish spoils quickly, and in the days before refrigeration, drying and salting were about the only ways to preserve it. Dried salt cod and salted herring quickly became the "cold" foods of choice, especially during Lent. Salted cod kept better than either salt herring or whale meat and was easily transported in bulk.

Cod had been a European staple since Roman times. Dried and salted fish was light and durable, ideal hardtack for mariners and armies. In 1282, preparing to campaign in Wales, King Edward of England commissioned "one Adam of Fulsham" to buy 5,000 salted cod from Aberdeen in northeastern Scotland to feed his army. Salt cod fueled the European Age of Discovery and was known to Elizabethan mariners as the "beef of the sea." Portuguese and Spanish explorers relied heavily on it to provision their ships during their explorations of the New World and the route to the Indies around the Cape of Good Hope. No one held the stuff in high esteem. On land and at sea, people washed it down with beer, cider, malmsey wine, or "stinking water" from wooden barrels. For

centuries, thousands of fishermen, especially Basques from northern Spain, Bretons, and Englishmen, pursued cod despite horrifying casualty rates at sea in all weathers. A commodity with a value higher than gold, cod sustained entire national fisheries for centuries.[7]

The Atlantic cod, *Gadus morhua*, flourishes over an enormous area of the North Atlantic, with a modern range from the northern Barents Sea south to the Bay of Biscay, around Iceland and the southern tip of Greenland, and along the North American coast as far south as North Carolina. Streamlined and abundant, it grows to a large size, has nutritious, bland flesh, and is easily cooked. It is also easily salted and dried, an important consideration when the major markets for salt cod were far from the fishing grounds, and often in the Mediterranean. When dried, cod meat is almost 80 percent protein.

Cod are highly temperature sensitive and poorly suited to extremely cold water. Their kidneys do not function well below about 2°C, but the fish thrive in water between 2 and 13°C. Temperatures between 4 and 7°C are optimal for reproduction. Greenland is a telling indicator of how cod populations move with changing water temperatures. For much of the past five cool centuries, the waters of Greenland were too cold for large cod populations except in the most sheltered areas. After 1917, the warmer Irminger current, which flows south of Iceland, extended around Greenland's southern tip. Cod eggs and larvae from spawning grounds north and west of Iceland were carried across the Denmark Strait and around the southern tip of Greenland by the West Greenland Current. By 1933, water temperatures were high enough for cod to thrive up to 72° north. By 1950, cod still abounded as far north as Disko Bay, at 70° north. During the past four decades, the water has turned much colder and Greenland cod stocks have plummeted.[8]

Similar movements of water masses and the resulting changes in sea temperatures affected cod populations in past centuries. We can sometimes track the effects in fisheries records. During the bitterly cold seventeenth century, northern sea temperatures fell below the critical 2°C level along the Norwegian coast and far southward for periods of twenty to thirty years. The Faeroes cod fisheries failed totally in 1625 and 1629. There were no cod after 1675 for many years. By 1695, they were sparse even as far south as the Shetland Islands. The scarcity pertained for most of the time between about 1600 and 1830, during the coldest episodes of the Little Ice Age. Similar shifts in cod populations undoubtedly occurred

in earlier centuries, especially during the cooling of the thirteenth century, just when the demand for dried and salted cod was exploding. Had we the historical records, the changing distribution of cod in the far north would be a remarkable barometer of rising and falling sea temperatures. As it is, there is a strong connection between deteriorating climatic conditions, new designs of oceangoing fishing vessels, and an inexorable spread of cod fishing away from the European continental shelf onto another shelf, off virtually unknown lands far to the west.

During medieval times, the Basques of northern Spain, who controlled abundant salt deposits, acquired a sterling reputation as whale hunters.[9] They sold fresh and salted whale meat as "cold" flesh for holy days as far afield as London and Paris. By the ninth century they were skirmishing with the Norse in the Bay of Biscay and had begun to copy their adversaries' clinker-built ships, with overlapping planks fastened with iron rivets. The Norse, Europe's consummate long-distance voyagers, used dried cod as hardtack at sea as well as to sustain themselves during the winter months. Long before Eirik the Red sailed to Greenland, the Norse processed large quantities of cod and traded the surplus far and wide. The Lofoten islands in northern Norway were a major source of dried cod in the north as early as the twelfth century. The cold, dry winds and sunny conditions of early spring were ideal for desiccating split fish carcasses.

Atlantic cod are unknown off northern Spain but were common in the northern summer whaling grounds of Norway and the North Sea that became accessible to new generations of Basque fisherfolk once they began building Norse-style boats in the twelfth century. They pursued cod from the same small open dories they used to stalk whales, and applied the same salting methods as well. Like the Norse, they lived off cod hardtack at sea, sailing as far north as Norway, the Hebrides, even Iceland. By the fourteenth century, salted and dried Basque cod, *bacalao* in Spanish, was known throughout Spain and the Mediterranean. The Basques prospered off cod and boatbuilding. Their large, beamy ships with their exceptional hold capacity were in demand throughout Europe.

In the mid-fourteenth century, as ice conditions in the north became more severe and water temperatures fell, the cod stocks off Norway began to falter. Iceland had become increasingly isolated. The great days of Norse voyaging were over, and the islanders, living in a timberless land, showed little inclination to become seamen. They continued to fish for cod from small open boats close inshore—a tradition that would continue until the nineteenth century—while others reaped a rich fish harvest offshore. Year after year, no Norwegian ships arrived, nor vessels from elsewhere, except when a shipload of Scots was wrecked and "none understood their language."[10] Norway's close monopoly over trade with its dependency, maintained for generations, withered in the face of competition from the ever more aggressive Hanseatic League, based on the Baltic. The League was a powerful commercial association of member cities based in Lübeck in Germany, which reached the height of its power in the fourteenth century. The Hansa was a mercantile organization with significant political clout, which levied taxes to suppress piracy and inevitably became involved in the politics of established kingdoms. Its members dominated trade over northern Europe until the fifteenth century, when aggressive modern states provided overwhelming competition. For a time, the League effectively controlled Denmark's monarchy.

Iceland was "the desert in the ocean," increasingly isolated, her population decimated by the Black Death and increasingly severe winters. When Norway and Sweden were united with much more powerful Denmark in 1397, Iceland found itself at the mercy of a more distant, rapacious master who laid even heavier taxes on the island. The angry Icelanders were ready to ignore Norway's monopoly and welcome any foreign ships that arrived at their shores.

For generations, English fishermen and merchants had sought cod in Norwegian waters. The trade prospered despite a requirement that all catches had to be brought into the port of Bergen for taxation before export. The tax was little more than a nuisance until a cabal of Hansa merchants who controlled Bergen effectively closed Norwegian fisheries to foreigners in 1410. The prohibition may have been prompted by falling cod stocks off Norway due to colder water conditions. For English fishing communities, the only chance for good catches now lay in an increasingly stormy North Sea and much further afield in Iceland's cold, remote waters,

where cod were known to abound. English fishing fleets would have to sail far offshore in the depths of winter to bring salt cod to market in time for the autumn sales. The ships of the day were ill equipped for such voyaging.

The prudent medieval mariner avoided going to sea in winter. Thirteenth-century Scandinavians with their open boats stayed ashore from November to March. According to an early English poem, *The Seafarer*, Anglo-Saxons did not venture onto the open ocean until after the first cuckoo of early summer. They were wise, for severe gales are eight times more frequent in these waters during winter than in summer, with rough seas at least every fourth winter day, perhaps even more often during low cycles of the NAO. A higher frequency of gale-force winds and high seas between May and September, after centuries of kinder weather, would have wreaked havoc with fishing fleets and the heavy merchant vessels that plied these waters. Even into the twentieth century, decked, engineless fishing boats stayed in port if the wind blew above 30 knots (about 35 miles per hour). The undecked vessels of earlier times would not have left harbor in a strong breeze of more than 20 to 25 knots.

Even in favorable weather, medieval seafaring under oar and sail required a more intimate knowledge of ocean and weather than is possessed by almost anyone today. Patience and experience compensated for many deficiencies in ship design. Wise seamen, knowing the perils of sudden storms and strong headwinds, might wait at anchor for weeks on end for favorable winds. Even with more efficient rigs and infinitely more seaworthy ships, the rhythms of life under sail endured into this century. During the 1930s, the English yachtsman Maurice Griffiths frequently shared anchorages in eastern England river estuaries with fleets of Thames barges awaiting a northerly wind to head south to London. One memorable September dawn, after a long, stormy night in the sheltered Orwell River, he woke to the sound of clanking windlasses as dozens of waiting barges raised sail to an unexpected northwesterly wind. Within minutes, brown spritsails crowded the river in a long line down to the North Sea. Some of the barges had been in the anchorage for a week, waiting out the strong headwinds.

The Thames barge has a relatively efficient rig, ideal for easy handling in narrow creeks and shallow channels. Medieval cargo ships were not in the same league. They flew square sails before the wind and used oars to go to windward. Heavy cogs and *hulcs* carried bulk cargoes between Hanseatic ports in the Baltic and linked British ports to the Continent. Solidly built to carry heavy loads, mostly in shallow waters, they labored when faced with gale-force winds and high Atlantic swells. The clinker-built Norse *knarrs* and long ships were more seaworthy but were not intended for winter voyaging or fishing. The stormier seas of the thirteenth and fourteenth centuries, and the need to range far offshore each winter in search of cod, demanded more seaworthy craft.

As so often happens, new economic realities brought striking innovations in ship design. Herring abounded in the southern North Sea, but the fishermen could only stay at sea a short time until the Dutch invented the *buss*, a much larger ship that combined fishing with the gutting and salting of the catch on board. These remarkable vessels transformed the herring fishery into big business. By the mid-sixteenth century, as many as four hundred *busses* operated out of Dutch ports, each carrying from eighteen to thirty men who remained at sea for between five and eight weeks at a time.[11] Strict regulations controlled the quality of the product, with the ships often traveling in convoy to minimize the risk of piracy. For centuries, English merchants and fisherfolk had used open boats and larger decked vessels built in the Norse fashion—light and buoyant, but not designed to handle the large ocean swells and fierce winds of winter. These boats were built shell first, then strengthened with frames. Most of their strength, as a result, lay in their outer skin. Some enterprising boatbuilders eyed ships built by the Dutch and the Basques, who had adopted the practice of erecting the skeleton of a boat's hull before planking it. These ships proved much stronger, more durable, and easier to maintain. The new methods led to the English "dogger," an oceangoing vessel with two or three masts and high pointed bows that enabled it to breast steep head seas. A low stern made a good platform for fishing with lines and nets.[12]

The dogger was originally a small boat used on the Dogger Bank in the southern North Sea and for cod fishing. The rig had a square sail on the main mast set well forward and a three-cornered lateen-style sail on the after spar, enabling it to sail closer to the wind, an important consideration when sailing to and from Iceland in prevailing southwesterly

winds. For the first time, fishermen had access to vessels that were strong enough and seaworthy enough to sail almost anywhere. Simply constructed and easily repaired in the remotest convenient bay, the dogger expanded the cod fishery far beyond the narrow confines of the North Sea. Casualty rates at sea were enormous, but in an era of brief life expectancy and brutal conditions on the farm, people accepted the risk without question. So many doggers and other fishing craft vanished at sea that boatbuilders prospered at home, especially along the northern Spanish coast, where entire Basque villages did nothing but build replacement fishing boats.

The English were quick to make use of their doggers. In 1412, just a year after they were excluded from Bergen, "fishermen out from England" appeared off southern Iceland in defiance of Norwegian and Hansa monopolies. "Thirty or more" fishing boats arrived in 1413 and exchanged merchandise for cattle. The sailors endured hard conditions. In 1419, a gale on Maundy Thursday wrecked twenty-five English fishing boats. "All the men were lost, but the goods and splinters of the ships were cast up everywhere."[13] Before long, the English were so well established in the Icelandic cod trade that Bergen's restrictions were relaxed out of necessity.

The English dogger fleets were so efficient that Iceland's leaders soon complained to their Danish masters that the foreigners were decimating the fish population. Denmark protested in turn to English King Henry V, who promptly prohibited the voyages by proclamation in every port, despite protests from the House of Commons that "as is well known" the cod had forsaken their former haunts off Norway. Neither English fisherfolk nor Icelanders living close to the fishing grounds took any notice of the prohibition, for the trade was extremely lucrative to both sides. One dogger could carry ten men with the summer's provisions and salt for the catch and return with about 30 tons of fish. The fleet left England in February or March and with favorable winds and a bit of luck would reach Iceland in about a week. If they were unlucky, winter gales would swamp several of their boats and wash many crewmen overboard. Once off Iceland, the doggers fished some distance from

shore all summer, with only occasional passages home to unload their catch and reprovision. They were fearless seamen, who suffered incredible hardships from ice-cold spray and cutting winds, with almost no protection whatsoever. Imagine lying to a March gale far from land in the open Atlantic, no means of keeping warm for fear of fire, drifting at the mercy of huge waves, pumping constantly to keep afloat, in near-zero temperatures, in soaking clothes. The fishermen routinely endured conditions that are unimaginable today. But the Lenten market had to be satisfied.

The fish themselves were sold in October and November for the following Lent. If stored carefully between layers of straw, the dried fillets would keep for up to two years. Quite simply, Icelandic cod was money. Its value endured far longer than the gold of the Indies.

For decades, English fishermen were unchallenged by competitors. But inevitably, the ubiquitous Hanse began arriving on the fishing grounds in the 1430s, even transporting cod direct to London. Fighting broke out, cargoes were plundered, diplomatic notes exchanged. Icelandic waters were too crowded and cod stocks were becoming depleted, partly because of occasional severe cycles of colder sea temperatures. The more enterprising Basque and English skippers sought new fishing grounds farther out in the Atlantic.

Cod abounded on the continental shelves off Europe, Iceland, and North America. Norse exploration north and west in warmer times had coincided with the range of the vast cod schools. As pack ice increased and water temperatures fell off Greenland, the schools shifted southward and westward away from Iceland, where stocks seem to have been erratic, although the fluctuations are poorly documented. With inexorable skill, fifteenth- and sixteenth-century skippers followed the cod far over the western horizon.

Fisherfolk are reticent people who know that their living depends on carefully guarded knowledge, passed from one generation to the next and never committed to paper or shared with officials. The Basque were already formidable coastal voyagers, unafraid of passages of 2,000 kilometers or more across the Bay of Biscay to the North Sea and beyond. They

pursued whales into subarctic waters and followed them west to Green-land along ancient sailing routes. They visited the Norse Eastern Settle-ment as early as 1450, where their artifacts have been found, then proba-bly dropped southward along the Labrador coast not soon afterward. There they found not only whales but cod in abundance. Inevitably, ru-mors of new fishing grounds and mysterious lands far to the west spread from taverns and fishing villages to merchants' ears.

Bristol, on southwestern England's Severn River, had by 1300 become a major trading port. Its well-protected harbor occupied a strategic loca-tion midway between the cod of Iceland and the vineyards of southwest-ern France and Spain. Bristol prospered off this trade until 1475, when the Hanseatic League abruptly cut off the city's merchants from buying Icelandic cod. By this time the worthy burghers of Bristol were well aware of Basque fishermen's activities in the Atlantic Ocean. They had also heard persistent rumors of lands far over the western horizon, among them a place called Hy-Brazil. In 1480, a wealthy customs official, Thomas Croft, and a merchant named John Jay sent a ship in search of Hy-Brazil as a potential base for cod fishing. The following year, Jay dis-patched a further two ships, the *Trinity* and the *George*. History does not record whether they ever landed anywhere, but the ships returned with so much cod that the city told the Hanseatic League it was not interested in negotiations to reopen the Icelandic fishery.

Croft and Jay kept quiet as to where the cod came from, but inevitably the word got out. In 1497, five years after Christopher Columbus landed in the Bahamas, the Genovese merchant Giovanni Caboto (John Cabot) sailed westward from Bristol searching not for cod but for a northern route to the spice fields of Asia. Thirty-five days later, he sighted a long, rocky coastline washed by a sea teeming with cod, where Basque fishing vessels abounded. A letter written by an Italian visiting London, who heard tales of Cabot's voyage, recounts how "the sea is covered with fishes, which are caught not only with the net but with baskets, a stone being tied to them in order that the baskets may sink in the water." For their part, the Bristol men aboard the *Mathew* returned in great satisfaction for their ships "will bring so many fishes that this kingdom will no longer have further need of Iceland."[14]

◁ | By 1500, huge fishing and whaling fleets sailed every year for the Grand Banks. Half a century later, more than 2,000 Basques visited Labrador

each summer, where they processed their catches before sailing home on the fall westerlies. Bristol fleets sailed first to Portugal for salt, braving the stormy Bay of Biscay in winter, then crossed to Newfoundland for cod. They returned to Portugal with their catch, then filled their holds with wine, olive oil, and more salt for Bristol. English vessels beat southward along the rugged Nova Scotia and Maine coasts following a bonanza of cod. On May 15, 1602, the ship *Concord* rounded a "mighty headland," Cape Cod, and "anchored in 15 fathoms, where we took great store of codfish." The *Concord's* skipper, Bartholomew Gosnold, noted that in spring "there is upon this coast, better fishing, and in as great plentie, as in Newfoundland . . . and, besides, the places . . . were but in seven faddome water and within less than a league of the shore; where in new-found-land they fish in fortie or fiftie faddome water and farre off."[15] He had left on his voyage just after his wife Martha had given birth and named a tree-covered island after her: "Martha's Vineyard." For two decades, fishermen were content to catch and dry their cod close offshore during the favorable months, but no one stayed through the stormy and harsh winters in a time of increasing severe cold. Then, in 1620, the *Mayflower* brought the Pilgrims to settle New England, to "serve their God and to Fish."[16] Thus it was that cooler conditions in the Arctic after the eleventh century, stormier, more unpredictable weather at sea, and the search for better fishing grounds helped Europeans settle in North America.)

5

A VAST PEASANTRY

The world between the fifteenth and eighteenth centuries con-
sisted of one vast peasantry, where between 80% and 90% of
people lived from the land and from nothing else. The
rhythm, quality and deficiency of harvests ordered all material
life.

—*Fernand Braudel,* The Structures of Everyday Life

Semur-en-Auxois is an ancient mining community near Dijon, in
France's Côte-d'Or. A stained glass window in the sixteenth-century
church depicts Saint Médard, who always interceded for rain, and Saint
Barbara, patroness of miners and protector against thunder and light-
ning. Saint Barbara appears as a martyr with bare breasts, her body lashed
with stripes, her flesh torn by red-hot pincers and spitted on hooks. She is
finally burnt at the stake. Her martyrdom immunizes humanity against
the vagaries of weather and guides miners' picks safely into the bosom of
the earth.[1]

The image of saint as protector and martyr appeared in stained glass,
in wood, and on canvas. Dozens of saints' days commemorated the spiri-
tual benefactors who protected farmers and townspeople against drought
or rain. In 1350, when Europe was at the mercy of increasingly unpre-
dictable weather, forecasting was confined to what one could see from
atop a hill or church tower, to immediate spikes of cold, extreme heat, or
torrential downpours that at best could be foretold a day ahead in the
coming. Even those cultivating the most fertile soils kept a constant eye
on the skies, on telltale signs of the passing seasons, on early flowerings of

apple trees, vivid sunsets that portended heavy rain, unseasonable frosts that killed ripening grapes. No rural community ever kept systematic records of the weather that brought prosperity one year and desperate hunger the next. Human memory, cumulative experience and folklore, and a belief in the power of saints were their only protection. Vulnerability was a reality of daily life: however adaptable farmers were, Europe still lacked an effective infrastructure for moving large quantities of grain and other commodities at short notice.

Tree rings and ice cores chronicle the ever changing climate after 1320—through the terrible years of the Black Death, through the Hundred Years War, fought mainly on French soil, the reign of Elizabeth I of England, and the ascendancy and defeat of the Spanish Armada. The rings and cores record irregular cycles of warmer and colder summers, of wet springs and extreme heat waves, seemingly with no long-term pattern until the late sixteenth century, when cooler conditions became more prevalent. Those who suffered through good and poor years left few records behind them, except for occasional references to exceptionally good or poor harvests, or unusually wet or dry weather. They accepted unpredictable cycles of good or bad years as happenstance, or the result of Divine Will, but, in fact, they were living in a climatically somewhat different world.

The Medieval Warm Period had seen few of the pronounced extremes that marked the fourteenth to sixteenth centuries. The years of the Great Famine, 1315 to 1319, were the wettest between 1298 and 1353. According to the Bishop of Winchester's archives, 1321 to 1336 were dry or unusually dry. Decades of unexceptional weather then followed. The next wet years of significance came between 1399 and 1403, but they never approached the extremes of the famine rains. With no food shortages to contend with on more than a local level, Europe quickly recovered from the great hunger.

After the famine, the quality of nutrition in town and village seems to have improved somewhat or at least held steady. Populations declined in some districts, making farming land more plentiful. Slightly more efficient agriculture came from a slow trend toward larger farms, a precursor of the large scale enclosures of common land in later centuries.

Northern Europe never again endured a hunger as catastrophic as that of 1315. Later famines, however local, served as reminders of the great fragility of society. Not until the late seventeenth century in England, and more than a century later in France, did new agricultural methods and crops, much improved commercial infrastructures, and large-scale food imports significantly reduce the threat of famine.

Village life in France was typical of that over much of Europe. In 1328, agents of the King of France counted households and parishes across the land and found between 15 and 18 million people living within the geographical extent of what was, three centuries later, the sovereign nation known as France.[2] Ninety percent of Frenchmen were peasants, an enormous number relative to the available food supply. Despite areas of high agricultural productivity, like the great estates around Paris and the wine-growing region near Bordeaux, nine-tenths of the nation's labor was dedicated simply to feeding itself. As the population quickly recovered after the 1315–22 famine at a time of relatively low crop yields and finite cultivable land, grain production reached an inevitable ceiling, making the rural population all the more vulnerable to poor harvests. At the same time, the peasants suffered under high rents, low wages, and excessive subdivision of the land, most of which belonged to the nobility. Nevertheless, the early fourteenth century was relatively prosperous. Some French historians refer to this period as the *monde plein*, "the full world."

The "full world" did not last long. By the thirteenth century, the Mongol empire extended from the Yunan region of southern China across Eurasia to the Black Sea. Mongol networks of highly mobile horsemen linked Asia to Europe and India to Manchuria. During the fourteenth century, Mongol supply trains picked up rats carrying fleas infected with a complex series of bacterial strains known as *Yersinia pestis*, which cause bubonic (glandular) plague.[3] Where they did so is a matter of debate, but it was probably in the Gobi Desert. Bubonic plague broke out in Central Asia in 1338/39 and reached China and In-

dia in 1346. Harsh climatic change may have hastened the spread of the disease. As Europe went through a wetter cycle, hotter, drier conditions affected Central Asia, triggering constant movements of Mongol populations searching for fresh grazing grass. Plague fleas and their hosts accompanied them. The epidemic reached the Black Sea port of Caffa by 1347 when besieging Mongols are said, implausibly, to have hurled plague-infested corpses over the walls with catapults. It is more likely that the disease entered the town on the back of infiltrating rodents. Fleeing Genoese ships then carried the fleas and their hosts to Constantinople, Italy, and Marseilles. At least 35 percent of Genoa's population perished in the first onslaught.

From the prosperous Italian cities, the Black Death spread in waves over western Europe. In the Paris region, the population fell by at least two-thirds between 1328 and 1470. The district of Caux in Normandy lost at least two-thirds of its villagers. One estimate places the population loss for France as a whole at no less than 42 percent, much of the mortality among people who had suffered from malnutrition during the great famine a generation earlier. The plague entered Britain through several ports, among them Bristol, where the plague swept ashore in August 1348, "where almost the whole strength of the town perished, as it was surprised by sudden death; for few kept their beds more than two or three days, or even half a day."[4] By July 1349, the Black Death had reached Scotland, where "nearly a third of mankind were thereby made to pay the debt of nature. . . . The flesh of the sick was sometimes puffed out and swollen and they dragged out their earthly life for barely two days."[5] This first onslaught did not run its course until 1351.

The Black Death left a legacy of irregular epidemics, which descended about every decade, sometimes more frequently, especially in crowded towns. People were powerless to combat the epidemics, their only perceived recourse the centuries-old panacea of religious processions and prayer. In Germany, penitents stripped to the waist and beat their backs with weighted scourges, singing hymns in loud voices. "They sang very mournful songs about nativity and the passion of Our Lord. The object of this penance was to put a stop to the mortality, for in that time . . . at least a third of all the people died."[6] Not until the seventeenth and eighteenth centuries did rational quarantine methods such as disinfection

and isolation come into widespread use by armies, hospitals, and civil authorities.

By the beginning of the fifteenth century, the depopulation of the countryside by famine, plague, and war had led to the abandonment of as many as 3,000 villages across France alone. Thousands of hectares of arable land lay vacant and did not come back into cultivation until the end of the century or even later. Again, war was a villain. Frightened peasants fled behind city walls and dared not venture out to cultivate fallow land nearby, thereby compounding food shortages caused by poor harvests and wet weather. In Scandinavia, sodden fields prevented farmers from planting. English visitors to a Danish royal wedding in 1406 remarked that they passed many fields, but saw no growing wheat. Farmhouses were abandoned by the score, as families now shared the same buildings.

The recurrent plagues and regular famines kept population in check for generations. There were well-documented food crises around Paris and Rouen in 1421, 1432, 1433, and especially from 1437 to 1439, probably years when a high NAO index brought unusually heavy rainfall ashore in western Europe. The famines resulted in large part from poor harvests, mostly caused by excessively wet winters, springs, and summers, when waterlogged and flattened cereal crops spoiled in the fields. Bad harvests came about every ten years, at a time when food shortages were aggravated by constant war and brigandage. With the population much reduced, there should have been fewer food shortages, but famine scourged the land with distressing regularity, in large part because of the constant fighting associated with the Hundred Years War.

The 1430s brought a run of exceptionally harsh winters, with at least seven years of prolonged frost and severe storms. French vineyards suffered much frost damage in 1431/32, when a persistent high pressure center over Scandinavia brought intense cold to Britain and much of western Europe. Dozens of ships were wrecked in Bay of Biscay storms with the loss of hundreds of lives. Far out in the Atlantic, a Venetian ship bound for the port of Bruges was blown far off course by a fierce, ten-day northeasterly

gale. The crew abandoned the vessel far out in the Atlantic the day after Christmas 1431 and, in a remarkable feat of seamanship, reached the Norwegian coast safely in a small open boat on January 14.[7] Tree rings from southern English oaks confirm a series of stressful years with many cold winters and springs, also some warm summers, between 1419 and 1459. A Europe-wide famine in 1433–38 almost rivaled the great hunger in its intensity. By 1440, wine growing had virtually disappeared in Britain. Only the vineyards at Ely in eastern England persisted until 1469, before they, too, ceased operation after years of producing sour, unripe juice.

The first signs of recovery in France came with the end of the Hundred Years War in 1453, during a time of milder oceanic conditions. The next half-century saw spectacular gains in grain production as land that had been abandoned after the Black Death was again cultivated. Food shortages were unknown in many areas until at least 1504. Grain became so cheap that many producers turned to livestock and other more profitable foods. Cattle and sheep were excellent investments and good insurance for landowners against poor harvests, even if their tenant farmers and the poor went hungry in bad years. So were fish. Between 1460 and 1465, a chancellor of France built a large pond with a forty-meter dam near Lassay. The elaborate barrier had three outlets and formed a fifty-four-hectare, reed-lined lake with a depth of six meters, where thousands of fish flourished. Every three or four years, the outlets were opened, the water drained and thousands of fish gathered, to the delectation of local fish merchants. While the landowner counted his profits, his peasants plowed the wet land beneath the dam and planted oats or grazed cattle.[8]

These benign conditions persisted into the early sixteenth century. The dates of the wine harvest hint at a long period of warm springs and summers between 1520 and 1560, surrounding three cold years with late harvests in 1527–29.[9] The 1520s produced five exceptional English harvests in a row, when people adapted readily to greater plenty. A spike of sudden cold weather in 1527 brought immediate threats of social unrest. In that year, the mayor's register at Norwich in eastern England noted "there was so great scarceness of corne that aboute Christmas the comons of the cyttye were ready to rise upon the ryche men."[10] Still, life in the countryside went on much as before. Crop diversification, self-sufficiency, and the realities of hunger and death changed little in rural England and France from year to

year. Nor did the simple farming technology of the day make adapting to cycles of warm or cold an easy matter.

Even relatively privileged landowners lived close to the edge, at risk from rain and drought, but like the peasants they have left few records of their prosaic lives. In the mid-1500s, a century after the end of the Hundred Years War, Gilles de Gouberville was a "quasi-peasant, lord of a small manor at Le Mesnil-en-Val, an hour's walk inland from Cherbourg in Normandy."[11] He was typical of his time except that for more than two decades he kept a journal, which offers a fascinating portrait of life on a large estate at near-subsistence level. He and his "farm-boys" relied on the simplest of technologies—and ran up constant blacksmith's bills because their light plow shares kept breaking in the rocky soil. Gouberville was a fairly efficient farmer with a strong practical streak, who placed little reliance on the superstitions of the time. He did not, for example, sow his crops at full moon, as many farmers did. The teachings of the seer Nostradamus about timing his planting briefly captivated him in 1557, but gave him only average results in 1558. Nostradamus's book stayed on the shelf after that. Instead, Gouberville diversified away from cereals.

Like everyone else, Gouberville rotated cereals, mixed fodder, and fallow in his fields, growing peas to regenerate his soil and produce more food. He tried all manner of fertilizers on his cultivated lands, but they failed to increase his crops, grown by the near-free labor of his villagers and mostly consumed by his family and his laborers—or by the rodents in his barns. Gouberville's profit came from livestock, especially cattle, horses, and pigs. His cattle roamed free in the nearby forests, the pigs fed on acorns from the forest. He also sold grazing rights in the forest to his villagers for large sums. Gouberville was no innovator, but he knew the wisdom of diversification and of drinking cider. "Cider restores the roots of humour and humidity," wrote a seventeenth-century academic, who praised its ability to keep the belly "soft and relaxed, by the benignity of its vapors."[12] Apart from these medical powers, cider kept people in "modesty" and "moderation." Gouberville tended the fourteen apple varieties in his orchards with sedulous care, for cider, a relatively sterile liquid, was far less dangerous than the polluted water supplies of the countryside. Cider was an insurance against illness and death. As Gouberville well knew, when local cider became too expensive, the peasants turned to water and the death rate promptly rose.

Gilles de Gouberville's archaic world was largely self-sufficient, his identity closely tied not to his noble ancestors but to the land he and his villagers inhabited. He cherished his ancestors for one reason alone: they bequeathed the privilege of tax exemption. Given the constant threat of sickness, hunger, and death, it is hardly surprising much of life revolved around strong food and drink. Round bellied, with a brick-red, coarse complexion, Gouberville and his gentleman contemporaries consumed enormous meals. His journal records a supper for three on September 18, 1544, which comprised two "larded" chickens, two partridges, a hare, and a venison pie. But most of his day-laborers and plowmen were thrown into destitution and near-starvation when the harvest failed, for cereals were the basic sustenance of all de Gouberville's people. (There was only one disastrous harvest during the twenty years covered by his journal.)

Gilles de Gouberville and his kind protected themselves and their people by diversifying their farming. Many European communities of the day, especially those cultivating marginal lands in places like the foothills of the Alps and Pyrenees, did not have that option. Like Icelandic and Norwegian glaciers, the European Alps are a barometer of constantly shifting climatic conditions. Their glaciers have always been on the move, waltzing in intricate patterns of advance and retreat decade to decade that defy the best efforts of glaciologists and historians to decipher. But we do know that the mountain ice sheets advanced far beyond their modern limits as significantly cooler temperatures and wetter summers descended on Europe after 1560.[13] After the 1560s, more frequent low NAOs brought persistent anticyclones over the North Sea and Scandinavia.

Life in the Alps was always harsh: there were a "lot of poor people, all rustic and ignorant." Strangers avoided a place where "ice and frost are common since the creation of the world." The occasional traveler who ventured to the mountains remarked on the poverty and suffering of those who lived on the marginal lands in the glaciers' shadow.

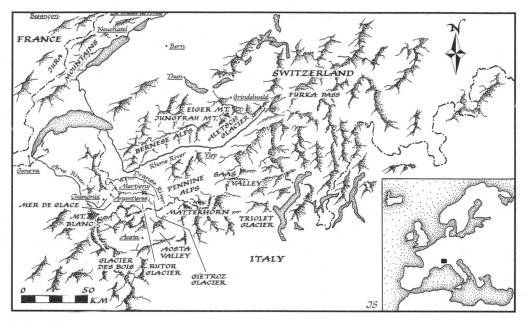

Alpine glacier region

On August 4, 1546, astronomer Sebastian Münster rode along the right bank of the Rhône River on his way to the Furka Pass in the Alps, where he wanted to explore the mountain crossing. All at once Münster found himself confronted by "an immense mass of ice. As far as I could judge it was about two or three pike lengths thick, and as wide as the range of a strong bow. Its length stretched indefinitely upwards, so that you would not see its end. To anyone looking it was a terrifying spectacle, its horror enhanced by one or two blocks the size of a house which had detached themselves from the main mass." The water flowing from the glacier was a frothy white, so filled with ice fragments that a horse could not ford the stream. Münster added: "This watercourse marks the beginning of the river Rhône." He crossed by a bridge that spanned the torrent just below the source.

The Rhonegletscher (Rhone glacier) was a formidable mass of ice in 1546, with a front between ten and fifteen meters high and at least two hundred meters wide. Today, the tongue of the glacier is very thin, with a height and width far smaller than in Münster's day. The ice sheet is high up the mountain, the stream that becomes the Rhône now flowing through a

narrow gorge and over several waterfalls. Münster rode up to the glacier front. Today, the ice is accessible only by foot and that after an arduous climb, and the landscape is entirely different from that of the sixteenth century. Yet, photographs from only a century ago reveal a glacier much larger than it is today, this despite a slow and constant retreat from earlier times. Between 1590 and 1850, during the height of the Little Ice Age, the Rhône glacier was an even more impressive mass, readily accessible on horseback, with a huge terminal tongue spread out over the plain.

In the sixteenth century, Chamonix, now a fashionable resort in the Arve River valley in sight of Mount Blanc, was an obscure, poverty-stricken parish in "a poor country of barren mountains never free of glaciers and frosts . . . half the year there is no sun . . . the corn is gathered in the snow . . . and is so moldy it has to be heated in the oven." Even animals were said to refuse bread made from Chamonix wheat. The community was so poor that "no attorneys or lawyers [were] to be had." Avalanches, caused by low temperatures and deep snowfall, were a constant hazard. In 1575/76 conditions were so bad that a visiting farm laborer described the village as "a place covered with glaciers . . . often the fields are entirely swept away and the wheat blown into the woods and on to the glaciers." The ice flow was so close to the fields that it threatened crops and caused occasional floods. Today a barrier of rocks separates the same farmland from a much shrunken glacier. The high peaks and ice sheets were a magnificent sight. Traveler Barnard Combet, passing through Chamonix in 1580, wrote that the mountains "are white with lofty glaciers, which even spread almost to the . . . plain in at least three places."

On June 24, 1584, another traveler, Bénigne Poissonet, was drinking wine chilled with ice in Besançon in the Jura. He was told that the ice came from a natural refrigerator nearby, a cave called the Froidière de Chaux. "Burning with desire to see this place filled with ice in the height of the summer," Poissonet was led through the forest along a narrow path to a huge, dark cave opening. He drew his sword and advanced into its depths, "as long and wide as a big room, all paved with ice, and with crystal-clear water . . . running in a number of small streams, and forming small clear fountains in which I washed and drank greedily." When he looked upward, he saw great ice stalactites hanging from the roof threatening to crush him at any moment. The cave was a busy place. Every night peasants arrived with carts to load with blocks of ice for Besançon's

wine cellars. Another summer visitor, a century later, reported a row of mule carts waiting to take ice to neighboring towns. As late as the nineteenth century, Froidière de Chaux was still being exploited industrially. As many as 192 tons of ice are said to have been removed from it in 1901. But after an extensive flood in 1910, the ice never reformed, as warmer conditions caused the glacier to retreat. No ice stalactites hang from the roof of the cavern today.

The glacial advance continued. In 1589 the Allalin glacier near Visp to the east descended so low that it blocked the Saas valley, forming a lake. The moraine broke a few months later, sending water cascading down the stream bed below the glacier, which had to be restored at great expense. Seven years later, in June 1595, the Giétroz glacier in the Pennine Alps pressed inexorably into the bed of the Dranse River. Seventy people died when floods submerged the town of Martigny. As recently as 1926, a bcam in a house in nearby Bagnes bore an inscription: "Maurice Olliet had this house built in 1595, the year Bagnes was flooded by the Giétroz glacier."

By 1594 to 1598, the Ruitor glacier on the Italian side of the Alps had advanced more than a kilometer beyond its late twentieth-century front. The glacier blocked the lake at its foot. In summer, a channel under the ice would release catastrophic floods over the valleys downstream. After four summer floods, the local people called in expert water engineers, who proposed risky strategies: either diverting the lake overflow away through a rock-cut tunnel or blocking the channel under the ice with wood and stone for a vast sum. Tenders were invited, but, hardly surprisingly, there were no takers.

In 1599/1600, the Alpine glaciers pushed downslope more than ever before or since. In Chamonix alone, "the glaciers of the Arve and other rivers ruined and spoiled one hundred and ninety-five journaux of land in divers parts."[14] Houses were destroyed by advancing ice in neighboring communities: "The village of Le Bois was left uninhabited because of the glaciers." If contemporary accounts are to be relied upon, the ice advanced daily.

Near Le Bois, the Mer de Glace glacier swept over small hills that protected nearby villages and hung over nearby slopes. The villages of Les Tines and Le Châtelard were under constant threat from glacial seracs (ice pinnacles) and were inundated with glacial meltwater summer after summer. Ten or fifteen years later, the government official Nicolas de

Crans visited the village, "where there are still about six houses, all uninhabited save two, in which live some wretched women and children. . . . Above and adjoining the village, there is a great and horrible glacier of great and incalculable volume which can promise nothing but the destruction of the houses and lands which still remain." Eventually, the village was abandoned.

The advances continued. In 1616, de Crans inspected the hamlet of La Rosière, threatened by a "great and grim glacier," which hurled huge boulders onto the fields below. "The great glacier of La Rosière every now and then goes bounding and thrashing or descending. . . . There have been destroyed forty-three journaux [of land] with nothing but stones and little woods of small value, and eight houses, seven barns, and five little granges have been entirely ruined and destroyed." The Mer de Glace and Argentière glaciers, the latter adjacent to La Rosière, were at least a kilometer longer in 1600 than they are today.

Throughout Europe, the years from 1560 to 1600 were cooler and stormier, with late wine harvests and considerably stronger winds than those of the twentieth century. Climate change became a highly significant factor in fluctuating food prices. Wine production slumped in Switzerland, lower Hungary, and parts of Austria between 1580 and 1600. Austria's wines had such a low sugar content from the cold conditions and were so expensive that much of the population switched to beer drinking. The revenues of the Hapsburg economy suffered greatly as a result. Deliveries of mice and moles killed for money dropped sharply after 1560, not to rise again until the seventeenth century. The Reverend Daniel Schaller, pastor of Stendal in the Prussian Alps, wrote: "There is no real constant sunshine, neither a steady winter nor summer; the earth's crops and produce do not ripen, are no longer as healthy as they were in bygone years. The fruitfulness of all creatures and of the world as a whole is receding; fields and grounds have tired from bearing fruits and even become impoverished, thereby giving rise to the increase of prices and famine, as is heard in towns and villages from the whining and lamenting among the farmers."[15]

As climatic conditions deteriorated, a lethal mix of misfortunes descended on a growing European population. Crops failed and cattle perished by diseases caused by abnormal weather. Famine followed famine bringing epidemics in their train, bread riots and general disorder brought fear and distrust. Witchcraft accusations soared, as people accused their neighbors of fabricating bad weather. Lutheran orthodoxy called the cold and deep snowfall on Leipzig in 1562 a sign of God's wrath at human sin, but the church's bulwark against accusations of witchcraft began to crumble when climatic shifts caused poor harvests, food dearths, and cattle diseases. Sixty-three women were burned to death as witches in the small town of Wisensteig in Germany in 1563 at a time of intense debate over the authority of God over the weather. Witch panics erupted periodically after the 1560s. Between 1580 and 1620, more than 1,000 people were burned to death for witchcraft in the Bern region alone. Witchcraft accusations reached a height in England and France in the severe weather years of 1587 and 1588. Almost invariably, a frenzy of prosecutions coincided with the coldest and most difficult years of the Little Ice Age, when people demanded the eradication of the witches they held responsible for their misfortunes. As scientists began to seek natural explanations for climatic phenomena, witchcraft receded slowly into the background. Only God or nature were responsible for the climate, and the former could be aroused to great wrath at human sins. Today, our ecological sins seem to have overtaken our spiritual transgressions as the cause of climatic change.[16]

Storm activity increased by 85 percent in the second half of the sixteenth century, mostly during cooler winters. The incidence of severe storms rose by 400 percent. From November 11 to 22, 1570, a tremendous gale moved slowly across the North Sea from southwest to northeast at about 5 knots. The storm, remembered for generations as the All Saints Flood, coincided with the unusually high tides of the full moon. As the tempest progressed northeastward, heavy rains deluged the low-lying coast. Frontal passage caused the wind to shift to the northwest. Enormous sea surges cascaded ashore, breaching dikes and flattening coastal defenses. At Walcheren Island in the Low Countries (now in the southern Netherlands), the dikes gave way between 4 and 5 o'clock on November 21, just as dark was gathering. By late evening, much of Rotterdam was under water. Salt water surged into Amsterdam, Dordrecht, and other

The depressions that affected the Spanish Armada.

Data compiled from Hubert Lamb and Knud Frydendahl, *Historic Storms of the North Sea, British Isles and Northwestern Europe* (Cambridge: Cambridge University Press, 1991).

cities, drowning at least 100,000 people. In the River Ems, sea levels rose four and a half meters above normal.

The storminess continued through the 1580s, to the discomfort of the Spanish Armada, which endured a "very great gale at SW" off Scotland's east coast in August 1588: "we experienced squalls, rain and fogs with heavy sea and it was impossible to distinguish one ship from another." Sir Francis Drake reported a "very great storm considering the time of year" in the southern North Sea on the same day. A month later, a strong cyclonic depression advanced northeast from the region of the Azores, perhaps the descendant of a tropical hurricane on the other side of the Atlantic. The leading ships of the retreating Armada encountered the storm in the Bay of Biscay on September 18. Three days later, the same westerly gale blew with great fury off western Ireland, where the stragglers of the great fleet found themselves on a hostile lee shore. "There sprang up so great a storm on our beam with a sea up to the heavens so that the cables could not hold, nor the sails serve us and we were driven ashore with all three ships upon a beach covered with fine sand, shut in one side and the other by great rocks." The Armada lost more ships to this episode of bad weather than in any conflict with the English.[17]

The weather records in the logs of Armada captains have been subjected to rigorous meteorological analysis. Modern estimates place the maximum wind squalls as high as 40 to 60 knots, approaching hurricane strength.

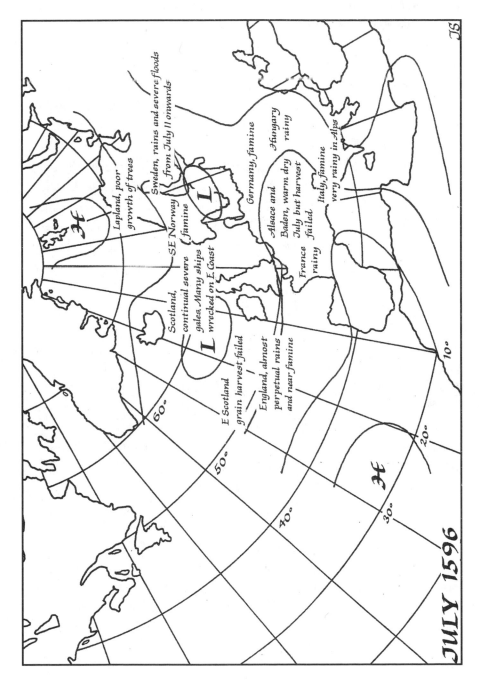

JULY 1596

Lapland, poor growth of trees

Sweden, rains and severe floods from July 11 onwards

SE Norway famine

Scotland, continual severe gales. Many ships wrecked on E. Coast

E Scotland grain harvest failed

England, almost perpetual rains and near famine

Germany, famine

Alsace and Baden, warm dry July but harvest failed

Hungary rainy

France rainy

Italy, famine very rainy in Alps

General characteristics of the weather in July 1596

On several occasions, the jet stream upper wind strengths between July and September 1588 exceeded the maxima recorded during the equivalent months between 1961 and 1970 and, probably, over a much longer period of the twentieth century. The unusually windy and stormy weather coincided with a strong thermal gradient caused by a vigorous southward extension of polar ice off East Greenland and Iceland and south of Cape Farewell. Elizabethan explorer John Davis, searching for the elusive Northwest Passage, found the seas between Iceland and Greenland blocked by ice in 1586 and 1587. Similar conditions probably continued into 1588.

The 1590s were the coldest decade of the sixteenth century. The poor harvests of 1591 to 1597 hit England hard three years after the triumphant defeat of the Spanish Armada. An observer wrote: "Every man complains against the dearth of this time." Food riots erupted in many counties, as the poor vented their anger over the enclosing of common lands to create larger, more productive farms. The towns suffered worst. In Barnstaple, Devon, one Philip Wyot wrote in 1596: "All this May has not been a dry day and night. . . . Small quantity of corn is brought to market [so] townsmen cannot have money for corn. There is but little comes to market and such snatching and catching for that little and such a cry that the like was never heard."[18] In towns like Penrith in the northeast, famine mortality rose to as much as four times normal.

England's Tudor monarchs presided over 3 million subjects and were constantly fretting about the possibility of grain shortages and famine. England was a country of subsistence farmers, whose methods and implements of tillage had little changed from medieval times. The government had ample cause for concern, for crop yields were low. On prime land, two bushels of wheat were reasonably expected to yield between eight and ten at harvest time, which left precious little margin for crop failure. The farmers gathered "good" harvests about 40 percent of the time, with sequences of three or four good years, then a cycle of as many as four poor harvests before a change in the weather pattern brought improved yields.[19] Grain prices fluctuated accordingly. The price changes hit the poor hardest of all and engendered a deep distrust of farmers among the growing urban population. At times of crop failure and grain shortages, suspicions of hoarding were rife. Preachers denounced hoarders from their pulpits with a text from Proverbs: "He that witholdeth corn, the people shall curse him," but with little effect.[20] England, like the rest of

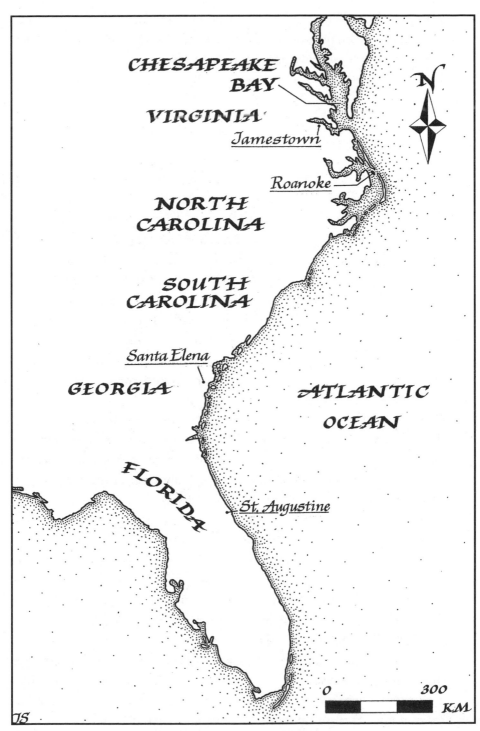

Locations of the first European colonies in North America

Europe, still lacked a large-scale infrastructure for moving grain from cousntry to town, or from one region to another, to relieve local famines. Even after the last widespread famine in southern England in 1623, hunger was never far from the door.

Farming was just as difficult in the fledgling European colonies in North America. Bald cypress tree rings along the Blackwater and Nottoway rivers in southeastern Virginia may help explain why most people in the southeastern United States speak English rather than Spanish.[21] The cypresses document several severe drought cycles between 1560 and 1612, just as Europeans were settling along the Carolina and Virginia coasts.

In 1565, Spanish colonists settled at Santa Elena on the South Carolina coast during an exceptionally dry decade. The settlement struggled from the beginning, then succumbed to a second, even more severe drought in 1587–9. The capital of Spanish Florida was moved to Saint Augustine. The evacuation came as British colonists were trying to establish a settlement at Roanoke Island, North Carolina, to the north. The Roanoke colonists were last seen by their British compatriots on August 22, 1587, at the height of the driest growing season in eight hundred years. Even as their compatriots departed, the colony's native American neighbors were concerned about the poor condition of their crops. The drought persisted for two more years and created a serious food crisis both for the local Croatan people and the colonists. Since the latter were heavily dependent on the Croatan, this very dependence must have aggravated already serious food shortages. Many historians have criticized the Roanoke colony for poor planning and for a seeming indifference to how they were going to feed themselves in the face of apparent disinterest from England. But even the best planned colony would have been challenged by the 1587–89 drought.

Further north, at Jamestown, the colonists had the bad luck to arrive at the height of the driest seven-year period in 770 years. Of the original 104 colonists who came in 1607, only 38 were still alive a year later. No fewer than 4,800 of the 6,000 settlers who arrived between 1607 and 1625 perished, many of them of malnutrition in the early years of the set-

tlement. Like their predecessors at Roanoke, the colonists were expected to live off the land and off trade and tribute from the Indians, a way of life that made them exceptionally vulnerable during unusually dry years. They also suffered from water shortages when the drought drastically reduced river levels. Jamestown's archives make frequent references to the foul drinking water and the illnesses caused by consuming it, especially before 1613, when the drought ended.

In 1600, hunger was still a familiar threat to anyone cultivating the soil, whether European peasant or English colonist on the edge of North America. But the first stirrings of an agricultural revolution were underway, stimulated by explosive city growth.

THE END OF
THE "FULL WORLD"

They are made up of many small terminal moraines, laid against and on top of each other, as is clearly shown in instances where individual moraines lie spread out in a series one behind another, with concentrically curving crests. They record for each glacier many repeated advances, all of approximately the same magnitude. How many centuries of glacial oscillation are represented by these moraine accumulations it is difficult to estimate.

—*François Matthes, "Report of Committee on Glaciers," 1939*

Year	Climate	England (Chapter 8)	France (Chapter 9)	Other Events
2000	Rapid Warming			Mt. Pinatubo eruption
	Cool Interval	World War II	World War II	World War II
	Gradual Warming	World War I	World War I	World War I
1900	Cold Winters (1880s)			Extensive European emigration
	Warming after 1850	Crimean War	Crimean War	Irish Potato Famine
1800	Cold (1812–21)	Napoleonic Wars	Napoleonic Wars	
	Cool and Unsettled		French Revolution	Laki eruption (Iceland)
	Cold (1739–41)	Increased pace of enclosure	Louis XVI (1774–93)	
			Louis XV (1716–74)	
	Warm and settled			Potato assumes importance in Ireland
1700		Great Storm (1703)		
	Cold and Unsettled	"Glorious Revolution"	Louis XIV (1643–1715)	Alpine glaciers advance
		More productive agriculture		Drought in eastern North America
		Civil War		
		Turnip introduced		
1600	Cold and Unsettled		Economic Revival	Huanyaputina eruption
		Spanish Armada		
	Warm Summers	Exceptional harvests	Gilles de Gouberville	
1550			Gains in cereal production	Agricultural innovation in Low Countries

Major historical and climatic events, 1500 to present

6

THE SPECTER OF HUNGER

The vines look as if they had been swept by fire. The poor people are obliged to use their oats to make bread. This winter they will have to live on oats, barley, peas, and other vegetables.

—A government official at Limousin, France,
October 18, 1692

I will always remember the sights, smells, and sounds of subsistence agriculture in Africa—rows of women hoeing newly cleared woodland, the scent of wood smoke and the hazy, ash-filled autumn skies, the endless thumping of wooden pestles pounding grain for the evening meal. I recall leisurely conversations by the fire or sitting in the shade of a hut, the talk of rain and hunger, of scarce years, of plentiful times when grain bins burst with maize and millet. The memories of October are the most vivid of all: the countryside shimmering under brutal, escalating heat, the great clouds massing on the afternoon horizon, anxious women watching for rain that never seemed to fall. When the first showers finally arrived with their marvelous, pungent scent of wet earth, the people planted their maize and waited for more storms. Some years there was no rain until December, and the crops withered in the fields. Stored grain ran out in early summer and the people faced scarcity. The specter of hunger was always in the air, never forgotten. I received a firsthand lesson in the harsh realities of subsistence farming, the brutal ties between climatic shifts and survival.

Surprisingly few archaeologists and historians have had a chance to observe subsistence farming at firsthand, which is a pity, for they sometimes

fail to appreciate just how devastating a cycle of drought or heavy rainfall, or unusual cold or warmth, can be. Like medieval farmers, many of to-day's subsistence agriculturalists in Africa and elsewhere have virtually no cushion against hunger. They live with constant, often unspoken, environmental stress. The same was true in Europe at the end of the sixteenth century, where well over 80 percent of the population was engaged in subsistence agriculture, by definition living barely above subsistence level, and at the complete mercy of short-term climatic shifts. The five centuries of the Little Ice Age were defined by these shifts: short periods of relatively stable temperatures were regularly punctuated by markedly colder or wetter conditions that brought storms, killing frosts, greater storminess, and cycles of poor harvests. While Europe's subsistence farmers muddled by in good years, such sudden changes brought great stress to communities and growing cities that were on the economic margins in the best of times. These stresses were not only economic; inevitably they were political and social as well.

Until recently, historians have tended to discount short-term climate change as a factor in the development of preindustrial European civilization, partly because we lacked any means of studying annual or even decadal climatic variations. French scholar Le Roy Ladurie argued that the narrowness in temperature variations and the autonomy of human phenomena that coincided with them in time made it impossible to establish any causal link. He reflected a generally held view, with only a few dissenters, among them the English climatologist Hubert Lamb, who was convinced climate and human affairs were related and was much criticized for saying so.[1] The ghosts of environmental determinism—discredited assumptions of three-quarters of a century ago that invoked climatic change as the primary cause of the first agriculture, the emergence of the world's first civilizations, and other major developments—still haunt scholarly opinion. Environmental determinism is an easy charge to level, especially if one is unaware of the subtle effects of climatic change.

Today, no one seriously considers that climate change alone caused such major shifts in human life as the invention of agriculture. Nor do they theorize that the climatic shifts of the Little Ice Age were responsible for the French or Industrial revolutions or the Irish potato famine of the 1840s. But the spectacular advances of paleoclimatology now allow us to

look at short-term climatic change in terms of broad societal responses to stress, just as archaeologists have done with much earlier societies. Climate variability leading to harvest failures is just one cause of stress, like war or disease, but we delude ourselves if we do not assume it is among the most important—especially in a society like that of preindustrial Europe, that devoted four-fifths of its labor just to keeping itself fed.

Observing subsistence farming at firsthand is a sobering experience, especially if you have spent all your life buying food in supermarkets. You learn early on that human beings are remarkably adaptable and ingenious when their survival depends on it. They develop complex social mechanisms and ties of obligation for sharing food and seed, diversify their crops to minimize risk, farm out their cattle to distant relatives to combat epidemic disease. These qualities of adaptability and opportunism came to the fore in sixteenth- to eighteenth-century Europe, when adequate food supplies in the face of changeable weather conditions became a pressing concern. A slow agricultural revolution was the result.

The revolution began in the Low Countries and took root in Britain by the seventeenth and eighteenth centuries, in France as a whole much later, and in Ireland as a form of hazardous monoculture based on the potato.[2] The historical consequences were momentous—in England, food to feed the burgeoning population of the Industrial Revolution, along with widespread social decay and disorganization; in France, a slow decline in peasant living standards, bringing widespread fear and unrest at a time of political and social uncertainty; and in Ireland, catastrophic famine that killed over a million people when blight destroyed its staple crop and Britain neglected its humanitarian responsibilities.

The severe weather of the 1590s marked the beginnings of the apogee of the Little Ice Age, a regimen of climatic extremes that would last over two centuries. There were spells of unusual heat and of record cold, like the winter of 1607, when savage frosts split the trunks of many great trees in England. Atmospheric patterns changed too, as the polar ice cap expanded, anticyclones persisted in the north, and depression tracks with their mild westerlies shifted southward. These anticyclones brought many weeks of northeasterly winds, as opposed to the prevailing southwesterlies experienced by earlier generations. Dutch author Richard Verstegan remarked in 1605 how retired skippers in the Netherlands remembered

that "they have often noted the voyage from Holland to Spayne to be shorter by a day and a halfe sayling than the voyage from Spayne to Holland."[3] In the century that followed, profound changes in European life were shaped, in part, by the coldest weather in seven hundred years.

The seventeenth century literally began with a bang. Between February 16 and March 5, 1600, a spectacular eruption engulfed the 4,800-meter Huanyaputina volcano seventy kilometers east of Arequipa in southern Peru.[4] Huanyaputina hurled massive rocks and ashy debris high into the air. Volcanic ash fell over an area of at least 300,000 square kilometers, cloaking Lima, La Paz and Arica, and even a ship sailing in the Pacific 1,000 kilometers to the west. During the first twenty-four hours alone, over twenty centimeters of sand-sized ash fell on Arequipa, causing roofs to collapse. Ash descended for ten days, turning daylight into gloom. At least 1,000 people died, 200 of them in small communities near the volcano. Lava, boulders, and ash formed enormous lakes in the bed of the nearby Rio Tambo. The water burst through and flooded thousands of hectares of farmland, rendering it sterile and unproductive. Many ranches lost all their cattle and sheep. The local wine industry was devastated.

The scale of the Huanyaputina eruption rivaled the Krakatau explosion of 1883 and the Mount Pinatubo event in the Philippines in 1991. The volcano discharged at least 19.2 cubic kilometers of fine sediment into the upper atmosphere. The discharge darkened the sun and moon for months and fell to earth as far away as Greenland and the South Pole. Fortunately for climatologists, the fine volcanic glass-powder from Huanyaputina is highly distinctive and easily identified in ice cores. It is found at high levels in South Pole ice layers dated to 1599–1604. The signal is also present, though less distinct, in Greenland ice cores. The sulphate levels are such that we know that the amount of sediment thrust into the stratosphere was twice that of Mount Pinatubo and about 75 percent of the vast Mount Tambora eruption of 1815, probably the greatest sulfur-producing event of the Little Ice Age.

Huanyaputina ash played havoc with global climate.[5] The summer of 1601 was the coldest since 1400 throughout the northern hemisphere, and among the coldest of the past 1,600 years in Scandinavia, where the sun was dimmed by constant haze. Summer sunlight was so dim in Iceland that there were no shadows. In central Europe, sun and moon were "reddish, faint, and lacked brilliance." Western North America lived through the coldest summer of the past four hundred years, with below-freezing temperatures during the maize growing season in many areas. In China, the sun was red and dim, with large sunspots.

Map of Huanyaputina area, Peru

Volcanic events produced at least four more major cold episodes during the seventeenth century, which is remarkable for having at least six climatically significant eruptions.[6] None rivaled summer 1601, but 1641–43, 1666–69, 1675, and 1698–99 experienced major cold spikes connected with volcanic activity. The identity of these eruptions remains unknown except for that of January 4, 1641, when Mount Parker on Mindanao in the Philippines erupted with a noise "like musketry." Wrote an anonymous Spanish eyewitness: "By noon we saw a great darkness approaching from the south which gradually spread over the entire hemisphere. . . . By 1 pm we found ourselves in total night and at 2 pm in such profound darkness that we could not see our hands before our eyes."[7] A nearby Spanish flotilla lit lanterns at midday and frantically shoveled ash off its decks, fearing in the darkness "the Judgement Day to be at hand." The dust from the eruption affected temperatures worldwide.

❧

Most European farmers still practiced subsistence agriculture familiar to
their ancestors since long before medieval times. But change was afoot,
stimulated by the growth of profitable markets in growing cities and by
the increasing risks of subsistence farming. Slowly and steadily, as they
battled unpredictable and more stormy climates, anonymous villagers
experimented with new agricultural methods. They adapted to new cli-
matic regimes where extremes of cold, heat, and rainfall were more com-
monplace and the danger of food shortages correspondingly greater.

The English were not the first to innovate. A low technology agricul-
tural revolution had begun in Flanders and the Netherlands as early as the
fourteenth and fifteenth centuries. Farmers everywhere still used scythes
for cutting the heads of grain, also light plows pulled by animals wearing
draught collars. They built simple windmills to drain and water their
land. Illiterate, unaware of agricultural innovations elsewhere, but with a
vast experience of their demanding environments, Flemish and Dutch
farmers experimented with lay farming, the deliberate growing of animal
forage and cultivated grass for cattle. Instead of letting valuable hectares
lie fallow, they planted field peas, beans, and especially nitrogen-rich
clover, all of which provided food for humans and beasts, as well as buck-
wheat, furze, and turnips for feeding animals. The amount of fallow land
contracted drastically until it was virtually nonexistent.

Late medieval Flanders developed these innovations at a time when the
population was growing slowly, despite a high density of people on the
land. With abundant forage, animal husbandry assumed ever greater im-
portance. More manure, meat, wool, and leather came onto the market as
the new agriculture broke the vicious cycle of overdependence on grain.
At the same time, farmers now chose fields that had been in use for some
time for cereals and sowed them with grass, or, in the sixteenth and seven-
teenth centuries, with clover. Cattle grazed on the meadow for five years
or more. The now well-fertilized soil was then plowed and planted with
cereals again. This self-perpetuating cycle led to much more productive
land, especially when combined with the planting and rapid harvesting of

turnips directly after harvesting rye or flax. In addition, the farmers diversified into purely industrial crops like flax, mustard, and hops, the last for brewing beer.

The revolution in agricultural practice came at a time when massive grain imports from Baltic ports were undermining local grain production. Inevitably and profitably, the farmers specialized away from subsistence farming. Adjustment to cycles of cold and higher rainfall were easy enough in a diversified agricultural economy with ready access to grain from Baltic ports and the waterways to transport it. The greatest problem was rising sea levels. In the lowest lying coastal areas, villages made systematic efforts to protect their communities with earthen dikes that closed off natural inlets and guarded against high tides and storm surges. The invention of water-pumping windmills that could be turned into the wind made it possible to pump enclosed fields dry, then dig out the resulting peat and sell it for fuel.

The enduring Dutch achievement was land reclamation that transformed an entire country. As professional sea wall engineering in the hands of experts gradually replaced the haphazard local efforts, Holland's farmland grew by a third—roughly 100,000 hectares—between the late sixteenth and early nineteenth centuries. Most of this land was reclaimed between 1600 and 1650. The Dutch possessed sufficient technological expertise and a sufficiently flexible social organization to diffuse the worst effects of short-term climatic change. The Little Ice Age may have imposed more benefits than costs on the Dutch. Extensive land reclamation turned liabilities into assets so powerful that they helped forge the first modern economy in Europe.[8]

The farming revolution in the Low Countries was accompanied by a rapid diminution of individual landholdings at a time of greater crop yields and rising farmer's income per hectare. These factors made small holdings reasonably efficient for farm owners living close to a market town. The competence and competitiveness of Dutch and Flemish farmers was unique in Europe. Their methods did not spread into England until the seventeenth and eighteenth centuries, and into France still later. The custom and prejudice of generations kept innovation at bay.

By 1600, the influence of Holland and Flanders was already felt around London, where market gardens grew "cabbages, colleflours, turnips, carrots, parsnips and peas."[9] Through the century, agricultural specialization increased and markets became larger and more attuned to more narrowly focused commercial agriculture. But specialization and purely commercial farming were held in check by the needs of small landowners and tenants, and those living on communal lands, who continued to practice subsistence agriculture. A steady stream of farming writers urged landowners to improve their methods, most famous among them Walter Blith, who advocated the use of water meadows, drainage of wet soils, enclosure to intensify production, and manures. He inveighed against the subsistence farmer: "He will toyle all his days himselfe and Family for nothing, in and upon his common arable fielde land; up early and downe late, drudge and moyle and ware out himself and family."[10] Blith and his contemporaries kept a close eye on agricultural developments across the North Sea, but just how influential their writings were is debatable. In most cases, farmers probably copied their neighbors or landlords in adopting new practices.

The changes and experiments paid off. A century after Queen Elizabeth, England's population was nearly 7 million, with enough grain for everyone, far above the 4 million figure at the time of the Black Death. The country was self-sufficient in all cereals except oats, which came from Ireland. Food prices moved over less extreme ranges. Britain was exporting grain "of all sorts to Africa, the Canaries, Denmark and Norway, Ireland, Italy, Madeira, Newfoundland, Portugal, Russia, Scotland, Sweden, Venice, Guernsey and the English plantations."[11] The amounts exported were tiny by modern standards, but the stimulus to domestic production was significant. In Daniel Defoe's words, Britain became "a corn country" where widespread famine was unknown. Intensive production and crop diversification guarded against poor grain harvests.

The changes came, above all, from self-improvement, from individual landowners adapting to cooler weather, more difficult farming conditions, and opportunities in the marketplace. By 1660, Dutch immigrants had introduced the more cold-resistant turnip to eastern England, where it was planted in September after the harvest on what would have been fallow land, then fed to milking cows and fattening bullocks for the

London market. Farmers turned to turnips with alacrity because of the cooler, often dry weather, for spring droughts often led to poor hay crops. Green turnip tops were an excellent fodder substitute for hay. In 1661, the churchwarden of Hingham in Norfolk complained of drought and little hay for the following winter. Fortunately, it rained in July and "the want of hay was supplied by the growing of turnips."[12] In Wiltshire, farmers raised sheep on water meadows and used them to manure arable higher ground. A thousand sheep would manure half a hectare overnight. The most spectacular changes came in eastern England, where the low-lying fenlands were a watery land inhabited by cattle herders, fowlers, and fisherfolk with a deep distrust of outsiders. Over the century, the Dutch engineer Cornelius Vermuyden, working with large landowners and the Crown, reclaimed over 155,000 hectares of fenland, creating some of the richest arable land in Britain. Sown mainly in oats and coleseed for animal fodder (the latter another Dutch import), the fens soon became a highly productive center of specialized farming for both food and industrial crops. Coastal marshes along the Lincolnshire coast were drained and used as sheep pasturage. English farmers were slowly breaking free of the tyranny of cereals that would beset France for two more centuries.

New crops, new farming methods, extensive manuring, and improved drainage: the major advances came first in eastern and western areas outside the confines of the old open-field regions. The ancient open-field village system still flourished in the fertile Midlands, where farmers cultivated arable land in narrow strips. Such communal agriculture was not conducive to experimentation and individual initiative. But even in the heart of subsistence farming country, change was afoot as communities took up hitherto waste land and farmed it as separate, hedged fields. Much of this land was carefully drained with the latest methods, manured, and often planted with turnips and other root crops. Many farmers wedded to the old ways saw the advantages of the new. But the full benefits of the new agriculture could not be realized without the enclosure of larger parcels of land.

In general terms, enclosure meant the extinction of common rights over farmlands and parish hectarage.[13] Scattered holdings in open fields were consolidated into compact blocks, usually fenced or hedged off,

then held "in severalty," in other words reserved for the sole use of individual owners or their tenants. Enclosure had begun in medieval times with the creation of large monastic estates and the gradual enclosure of strip fields and common land into bigger, more productive units, especially to increase wool production. Much such activity was a process of informal negotiation between families and individuals, freeholders and tenants with the simple objective of achieving more rational layout of farming land. By 1650, most peasants understood that enclosure was the only way they could break out of the subsistence farmer's vicious circle of living from harvest to harvest and continually risking hunger. Communal agriculture was not the answer, because the land could yield little more without proper drainage and manuring. Manure required more livestock, which in turn compelled more fodder for cold weather feed, in an era of numerous severe winters. Enclosure allowed farmers to combine grain cultivation with stock raising, to grow new fodder crops instead of fallowing land. Clover and other animal feeds added nitrogen to the soil and renewed it for cereals. The new circle of drainage, soil preparation, stock, and crops could double productivity.

From 1660 onward, enclosure proceeded briskly, much of it by communal agreement and negotiation. There were sporadic protests by small landowners and the dispossessed against the engrossing of farms. New dikes were thrown down, Dutch engineers in the fens thrown into the water and prodded with poles. But the inexorable forces of economic progress, increasingly colder climate, and history were against the small landowner with little capital and farmers with ill-defined rights to their land. A new age of landlord and tenant farming was dawning, where individual peasant rights were of little importance. In the short term, there were serious individual hardships at a time of increasing social tensions. In the long term, the enormous material benefits freed Britain from the constant subsistence crises that enveloped their neighbors across the Channel.

Seventeenth-century British farmers scorned an American import, the potato, whose tubers they regarded as barely suitable for animals. In the

end, however, the wealth generated by the potato would exceed all the gold and silver exported from the Americas. A single year's global potato harvest today is worth more than $100 billion.

A Spaniard returning home from South America brought the first potato to Europe in about 1570.[14] The unspectacular, lumpy tuber may have been an afterthought, a curio stuffed into a traveler's baggage to impress relatives back home. Not that the potato was new to the conquistadors. Indian farmers throughout the Andes cultivated many varieties of this important staple, often high on exposed hillsides. The tubers were misshapen and often downright ugly, but they could be freeze-dried, were rich in essential nutrients, and were easily stored.

Potatoes prevent scurvy, provide quick and cheap meals for farm laborers and their families, and require but the simplest of implements to plant and harvest. Combined with milk or other dairy products, they made up a diet that was far more complete nutritionally than the bread- and cereal-based diets of sixteenth-century Europe. You would think that Europeans would have embraced such a crop with immediate enthusiasm, but they did not.

Conquistadors regarded potatoes and the Andean Indians who grew them with contempt. The potato was poor people's food, vastly inferior to bread. Inevitably, strong social prejudice accompanied the few tubers that came to Europe. After beginning their European career feeding patients in a Seville hospital for the poor in 1573, potatoes soon became a botanical curiosity, even a luxury food, not a food for the indigent.

The new plant spread from garden to garden in the hands of ardent botanists and their wealthy patrons. Potatoes appeared in the pages of herbals, where readers learned that the Italians ate them "in a similar fashion to truffles."[15] In 1620, the English physician Tobias Venner praised them in his *Via Recta ad Vitam Longam* ("The Right Road to a Long Life") as "though somewhat windie, verie substantiall, good and restorative." He recommended roasting them in embers, then dunking them in wine. However cooked, "they are very pleasant to the taste and doe wonderfully comfort, nourish and strengthen the bodie." Venner prescribed them for the aged and remarked that the potato "incites to Venus."[16] Despite these good reviews, many people thought them exotic and poisonous. Potatoes were a root crop, not the kind of leafy plant that could flavor or garnish roast meat. They occasionally appeared on

royal menus as a seasonal food and were an expensive luxury. The English, not yet meat and potatoes folk, considered the potato an almost indelicate plant that did not belong in the diet of a seventeenth-century gentleman.

In 1662, a Mr. Buckland, a Somersetshire landowner, wrote to the Royal Society of London arguing that potatoes might help protect the country against famine. The Agriculture Committee of the Society promptly agreed and urged its landowning Fellows to plant such a crop. John Evelyn, the Society's gardening expert, wrote that potatoes would be good insurance against a bad harvest year, if for nothing else than to feed one's servants. In 1664, a pamphleteer named John Forster argued in a book entitled *England's Happiness Increased: A Sure and Easie Remedy against the Succeeding Dearth Years* that the potato was a sure remedy for food shortages, especially when mixed with wheat flour. Deep-rooted social prejudices among the political and scientific elite prevented them from setting an example and eating potato dishes. As for the poor, many of them preferred to go hungry than to give up their bread.

French peasants resisted potatoes for generations. In bad years, they made do with inferior or slightly moldy grain, suffered under ever higher prices, became hungry, and often joined bread riots. The potato was still an exotic food in France as late as 1750 and even then shunned by most gourmands. Burgundy farmers were forbidden to plant potatoes, as they were said to cause leprosy, the white nodular tubers resembling the deformed hands and feet of lepers. Denis Diderot wrote in his great *Encyclopaedie* (1751–76): "This root, however one cooks it, is insipid and starchy. . . . One blames, and with reason, the potato for its windiness; but what is a question of wind to the virile organs of the peasant and the worker."[17]

In England, the potato was grown as animal fodder, then as food for the poor, with flourishing potato markets in towns like Wigan in the north by 1700. Across the Irish Sea, the Irish rapidly embraced the potato as far more than a supplement. It was a potential solution to their food shortages. Quite apart from other considerations, potatoes were far more productive than oats, especially for poor people without money to pay a miller to grind their grain. Soon the Irish poor depended on potatoes to the virtual exclusion of anything else, a reliance that laid the foundations for catastrophe.

7

THE WAR AGAINST
THE GLACIERS

The sun is only one of a multitude—a single star among mil-
lions—thousands of which, most likely, exceed him in bril-
liance. He is only a private in the host of heaven. But he alone
. . . is near enough to affect terrestrial affairs in any sensible de-
gree, and his influence on them . . . is more than mere control
and dominance.

—*Charles Young*, Old Farmers Almanac, *1766*

Between 1680 and 1730, the coldest cycle of the Little Ice Age, tem-
peratures plummeted, the growing season in England was about five
weeks shorter than it was during the twentieth century's warmest decades.
The number of days each winter with snow on the ground in Britain and
the Netherlands rose to between twenty and thirty, as opposed to two to
ten days through most of the twentieth century.[1] The winter of 1683/84
was so cold that the ground froze to a depth of more than a meter in parts
of southwestern England and belts of sea ice appeared along the coasts of
southeastern England and northern France. The ice lay thirty to forty
kilometers offshore along parts of the Dutch coast. Many harbors were so
choked with ice that shipping halted throughout the North Sea.

Conditions around Iceland were now exceptionally severe. Sea ice of-
ten blocked the Denmark Strait throughout the summer. In 1695, ice
surrounded the entire coast of Iceland for much of the year, halting all
ship traffic. The inshore cod fishery failed completely, partly because the

114

Winter with no
extremes, probably
rather dry

"Average to
good winter"

Very severe
at Trondheim

Ice on the
Belts from
New Year

Severe
frost

Thames River
frozen, bearing
coach traffic

Bodensee &
Swiss lakes frozen.
Venice lagoon
frozen.
Ice on Adriatic
sea fringe in North.

Deep
snow

Severe
winter
weather

WINTER 1683-84

The map contains the following labels:

WINTER 1684-85

Cold winter
very severe in
late January.
Harbors frozen,
hundreds of people
on the ice in
Boston harbor

"Average to good"
winter

Severe

Severe
cold winter

Very severe

Thames River frozen
over at intervals
Bodensee & Swiss
lakes again frozen

Winters of 1683/84 and 1684/85. Data compiled from Hubert H. Lamb, *Climate Present, Past, and Future*, 2 vols. (London: Methuen, 1977); and *Climate, History and the Modern World* (London: Methuen, 1982).

fish may have moved offshore into slightly warmer water, but also because of the islanders' primitive fishing technology and open boats. On several occasions between 1695 and 1728, inhabitants of the Orkney Islands off northern Scotland were startled to see an Inuit in his kayak paddling off their coasts. On one memorable occasion, a kayaker came as far south as the River Don near Aberdeen. These solitary Arctic hunters had probably spent weeks marooned on large ice floes. As late as 1756, sea ice surrounded much of Iceland for as many as thirty weeks a year.

Cold sea temperatures brought enormous herring shoals southward from off the Norwegian coast into the North Sea, for they prefer water temperatures between 3 and 13°C. English and Dutch fishermen benefited from the herring surge, while the Norwegians suffered. This was not the first time the fish had come south. In 1588, in a previous cold snap, the great British geographer William Camden had remarked how "These herrings, which in the times of our grandfathers swarmed only about Norway, now in our times . . . swim in great shoals round our coasts every year."[2] The revived fisheries brought a measure of prosperity to Holland, as the country fought for independence, as did the development of simple windmills for draining low-lying fields. But repeated storms and sea surges overthrew many coastal defenses and inundated agricultural land. In Norway, the shortened growing season was even more marked than further south, at a time when mountain glaciers were advancing everywhere. The Norwegians turned the cold weather to their benefit. Many coastal villages abandoned their fields and began building ships to export the timber from nearby forests. Between 1680 and 1720, Norway developed a major merchant fleet based on the timber trade, transforming the economy of the southern part of the country.

The cold polar water spread southward toward the British Isles. The cod fishery off the Faeroe Islands failed completely, as the sea surface temperature of the surrounding ocean became 5°C cooler than today. Just as it had in the 1580s, a steep thermal gradient developed between latitudes 50° and 61–65° north, which fostered occasional cyclonic wind storms far stronger than those experienced in northern Europe today. The effects of colder Little Ice Age climate were felt over enormous areas, not only of Europe but the world.

The retreat of the San Josef Glacier, South Island, New Zealand, 1865–1965. The glacier face has retreated even farther since the 1960s. Redrawn from New Zealand Government sources; see also Jean Grove, *The Little Ice Age*

The Franz Josef glacier in New Zealand's Southern Alps thrusts down a deep valley backed by mountains that rise to the precipitous heights of Mount Tasman, 3,494 meters above sea level.[3] The path to the ice face winds through a barren valley floor, across fast-running streams fed by the melting glacier. As you walk up to the ice, you wend your way through massive blocks of hard rock polished into humps by the abrasive debris collected by the ice as it advanced and retreated along the valley. When you reach the face, you gaze up at a pale green river of ice glistening in the sun, a microcosm of the glacial fluctuations of the Little Ice Age.

ᵇ/ Franz Josef is a glacier on the move. Nine centuries ago, it was a mere pocket of ice on a frozen snowfield. Then Little Ice Age cooling began and the glacier thrust downslope into the valley below, smashing into the great rain forests that flourished there. The ice crushed everything in its path, felling giant trees like matchsticks. By the early eighteenth century, Franz Josef's face was within three kilometers of the Pacific Ocean, a river of aggressive ice pointing like an arrow toward the coast.)

Today, Franz Josef, like other New Zealand glaciers, is in retreat. Thousands of tourists walk up to the face every year, lingering at sunset to enjoy the sight of the mountain peaks bathed in rosy hues while the lower slopes lie in deep, purple shadow. Their pilgrimage takes them through rocky terrain that was completely covered with ice during the eighteenth and early nineteenth centuries. They can see how the glacier is a barometer of the greater cold of two centuries ago, followed by modern-day warming. Signs along the access path mark the spots where the end moraines halted at their maximum extent, then document the spectacular retreats and glacial fluctuations since 1850. The glacier retreated steadily until about 1893, when a sudden forward thrust destroyed the tourist trail to the face. In 1909, advances of up to fifty meters a month were reported. Franz Josef then retreated again before recovering about half the ground lost earlier in the 1920s. By 1946, the glacier was at least a kilometer shorter than it had been three-quarters of a century before. The pattern of advance and retreat continues to this day, with the retreats more prolonged than the advances.

The New Zealand Alps are one of the few places in the world where glaciers thrust into rain forest. It was here, at the foot of Franz Josef, that I realized the Little Ice Age at its apogee was a truly global phenomenon, not just something of concern to Alpine villagers on the other side of the world.

ᵇ/ The high tide of glacial advance at Franz Josef came between the late seventeenth and early nineteenth centuries, just as it did in the European Alps. Glaciers in the Alps advanced significantly around 1600 to 1610, again from 1690 to 1700, in the 1770s, and around 1820 and 1850. Ice sheets in Alaska, the Canadian Rockies and Mount Rainier in the northwestern United States moved forward simultaneously. Glaciers expanded at the same times during the nineteenth century in the Caucasus, the Hi-

malayas, and China. The Qualccaya ice core in Peru's southern Andes provides evidence of frequent intense cold from A.D. 1500 to 1720, with prolonged droughts and cold cycles from 1720 to 1860.

As Franz Josef shows, the cycles of glacial advance and retreat were never clear-cut, often rapid, and always irregular in duration. Nor did the maximum advances coincide from one region to the next. The northern glaciers in both Europe and North America advanced late in the Little Ice Age and retreated early. (Iceland is an exception: its glaciers reached their greatest extent in the late nineteenth century.) In contrast, the more southerly glaciers, like those in the New Zealand Alps, advanced early, retreated and advanced again and again to the same extended positions before shrinking decisively in the late nineteenth and early twentieth centuries.

The increasing cold affected not only glaciers but mountain snow levels, which extended lower than today. Snow cover lasted longer into the spring. High mountains in the Andes of Ecuador were perennially snow-capped until at least the late nineteenth century. Travelers in Scotland reported permanent snow cover on the Cairngorm Hills at about 1,200 to 1,500 meters, which would require temperatures 2 to 2.5°C cooler than those of the mid-twentieth century. Wrote traveler John Taylor of the Deeside area in about 1610: "the oldest men alive never saw but snow on the tops of divers of these hills, both in summer as well as in winter."[4] A temperature drop of only 1.3°C (about that recorded in central England at the time) would have been sufficient to bring the snowline down to about 1,200 meters in the Scottish mountains and would have allowed glacier ice to form in some shaded gullies.[5]

The colder conditions had striking biological consequences that we can only extrapolate from modern plant, tree, and animal movements. Trees like birch and pine extended into new territory when conditions became warmer near the northern forest line, then retreated as conditions grew colder, a process that was not necessarily instantaneous. Between 1890 and the 1940s, the North Atlantic Oscillation was in a high mode, bringing milder weather and a constant flow of depressions across northern Europe. During these warmer years, many European birds extended their ranges northward, for they are highly sensitive to the depth and duration of snow cover, the length and warmth of summers, and the harshness of winters. Animal distributions can also reflect the availability of

their favorite foods. For example, puffins declined sharply around Britain between 1920 and 1950 because the fish species they ate preferred colder water. When sea temperatures dropped after the 1950s, the sand eels returned, and northern puffin colonies increased again.

Iceland welcomed all manner of European bird species during the first half of the twentieth century, among them breeding pairs of blackheaded gulls, swallows, starlings, and fieldfare. Even more striking is the distribution of the serin, a bird that flourished among the sunny borders of woodlands throughout the western Mediterranean during the eighteenth century. By 1876, serins had colonized much of central Europe; they now breed as far north as the Low Countries, northern France, and Scandinavia. When northern latitudes cooled slightly in the 1960s, species like the snowy owl moved southward to nest in Shetland, and great northern divers returned to Scotland from the north.

All these changes, like those of moths and butterflies, are minor compared with the shifts in animal distributions that must have taken place during the coldest episodes of the Little Ice Age. Were these shifts noticed at the time? Except for economically important species like the herring and cod, any such observations were not written down—at least, they are unknown to modern scholars. But if people noticed a slow change in their local animals and plants, surely few of them knew of the remarkable lack of sunspots between 1645 and 1715.

Sunspots are familiar phenomena. Today, the regular cycle of solar activity waxes and wanes about every eleven years. No one has yet fully explained the intricate processes that fashion sunspot cycles, nor their maxima and minima. A typical minimum in the eleven-year cycle is about six sunspots, with some days, even weeks, passing without sunspot activity. Monthly readings of zero are very rare. Over the past two centuries, only the year 1810 has passed without any sunspot activity whatsoever. By any measure, the lack of sunspot activity during the height of the Little Ice Age was remarkable.

The seventeenth and early eighteenth centuries were times of great scientific advances and intense astronomical activity. The same astronomers who observed the sun discovered the first division in Saturn's ring and five of the planet's satellites. They observed transits of Venus and Mercury, recorded eclipses of the sun, and determined the velocity of light by observing the precise orbits of Jupiter's satellites. Seventeenth-century scholars published the first detailed studies of the sun and sunspots. In 1711, English astronomer William Derham commented on "great intervals" when no sunspots were observed between 1660 and 1684. He remarked rather charmingly: "Spots could hardly escape the sight of so many Observers of the Sun, as were then perpetually peeping upon him with their Telescopes . . . all the world over."[6] Unfortunately for modern scientists, sunspots were considered clouds on the sun until 1774 and deemed of little importance, so we have no means of knowing how continuously they were observed.

The period between 1645 and 1715 was remarkable for the rarity of aurora borealis and aurora australis, which were reported far less frequently than either before or afterward. Between 1645 and 1708, not a single aurora was observed in London's skies. When one appeared on March 15, 1716, none other than Astronomer Royal Edmund Halley wrote a paper about it, for he had never seen one in all his years as a scientist—and he was sixty years old at the time. On the other side of the world, naked eye sightings of sunspots from China, Korea, and Japan between 28 B.C. and A.D. 1743 provide an average of six sightings per century, presumably coinciding with solar maxima. There are no observations whatsoever between 1639 and 1700, nor were any aurora reported.

In the 1890s, astronomers F. W. G. Spörer and E. W. Maunder drew attention to this long sunspot-free period in the late seventeenth and early eighteenth centuries. If seventeenth-century observers were to be believed, almost all sunspot activity ceased for seventy years, a dramatic departure from the modern sun's behavior. This lacuna in sunspot activity has since been known as the "Maunder Minimum."

In later papers, Maunder made some striking assertions. First, very few sunspots were seen over the seventy years between 1645 and 1715. Second, for nearly half this time (1672–1704) no sunspots were observed on the

northern hemisphere of the sun whatsoever. Only one sunspot group at a time was seen on the sun between 1645 and 1705. Last, the total number of sunspots throughout the seventy years was less than the number that occur in a single active year today. Maunder quoted extensively from contemporary observations, among them that of the French astronomer Picard in 1671, who "was pleased at the discovery of a sunspot since it was ten whole years since he had seen one, no matter how great the care which he had taken from time to time to watch for them."[7] Maunder himself pointed out that this apparent anomaly in the sun's history might have had important consequences for terrestrial weather, perhaps far more important than the regular eleven-year cycles of solar activity in normal times.

Better catalogs of historical solar aurorae, hitherto unknown sunspot observations by early Asian scholars and new tree-ring data have all upheld the validity of the Maunder Minimum. Radiocarbon-dated tree rings are a valuable source of information on fluctuations in solar radiation. Carbon 14 is formed in the atmosphere through the action of cosmic rays, which are in turn affected by solar activity. When the sun is active and sunspot cycles are at their maximum, some of the incoming galactic rays are prevented from reaching the earth, resulting in less 14C in the tree rings of the day. When the cycle is low, terrestrial bombardment by cosmic rays increases and 14C levels rise. The dated tree-ring sequences document a well-defined fall in 14C levels and a peak in solar activity between about A.D. 1100 and 1250, the height of Europe's Medieval Warm Period. Carbon 14 levels rose significantly as solar activity slowed between 1460 and 1550 (the Spörer Minimum), then fell for a short time before rising again sharply between A.D. 1645 and 1710, peaking in about 1690, an anomaly so marked that it is named the De Vries Fluctuation, after the Dutch scientist who first identified it. This anomaly coincides almost exactly with the Maunder Minimum.

Was there a relationship between solar activity and the Little Ice Age? There is certainly a nearly perfect coincidence between major fluctuations in global temperature over the past 1,000 years and the changes in 14C levels identified in tree rings. This implies that long-term changes in solar radiation may have had a profound effect on terrestrial climate over decades, even centuries. Certainly the sun has never been constant, and over the past 1,000 years it has shone with periods of greater and lesser activity far more extreme than the levels of today.[8] We may never be able

to decipher the direct linkages between sun and short-term climatic change, but there are compelling connections between the prolonged periods of low solar activity and the maxima of the Little Ice Age.

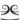

Average Europeans would have complained about the cold winters and sudden heat waves of their day, especially if they were farmers at the mercy of the capricious weather, but their sufferings paled beside the anxiety of those who lived in the shadow of the Alps.

The threat of advancing ice had been around for a long time. The superstitious shook their heads when Saint Petronella's chapel succumbed to the ice. The cult of Saint Petronella was popular in the Alps as early as the eleventh century, for she was believed to cure fever. Her chapel lay at Grindelwald at the foot of the Eiger, in the shadow of a glacier, presided over by a single monk as recently as 1520. A generation later, Hans Rebmann, prior of the monastery at Thun, wrote: "On the side of the mountain [the Eiger], at Sainte-Pétronelle, there was once a chapel, a place of pilgrimage. But a great glacier now hangs there and has entirely covered the site."[9] Local legend claimed that on a clear day one could even see the chapel door through the ice.

Alpine glaciers, which had already advanced steadily between 1546 and 1590, moved aggressively forward again between 1600 and 1616. Villages that had flourished since medieval times were in danger or already destroyed. Land values in the threatened areas fell. So did tithe receipts. During the long period of glacial retreat and relative quiet in earlier times, opportunistic farmers had cleared land within a kilometer of what seemed to them to be stationary ice sheets. Now their descendants paid the price of opportunism. Their villages and livelihoods were threatened.[10]

The glacial thrust continued inexorably. The Vernagt glacier in the eastern Alps advanced vigorously in 1599 and 1600, forming a large lake behind a huge ice barrier. When the dike burst on July 10, 1600, a tidal wave of glacial melt inundated fields, bridges, and cart tracks, causing 20,000 florins worth of damage. The glacier continued to grow the following winter, again forming a lake. Fortunately the water seeped away during the warm months.

Between 1627 and 1633, seven cold and wet summers led to aggressive advances along ice fronts throughout the Alps, causing large rock falls and floods, and destroying trees, farmsteads, and bridges. Between 1628 and 1630, Chamonix lost a third of its land through avalanches, snow, glaciers, and flooding, and the remaining hectares were under constant threat. In 1642, the Des Bois glacier advanced "over a musket shot every day, even in the month of August." The people at Rogationtide marched in solemn procession to implore God's protection against the ice. In 1648, the inhabitants of the village begged the local tax collector to take account of the "other losses, damage, and floods recently caused in the said parish." By this time, people near the ice front were planting only oats and a little barley in fields that were under snow for most of the year. Their forefathers had paid their tithes in wheat. Now they obtained but one harvest in three, and even then the grain rotted after harvesting. "The people here are so badly fed they are dark and wretched and seem only half alive."[11]

Inevitably, the scourge of advancing ice was seen as divine vengeance. When the Des Bois glacier threatened to block the Arve River, the inhabitants of Chamonix sent community leaders to brief the Bishop of Geneva on their plight. They told him of the constant threat posed by ice and wondered whether they were being punished for their sins. In early June 1644, the bishop himself led a procession of about three hundred people to the place where the "great and horrible glacier" threatened the village of Les Bois. The prelate blessed the menacing ice sheet, then repeated the ritual at another glacier near the village of Largentière, at one poised above Le Tour, and at a fourth ice sheet at Les Bosson. The villages were literally hemmed in by moving ice, which lies a good kilometer away today. Fortunately, the blessings worked. The glaciers slowly retreated until 1663, but they left the land so scarred and barren that nothing would grow.

The Aletsch glaciers advanced somewhat later than those around Chamonix. In 1653, the alarmed villagers of Naterser sent a deputation to the Jesuit community at Siders, asking for assistance, saying they were ready to do penance and to undertake other "good Christian works." Fathers Charpentier and Thomas spent a week at Nater, preaching, then leading a procession to the glacier four hours' walk away. The people plodded along, bareheaded in the rain, singing psalms and hymns every step of the way. At the glacier front, the Jesuits celebrated mass and preached a sermon at

the glacier: "The most important exorcisms were used." They sprinkled the terminus with holy water and set up an effigy of Saint Ignatius nearby. "It looked like an image of Jupiter, ordering an armistice not to his routed troops, but to the hungry glacier itself."[12] The Jesuit disputation worked. We are told that Saint Ignatius "caused the glacier to be still."

The glaciers seemed to retreat for a while, then advanced again, prompting renewed devotions and sermons at Chamonix and elsewhere. Ice loomed on every side. In 1669, a visiting salt tax collector wrote in disappointment to a lady friend: "I see here three mountains which are just like yourself . . . five mountains of pure ice from head to foot, whose coldness is unchanging."[13] The 1670s saw the maximum advance in the eastern Alps in modern historical times, especially of the Vernagt glacier, sketched by a Capuchin monk sent there to plead for divine mercy. After the advancing glacier blocked the Rofenthal Valley, a vagrant suspected of practicing black magic was arrested and burned at the stake by hysterical villagers. For five summers in a row, the ice barrier burst, flooding the valley below. The glacier tongue did not retreat more than a few meters until 1712.

Disasters continued. In July 1680, the Mattmarksee lake, blocked by the growing Allalin glacier, flooded huts in the surrounding mountain pastures. The summer was very hot. In July, the lake broke through the weakened ice barrier and ravaged the valley beneath. The people swore they would deflect divine wrath by abstaining from banquets, festivities, balls, and card playing for forty years. The chronicler of Zurbrüggen remarked that "people are always very clever and provident after the event—after the disaster has happened, after the horse has bolted, after the glacier has broken its bounds."[14]

After 1680 the glaciers retreated somewhat. Bishop Jean d'Arenthon of Geneva wrote of the gratitude of the people of Chamonix for his predecessor's visitation. They had invited him back at their expense in his old age to witness how the threatening ice had withdrawn some eighty paces. The old man duly visited the village and repeated his blessing. "I have a sworn benediction. . . . The glaciers have withdrawn an eighth of a league from where they were before and they have ceased to cause the havoc they used to do." However, the retreat was a small one, in no way comparable to that of the past century and a half. It was, as Le Roy Ladurie remarks, "only an oscillation, a little local trough in the great secular high tide."[15] This did not prevent the Chamoniards from petitioning their monarch,

the King of Sardinia, for tax relief, their pleas accompanied by harrowing descriptions of tumbling rocks, floods, and falling ice.

Even with this temporary retreat, the glaciers of the Alps were much larger in the time of King Louis XIV than today. In 1691, Philibert Amédée Arnod wrote an account of the passes and peaks of the Alps. A talented judge as well as a military engineer and a skilled climber, he spent much of his career inspecting mountain fortifications protecting the state of Savoy. Blessed with strong curiosity, Arnod organized a climbing party of three hunters with "climbing irons on their feet and hooks and axes in their hands" to verify a rumor that there was an ancient ice-free pass over the Alps from Savoy to Chamonix. Despite the latest mountaineering equipment, his party was forced to turn back when ice blocked their way. In Arnod's day, glaciers flowed low into the Val Veni and other alpine valleys where today only glacial moraines remain. The ice has retreated deep into the mountains and the pass is clear.

By 1716, the inhabitants of Chamonix were again complaining of governmental neglect, of glacier-caused floods, and villages in great danger of destruction. The Gurgler glacier in the Otzthal region entrapped a large lake, which soon measured a thousand paces long and five hundred wide. In 1718, the local villagers organized a solemn procession to the glacier and celebrated mass on a rocky platform near the ice sheet. The mass had no visible effect, but the lake never flooded the land downstream. The organizers of the procession had heard about the disaster that hit the village of Le Pré-du-Bar in the Val d'Aosta the year before. On September 12, the village had vanished under a glacier-caused landslide so sudden that it was said that even birds perched in trees were immolated. In the same year, the front of the Triolet glacier collapsed in a cataclysm of boulders, water, and ice that rushed downstream with great force, covering "in the depths all moveable chattels, one hundred and twenty oxen or cows, cheeses, and men to the number of seven who perished instantly."[16]

The maximum came between 1740 and 1750, also the years when wealthy tourists discovered the glaciers of the Alps. In 1741, English nobleman George Windham became the first foreign tourist to visit Chamonix. He entered the area with some trepidation, having been advised that "we shall scarcely find any of the Necessities of Life in those Parts." His party traveled with heavily laden horses and a tent, "which was of

some use to us." Windham described how, from the village itself, the glacier fronts "looked like white rocks or rather enormous blocks of ice."[17] His guides told him the glaciers "went on increasing every year." Windham made his way cautiously to the ice front over loose rock and dry, crumbling earth. A year later, French traveler Pierre Martel climbed up to the source of the Arveyron stream at the foot of the Le Bois glacier. "It issues from beneath the ice through two icy caves, like the crystal grottoes where fairies are supposed to live. . . . The irregularities of the roof, over eighty feet high, make a marvellous sight. . . . You can walk underneath, but there is danger from the fragments of ice which sometimes fall off."[18] The Arveyron cave became a popular tourist attraction, a cavern "carved by the hand of nature out of an enormous rock of ice." The changing sunlight made the ice change from white and opaque to transparent and "green as aquamarine." The retreat of the Le Bois glacier over the next century and a half caused the cave to vanish in about 1880.

Glaciers also swelled elsewhere. Between 1742 and 1745, Norwegian glaciers were several kilometers in advance of their present positions, destroying farms and burying valuable summer pasture. Icelandic glaciers also advanced, their movements complicated by volcanic eruptions, like that at Öraefi in 1727, which caused the Skeidarárjökull glacier to oscillate violently, "spouting from its foundations innumerable rivers, which appeared and vanished again almost instantaneously." Spectators had to take refuge on a sandbank and no one could travel in the vicinity for months.[19]

The glacial "high tide" in the Alps lasted from about 1590 to 1850, before the ebb began that continues to this day. These two and a half centuries at the climax of the Little Ice Age straddle momentous changes in European society.

8

"More Like Winter Than Summer"

When the land is inclosed, so as to admit of sowing turnips, clover, or other grass seeds, which have an improving and meliorating tendency, the same soil will, in the course of a few years, make nearby double the return it did before, to say nothing of the wonderful improvements which sometimes result from a loam or clay; which will, when well laid down, often become twice the permanent value in pasture, that it ever would as ploughed ground.

—*Nathanial Kent,* General View of the Agriculture of the County of Norfolk, *1796*

London has never forgotten the summer of 1666. By then, the sprawling metropolis had burst the bounds of the ancient medieval town. The City of London itself was a densely populated maze, with no less than 109 parish churches and the magnificent halls of the livery companies standing amidst narrow alleyways and squalid hovels. A place of extremes of wealth and poverty, London was a busy and overcrowded seaport and mercantile center where disease, crime, and violence were rampant. In 1665, bubonic plague had killed at least 57,000 people and left few families unscathed. The plague subsided during the cold winter of early 1666, which gave way to an intensely hot, dry summer. By September, London's wooden houses were tinder-dry. Diarist Samuel Pepys wrote: "After so long a drought even the stones were ready to burst into flames." Every Londoner was well aware of earlier fires that had swept through the city,

but no one, least of all the authorities, was prepared for the firestorm that broke out on Sunday, September 2, 1666.[1]

The North Atlantic Oscillation was probably in a low mode, causing a persistent anticyclone over northern Europe. For weeks, an arid north-easterly wind had been blowing across the North Sea, further drying out an already parched city. The persistent "Belgian winds" had the authorities on high alert, for England was at war with the Dutch and the breeze favored an attack from across the North Sea. In the small hours of September 2, a fire broke out in the house of the Royal Baker in Pudding Lane, then burst outward across the street to a nearby inn. By 3 a.m., fanned by the strong wind, the fire was spreading rapidly westward. Flames already enveloped the first of more than eighty churches. The Lord Mayor of London distinguished himself by observing the fire and remarking casually: "Pish, a woman might piss it out."[2] He returned to bed while over three hundred structures burned. By morning, the fire was spreading through the wooden warehouses on the north bank of the river. Dozens of houses were pulled down in vain attempts to stem the flames. Huge cascades of fire leapt into the air and ignited roofs nearby, while rumors spread that invading Dutch had started the conflagration. Such fire engines as there were got stuck in narrow alleys. Samuel Pepys walked through the city, "the streets full of nothing but people; and horses and carts loaden with goods, ready to run over one another, and removing goods from one burned house to another." Hundreds of lighters and boats laden with household goods jammed the Thames. By dark Pepys saw the blaze "as only one entire arch of fire . . . of above a mile long. . . . The churches, houses, and all one fire, and flaming at once; and a horrid noise the flames made, and the crackling of houses at their ruin."[3]

The great Fire of London burned out of control for more than three days, traveling right across the city and destroying everything in its path. King Charles II himself assisted the firefighters. On September 5, the northeasterly wind finally dropped, but the fire did not finally burn itself out until the following Saturday. A hot and exhausted Pepys wandered through a devastated landscape: "The bylanes and narrow streets were quite filled up with rubbish, nor could one possibly have known where he was, but by the ruins of some church or hall, that had some remarkable tower or pinnacle standing."[4] The city surveyors totted up the damage: 13,200 houses destroyed in over 400 streets or courts; 100,000 people

were homeless out of a population of 600,000. Astonishingly, only four Londoners died in the flames. The first rain in weeks fell on Sunday, September 9, and it poured steadily for ten days in October. But embers confined in coal cellars ignited periodically until at least the following March.

No one blamed the long drought and northeast winds for turning London into an arid tinderbox. The catastrophe was laid at the feet of the Lord. October 10 was set aside as a fast and Day of Humiliation. Services were held throughout the country to crave God's forgiveness "that it would please him to pardon the crying sins of the nation, especially which have drawn down this last and heavy judgement upon us."[5] The City was rebuilt on much the same street plan, but with one important difference. A regulation required that all buildings now be constructed of brick or stone.

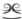

The late seventeenth century brought many severe winters, probably from persistent low NAOs. Great storms of wind occasionally caused havoc with fishing boats and merchant vessels. On October 13, 1669, a northeasterly gale brought sea floods a meter above normal in eastern Scotland, where "vessels were broken and clattered. . . . A vessel of Kirkcaldie brake loose out of the harbour and spitted herself on the rocks."[6] The land itself was on the move. Strong winds blew formerly stable dunes across the sandy Brecklands of Norfolk and Suffolk, burying valuable farmland under meters of useless sand. The sand crept forward for generations. In 1668, East Anglian landowner Thomas Wright described "prodigious sands, which I have the unhappiness to be almost buried in" in the pages of the *Philosophical Transactions of the Royal Society.* The sand had originated about eight kilometers southwest of his house at Lakenheath, where some great dunes "broken by the impetuous South-west winds, blew on some of the adjacent grounds." They moved steadily across country, partially burying a farmhouse, before stopping at the edge of the village of Stanton Downham in about 1630. Ten or twelve years later, "it buried and destroyed various houses and overwhelmed the cornfields" in a mere two months, blocking the local river. Some 100,000 to 250,000 tons of sand overwhelmed the village, despite the use of fir trees and the laying of "hundreds of loads of muck and good earth."[7] Not until the 1920s was the area successfully reforested.

On January 24, 1684, the diarist John Evelyn wrote: "Frost . . . more & more severe, the Thames before London was planted with bothes [booths] in formal streets, as in a Citty. . . . It was a severe judgement on the Land: the trees not onely splitting as if lightning-strock, but Men & Catell perishing in divers places, and the very seas so locked up with yce, that no vessells could stirr out, or come in."[8] The cold was felt as far south as Spain. The following summer was blazing hot, only to be followed by another bitter winter with a frozen Thames, then more summer heat. The twenty years between 1680 and 1700 were remarkable for their cold, unsettled weather at the end of a century of generally cooler temperatures and higher rainfall.

Wine harvests were generally late between 1687 and 1703, when cold, wet springs and summers were commonplace. These were barren years, with cold summer temperatures that would not be equaled for the next century. The depressing weather continued as the Nine Years War engulfed the Spanish Netherlands and the Palatinate and Louis XIV's armies battled the League of Augsburg. The campaigning armies of both sides consumed grain stocks that might have fed the poor. As always, taxes were increased to pay for the war, so the peasants had little money to buy seed when they could not produce enough of their own in poor harvest years.

From 1687 to 1692, cold winters and cool summers led to a series of bad harvests. On April 24, 1692, a French chronicler complained of "very cold and unseasonable weather; scarce a leaf on the trees."[9] Alpine villagers lived on bread made from ground nutshells mixed with barley and oat flour. In France, cold summers delayed wine harvests sometimes, even into November. Widespread blight damaged many crops, bringing one of the worst famines in continental Europe since 1315 and turning France into what a horrified cleric, Archbishop Fénelon, called a "big, desolate hospital without provisions." Finland lost perhaps as much as a third of its population to famine and disease in 1696–97, partly because of bad harvests but also because of the government's lack of interest in relief measures.

Unpredictable climatic shifts continued into the new century. Harsh, dry winters and wet, stormy summers alternated with periods of moist, mild winters and warmer summers. The cost of these sudden shifts in human lives and suffering was often enormous.

The Culbin estate lies close to the north-facing shore of Moray Firth, near Findhorn in northeastern Scotland. During the seventeenth century, the Barony of Culbin was a prosperous farm complex lying on a low

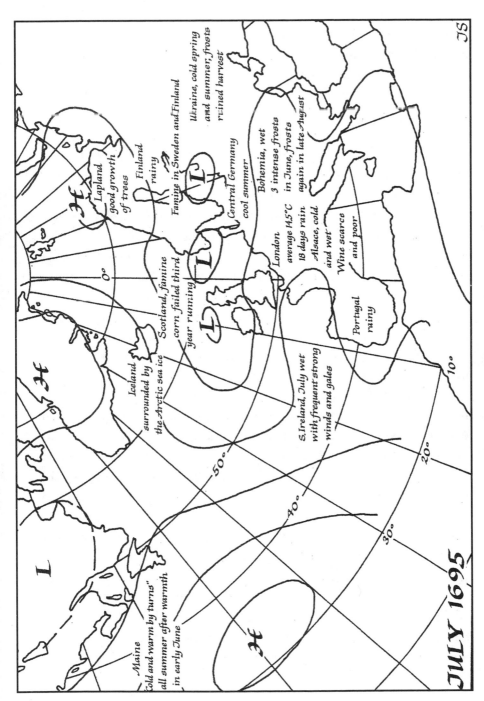

The map contains the following labels (rotated):

- **JULY 1695**
- Maine "cold and warm by turns" all summer after warmth in early June
- Iceland surrounded by the Arctic sea ice
- Lapland good growth of trees
- Finland rainy
- Famine in Sweden and Finland
- Ukraine, cold spring and summer, frosts ruined harvest
- Scotland, famine corn failed third year running
- Central Germany cool summer
- Bohemia, wet 3 intense frosts in June, frosts again in late August
- London average 14.5°C 18 days rain
- Alsace, cold and wet
- Wine scarce and poor
- S.Ireland, July wet with frequent strong winds and gales
- Portugal rainy
- Latitude/longitude lines: 0°, 10°, 20°, 30°, 40°, 50°
- JS

Prevailing climatic conditions over western Europe and the North Atlantic in July 1695.

peninsula between two bays and curving round to enclose the estuary of the Findhorn river. The farms were protected by coastal dunes built up by prevailing southwesterly winds but had long been plagued by windblown sand, which threatened growing crops. Wheat, bere (a form of barley), and oats grew easily in this sheltered location; salmon runs also brought prosperity.

In 1694, the Kinnaird family under the laird Alexander owned the Barony of Culbin and its valuable 1,400-hectare estate. The laird himself lived in an imposing mansion, with its own home farm, fifteen outliers, and numerous crofts. A cool summer that year had given way to a stormy fall. Cold temperatures had already descended on London, where north and northwesterly winds blew for ten days in late October accompanied by frost, snow, and sleet. Sea ice had already advanced rapidly in the far north, propelled by the same continual northerly winds. The bere harvest was late and the estate workers were hard at work in the fields when, around November 1 or 2, a savage north or northwesterly gale screamed in off the North Sea. For thirty hours or more, storm winds and huge waves tore at the coastal dunes at strengths estimated at 50 to 60 knots, maybe much higher.

The wind rushed between gaps in the dunes, blowing huge clouds of dust and sand that felt like hail. Loose sand cascaded onto the sheltered fields inland without warning. Reapers working in the fields abandoned their stooks. A man choking with blowing sand fled his plow. When they returned some hours later, both plow and stooks had vanished. "In terrible gusts the wind carried the sand among the dwelling-houses of the people, sparing neither the hut of the cottar nor the mansion of the laird."[10] Some villagers had to break out through the rear walls of their houses. They grabbed a few possessions and freed their cattle from the advancing dunes, then fled through the wind and rain to higher ground, only to find themselves trapped by rising waters of the now-blocked river. The resulting flood swept away the village of Findhorn as the river cut a new course to the sea. Fortunately, the inhabitants escaped in time. The next day, nothing could be seen of the houses and fields of the Culbin estate. Sixteen farms and their farmland, extending over twenty and thirty square kilometers, were buried under thirty meters of loose sand.

A rich estate had become a desert overnight. Laird Alexander was transformed from a man of property to a pauper in a few hours and was obliged to petition Parliament for exemption from land taxes and protection from his creditors. He died brokenhearted three years later. For three centuries, the area was a desert. Nineteenth-century visitors found themselves walking on "a great sea of sand, rising as it were, in tumultuous billows." Hills up to thirty meters high consisted "of sand so light that its surface is mottled into delicate wave lines by the wind."[11] Today there are few signs of the disaster. Thick stands of Corsican pines planted in the 1920s mantle the dunes, forming Britain's largest coastal forest.

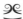

Severe storms continued into the first years of the eighteenth century, culminating in the great storm of November 26–27, 1703. After at least two weeks of unusually strong winds, a deep low pressure system with a center of 950 millibars passed about 200 kilometers north of London. The pressure in the capital fell rapidly by some 21–27 millibars. Daniel Defoe remarked in an account entitled *The Storm* that "It had been blowing exceeding hard . . . for about fourteen days past. The mercury sank lower than ever I had observ'd . . . which made me suppose the Tube had been handled . . . by the children."[12] Defoe was somewhat of an expert on storms. He had a bad experience during a tempest in 1695 when he barely escaped being decapitated by a falling chimney in a London street. There were numerous casualties on that occasion: "Mr Distiller in Duke Street with his wife, and maid-servant, were all buried in the Rubbish Stacks of their Chimney, which blocked all the doors."[13] Distiller perished, his wife and servant were dragged from the ruins.

The 1703 storm resulted from a low pressure system that had moved northeastward across the British Isles to a position off the coast of Norway by December 6. A much severer depression followed from the southwest and progressed across northeast Britain and the North Sea at about 40 knots. Defoe believed that this storm might have originated in a late season hurricane off Florida some four or five days earlier. He wrote: "We are told they felt upon that coast [Florida and Virginia] an unusual Tem-

136

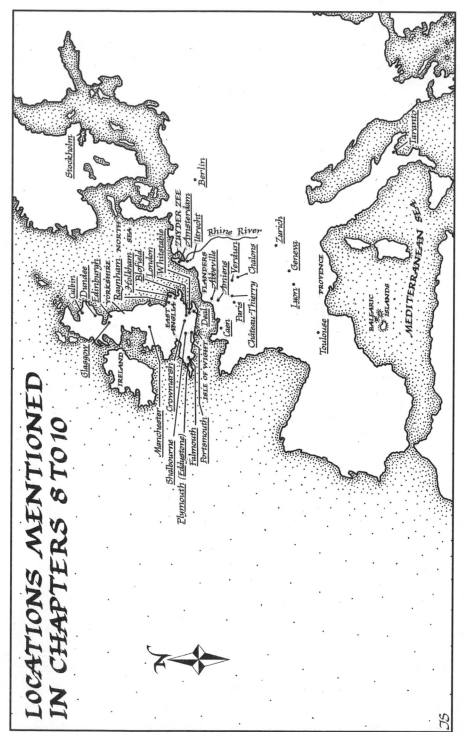

Locations mentioned in Chapters 8 to 10

pest a few days before the fatal [day]."[14] He was probably right. The gale brought exceptionally strong winds, at the surface in excess of 90 knots, with much more boisterous squalls that may have exceeded 140 knots.

The great storm traveled steadily across south England on the wings of an unusually strong jet stream. Vicious southwesterly winds blew off house roofs in Cornwall and toppled dwellings. Defoe tells how a small "tin ship" with a man and two boys aboard was blown out of the Helford estuary near Falmouth at about midnight on December 8 by winds estimated to be between 60 and 80 knots. She dashed before the wind under bare poles on a rush of surface water propelled by the gale. Eight hours later, the tiny boat, its crew safe and sound, was blown ashore between two rocks on the Isle of Wight, 240 kilometers to the east. The same night, enormous waves battered the ornate and newly built Eddystone Lighthouse off Plymouth Sound and toppled it, killing the keepers and their families as well as the designer, who happened to be visiting.

In the Netherlands, Utrecht cathedral was partly blown down. Sea salt encrusted windows in the city, not only those facing the wind, but in the lee as well. Thousands of people perished in sea surges. Dozens of ships foundered on Danish coasts, where the damage inland was "gruesome." Little rain fell despite dark clouds. Fortunately, the storm was followed by a dry spell. Wrote a Mr. Short: "a happy [circumstance] for those whose roofs had been stripped."[15]

The cold weather continued. The winter of 1708/9 was of exceptional severity throughout much of western Europe, except for Ireland and Scotland. Even there, severe weather caused major crop failures. Mortality rose sharply in Ireland, where the poor now depended on potatoes. Fortunately, the Irish Privy Council quickly placed an embargo on grain exports, saving thousands of lives. Further east, people walked from Denmark to Sweden on the ice as shipping was again halted in the southern North Sea. Deep snow fell in England and remained on the ground for weeks. Drought and hard frosts in France killed thousands of trees. Provence lost its orange trees, and all vineyards in northern France were abandoned because of the colder weather until the twentieth century. Seven years later, England again suffered through exceptional cold: 1716 brought a cold January, when the Thames froze so deep that a spring tide raised the ice fair on the river by four meters. So many people went to the

festival that theaters were almost deserted. Most summers in these decades were unexceptional, but that of 1725 was the coldest in the known temperature record. In London, it was "more like winter than summer."[16]

Then, suddenly, after 1730, came eight winters as mild as those of the twentieth century. Dutch coastal engineers found wood-boring teredo worms in their wooden palisades that were the first line of defense against sea surges. It took more than a century to replace them with stone facings. They also found themselves coping with silting problems in major harbors and rivers, as well as drinking-water pollution caused by poor drainage and industrial wastes.

The agricultural innovations of the seventeenth century had insulated the English from the worst effects of sudden climatic change, but not from some of the more subtle consequences of food shortages. In late 1739, the NAO swung abruptly to a low mode. Blocking anticyclones shifted the depression track away from its decades-long path. Southeasterly air flows replaced prevailing southwesterlies. The semipermanent high-pressure region near the North Pole expanded southward. Easterly air masses from the continental Arctic extended westward from Russia, bringing winter temperatures that hovered near or below zero. Europe shivered under strong easterly winds and bitter cold for weeks on end.

For the first time, relatively accurate temperature records tell us just how cold it was.[17] An extended period of below-normal temperatures began in August 1739 and continued unabated until September of the following year. January and February 1740 were 6.2° and 5.2°C colder than normal. Spring 1740 was dry with late frosts, the following summer cool and dry. A frosty and very wet autumn led into another early winter. In 1741 the spring was again cold and dry, followed by a prolonged summer drought. The winter of 1741/42 was nearly as cold as that of two years earlier. In 1742, milder conditions finally returned, probably with another NAO switch. The annual mean temperature of the early 1740s in central England was 6.8°C, the lowest for the entire period from 1659 to 1973.

In 1739, Britain's harvests were late due to unusually cold and wet conditions that caused considerable damage to cereal crops. In northern England, "much Corn, and the greatest part of Barley [was] lost."[18] English grain prices rose 23.6 percent above the thirty-one-year moving average in 1739, partly as a result of the deficient harvest, especially in the west where September storms damaged wheat crops. The cold weather caused exceptionally late grain and wine harvests over much of western Europe. Western Switzerland's cereal harvest did not begin until about October 14, the second latest from 1675 to 1879. Ice halted Baltic shipping by late October and rivers in Germany froze by November 1. All navigation on the River Thames ceased between late December and the end of February. Violent storms, wind, and drifting ice cast lighters and barges ashore. Ice joined Stockholm in Sweden with Abo across the Baltic in Finland. The rock-hard ground bent farmers' plows. Because they could not turn the soil for weeks, winter grain yields were well below normal in many places.

There was no refuge from the cold, even indoors. Early January 1740 brought savagely cold temperatures. The indoor temperatures in the well-built, and at least partially heated, houses of several affluent householders with thermometers fell as low as 3°C. Few of the poor could afford coal or firewood, so they shivered and sometimes froze to death, huddled together for warmth in their hovels and huts. Urban vagrants on the streets were worst off, for they had nowhere to go and the rudimentary parish-based welfare system passed them by. Wrote the *London Advertiser*: "Such Swarms of miserable Objects as now fill our Streets are shocking to behold; many of these having no legal Settlements, have no Relief from the Parish; but yet our fellow Creatures are not to be starved to Death; yet how are they drove about by inhuman Wretches from Parish to Parish, without any Support."[19] The *Caledonian Mercury* in Edinburgh wrote of: "the most bitter frost ever known (or perhaps recorded) in this part of the World, a piercing Nova Zembla Air, so that poor Tradesmen could not work . . . so that the Price of Meal, etc. is risen as well as that of Coals."[20]

Thomas Short summarized 1840 aptly: "Miserable was the State of the poor of the Nation from the last two severe Winters: Scarcity and Dearth of Provisions, Want of Trade and Money."[21] Thousands died, not so much from hunger but from the diseases associated with it, and from extreme cold.

By 1740, infectious diseases like bubonic plague were no longer a major cause of death in western Europe. The higher mortality of dearth years resulted primarily from nutritional deficiencies that weakened the immune system, or from social conditions that brought people into closer than normal contact, where they could be infected by various contagions. Everywhere in eighteenth-century Europe, living conditions in both rural and urban areas were highly unsanitary. Chronic overcrowding, desperate poverty, and ghastly living conditions were breeding grounds for infectious diseases at any time, even more so when people were weakened by hunger. In preindustrial England, for example, mortality rates increased more as a result of extreme heat and cold.[22]

Most of these deaths came not from chronic exposure, which can affect seamen and people working outside at any time, but from a condition known as accident hypothermia. When someone becomes deeply chilled, blood pressure rises, the pulse rate accelerates, and the patient shivers constantly, a reflex that generates heat through muscle contraction. Oxygen and energy consumption increase, and warm blood flows mainly in the deeper, more critical parts of the body. The heart works much harder. The shivering stops when body temperature falls below 35°C. As the temperature drops further, blood pressure sinks, the heart rate slows. Eventually the victim dies of cardiac arrest.

Most accidental hypothermia victims are either elderly or very young, caught in situations where they are unable to maintain their normal body temperature. Fatigue and inactivity, as well as malnutrition, can hasten the onset of the condition. Few houses in the Europe of 1740 had anything resembling good heating systems. Even today, hypothermia can kill the elderly in dwellings without central heating when indoor temperature falls below 8°C. As many as 20,000 people a year died in Britain from this condition in the 1960s and 1970s, almost all of them elderly, many malnourished. Conditions were unimaginably worse in 1740, even in the finest of houses, where warmth was confined to the immediate vicinity of hearths and fireplaces. The newspapers of 1740–41 carry many stories of death from the "Severity of the Cold."[23]

At the same time, the sharp temperature changes brought increases in pneumonia, bronchitis, heart attacks, and strokes. The elderly in particular have a reduced ability to sense changes in temperature, and thermal

stress can also lower resistance to infectious diseases. The London Bills of Mortality for the first five months of 1740 show a 53.1 percent rise in the number of registered deaths over the same period in the previous year. A breakdown of the mortality data shows climbs in all age groups, with the largest increase (over 97 percent) in the group over sixty years of age.

Many of the hungry were also killed by famine diarrhea, a condition resulting from prolonged malnutrition and pathological changes in the intestines that upset the water and salt balance in the body. The diarrhea often began after the victims ate indigestible food or the rotting flesh of dead animals. As starvation persisted and they continued to lose water through their bowels, the sufferers lost weight until they died in a state of extreme emaciation. Famine diarrhea was common in World War II concentration camps. Long periods of food dearth also produce many cases of what is sometimes called "bloody flux," owing to the passing of blood in the victim's watery stools.

Cycles of colder, wetter, or drier years with their bad harvests had a direct health effect. Any serious food shortage penetrated to the heart of rural and urban communities, throwing thousands onto the inadequate eighteenth-century equivalents of the welfare rolls. The hungry would often abandon their homes and villages and congregate in hospitals or poorhouses, where sanitary conditions were appalling. Crowded prisons were also hotbeds of infection, as were billets used by military units. Under these conditions, epidemics of louse-borne typhus infections, relapsing fever, and typhoid fever flared up, especially in colder climates, where malnourished people huddled together in crowded lodgings for warmth. When the destitute died or sold their possessions, their clothing, and even underwear, were passed on to others, together with the infections that lay within them.

Unemployment, hunger, and war nourished typhus in particular. A fierce epidemic raged in Plymouth in southwestern England in early 1740, reaching a peak during the summer months. By 1742, the disease had spread throughout the country. Devonshire in the west suffered worst. Physician John Huxham observed the epidemic at firsthand and wrote: "Putrid fevers of a long Continuence . . . were very rife among the lower Kind of People. . . . Some were attended with a pleurisy, but those destroyed the Patients much sooner." Another physician, John Barker, at-

tributed the epidemic to the bad weather and harvest shortfalls, exactly the same conditions, he remarked, as those during the outbreak of 1684/85.[24] Typhoid and typhus fever killed hundreds of the poor in County Cork, elsewhere in southern Ireland, and in Dublin.

Even in normal times, bacillary dysentery, easily spread by dirty fingers, poor water, or infected food, was endemic throughout eighteenth-century Europe. Hunger merely accentuated already high mortality rates among the poor. During food dearths, when standards of personal hygiene deteriorated even further as people deserted their homes, the number of cases exploded. During the long summer droughts of 1740–41, dust carried dysentery bacteria everywhere.

Thomas Burtt, an English gentleman traveling in Scotland in 1741, commented on the poor state of young children, "miserable objects indeed and are mostly overrun with that distemper [diarrhea] which some of the old men are hardly ever freed of from their infancy. I have seen them come out of their huts early in a cold morning, stark naked, and squat themselves down (if I might decently use the comparison) like dogs on a dunghill."[25] It did not help that contaminated house middens, sited close to dwellings, leaked bacteria back into the earth and contaminated the soil. The middens were a valuable source of field manure.

Under subsistence conditions, tens of thousands would have died from a general famine in 1740–41, as they did in 1315. This time the killers were cold, the social conditions of the day, and cold- and hunger-related diseases. The suffering was mitigated to some degree by a sharp break from the tyranny of subsistence agriculture.

Every time I visit the National Gallery in London, I pause for a moment in front of *Mr. and Mrs. Robert Andrews*, a 1751 portrait by Thomas Gainsborough. The young squire in a jaunty tricorn hat leans against a garden bench, flintlock musket in hand, dog at his heels. His wife sits placidly beside him, her light summer dress flaring over the seat. But my eyes are always drawn to the ordered countryside in the background: rolling Suffolk hills, neatly stacked corn stooks in a field that has been

carefully planted in neat rows, a wooden gate leading to a green meadow where fat sheep graze, cattle chewing the cud beside newly constructed barns. One gazes over an agricultural utopia oddly devoid of the harvesters, shepherds, carters, and dozens of other farm workers who created this fertile landscape. The Andrews portrait epitomizes the profound changes in English agriculture during the eighteenth century.[26]

The Andrewses were comfortable landed gentry, one of the 20,000 or so families who owned about three-quarters of England's agricultural land. There were still many smaller farms of less than 40 hectares, but their numbers dwindled throughout the eighteenth century. The logic of enclosure, of larger farms and fields, was too strong to be resisted. More and more open-field landscapes vanished as the English countryside began to assume something of its modern appearance. The medieval farmer had usually cultivated grain alone, leaving animal husbandry to communities living on natural pasture land. Enclosed farms in the hands of enlightened owners and, increasingly, landlords combined cereals and stock-raising and used fodder crops such as clover to keep their beasts fat during the winter. Books and newsletters like John Houghton's *Collection of Letters for the Improvement of Husbandry and Trade*, which appeared between 1691 and 1702, helped overcome old prejudices and spread new ideas. Powerful interests, including the scientific elite of London's Royal Society, backed efforts to increase food production and large-scale commercial agriculture.

Commercial farming first took hold in lighter soiled areas like East Anglia and parts of the west, where the open-field system had never flourished and farms were relatively close to urban centers like Bristol, London, or Norwich. Much of the impetus for change came from the demands of city markets and from a growing export trade across the North Sea. Corn and malting barley for brewers flowed to Holland from East Anglian ports, with clover and turnip seed traveling back in the same ships.

A nucleus of improving landlords spearheaded the revolution. Their experiments and extensive demonstrations, built on earlier advances, attracted widespread attention. Landowner Jethro Tull earned such a reputation for innovation that he was named "the greatest individual improver." Tull farmed at Howbery near Crowmarsh in Oxfordshire, and later at Prosperous Farm, by Shalbourne in Berkshire. Defying both his

laborers and conservative neighbors, he worked hard to improve his soil, especially after a visit to observe the methods used by wine growers in southern France. "The more the iron is given to the roots, the better for the crops," he wrote in *The New Horse Hoeing Husbandry*, published in 1731.[27] Tull advocated deep plowing, the better to turn and clean the soil, careful spacing of the seed in laid out rows, and the use of a horse-drawn hoe to weed between the rows of growing crops.

Viscount "Turnip" Townshend was a contemporary of Tull and a landowner at Raynham in Norfolk. Townshend first became a politician, found himself in violent disagreement with his brother-in-law, the powerful minister Sir Robert Walpole, and soon left politics for agriculture. He embraced the ancient Norfolk practice of marling, treating the soil with a mixture of clay and carbonate of lime. Townshend had a passion for turnips, which he grew in large fields, rotating them with wheat, barley, and clover in the famous Norfolk four-course rotation. He sold his wheat and barley for bread or brewing and fed turnips and clover hay to his animals. His methods made eminent good sense to his neighbors and were soon copied, especially because they provided ample winter feed for cattle, thereby eliminating the need to slaughter most of one's stock in the fall.

Many landowners, while of course ignorant of genetics, tried to improve their cattle and sheep breeds, using the hard-won experience of earlier generations. Robert Bakewell of Dishley Grange, Lincolnshire, was one such experimenter, but one with a taste for self-promotion, who kept careful records of the genealogies of his beasts and selected individual breeding animals with the characteristics he wanted to preserve. He bred sheep with thick fleeces, strong cart horses from Dutch stock, and long-horned cattle that produced excellent beef but little milk. Many farmers visited his herds and copied his methods.

For all the interest in innovation, change came slowly, especially in areas where the soils were heavier. Capital to pay the weighty expenses of enclosure was short, farmers were conservative people, and even large estates were isolated from nearby markets. Nor could methods used successfully in one place necessarily be copied even a few kilometers away, where soil conditions were different. Nevertheless, the new methods gradually spread, thanks in large part to Arthur Young, one of the greatest English farming writers of the day.[28] Not a farmer himself, Young trav-

eled widely and recorded his observations in a series of much-consulted books. While the French nobility had little concern with their landholdings except as a source of revenue, many of their British equivalents had a profound interest in farming. Young aimed his books at these gentlemen, arguing that additional food supplies required land enclosure to ensure the productive use of currently unused woodland, heath, and hill country as well as open fields and commons. He harshly criticized small farmers for their conservatism and ignorance, and for their neglect of land that could yield ample profits. Self-sufficient rural communities with their "lazy, thieving sort of people"—that is, subsistence farmers—were irrelevant in the new agricultural economy.

Inevitably, many small farmers were swallowed up in accelerating enclosure, this time not by mutual agreement but by private Acts of Parliament submitted by large landowners who had acquired the agreement of at least some of those living on the hectares to be enclosed.[29] Between 1700 and 1760, 137,000 hectares were enclosed by parliamentary action, most of it after 1730, with even more being enclosed later in the century. The commons, unenclosed and unimproved pastureland, shrank rapidly in the face of a world where the feudal lord of the manor had long vanished and landowners and tenant farmers hired laborers to work their land. By the time enclosure was restrained by legislation in 1865, only about 4 percent of Britain's land was in common ownership.

The social cost of enclosure was enormous. The commons had once supported tens of thousands of rural poor in small villages, where they kept swine and cattle, "starved, tod-bellied runts neither fit for the dairy nor the yoke."[30] Arthur Young quoted an example from Blofield, Norfolk, where 30 families of squatters maintained 23 cows, 18 horses, and sundry other animals on 16 hectares of a 280-hectare commons. Now that the commons had vanished, such people were forced to choose between living in extreme poverty in their home villages or migrating to the cities in search of manufacturing work. Thousands of descendants of subsistence farmers merely exchanged one form of precarious existence for another at the hands of wage-paying landlords and tenant farmers. Many landowners favored a high rate of unemployment because it ensured low agricultural wages. The rural poor became almost a separate form of human being: "the lower orders." When proposals came forward to allocate

at least minimal land to agricultural laborers, the idea was considered too generous to the poor. In many parts of Britain, farm laborers' wages were at or below starvation level, even when wages in kind and free housing were factored in, and when other members of the household worked at crafts or gathered firewood for money. Few landlords took steps to replace their tenants' unhealthy hovels, which were devoid "of every improvement for economizing labour, food, and manure."[31]

By 1780, in Britain, unlike Denmark, Sweden, Prussia, or postrevolutionary France, few agricultural workers owned any land. Ninety percent of it was farmed by tenants, the main employers of casual labor. Farm laborers lived in extraordinary squalor. The journalist and reformer William Cobbett wrote in his *Rural Rides* (1830): "I never saw human wretchedness equal to this; no, not even among the free negroes of America."[32] The living standard of the average English farm laborer in 1800 was worse than that of many modern-day Third World subsistence farmers. Filthy, clad in rags, barely surviving on a diet of bread, cheese, and water, the rural worker of eighteenth- and nineteenth-century Britain was a far cry from the attractive, apple-cheeked villager so beloved of artists and greeting card companies. Writes Robert Trow-Smith: "What laughter and neatness and health there was in the countryside at this time were a triumph of suffering mankind over its circumstances."[33] Employment was at best seasonal, at planting and harvest time, and even that was much reduced with the development of the threshing machine.

By the mid-eighteenth century, Britain was no longer a rigidly hierarchical society with rights based on birth, but one where property ownership was all important. Society was more fluid, with intermarriage between landed gentry and urban money commonplace and upward mobility unremarkable. Landowners ceased to be a closed caste. This contrasted sharply with France, where a noble who engaged in commercial enterprises could lose aristocratic privileges, except when the activity was deemed in the national interest. In Britain, legal definitions of rank below the peerage were vanishing fast, and divisions between country and town becoming blurred. Still over half the population consisted of "the poor"—small shopkeepers, artisans, mechanics, laborers, soldiers and seamen, vagrants and beggars—who had inadequate cushions against the ravages of poor harvests or old age. They had to rely on charity or theft to

stay alive and represented the most serious threat to law and order government faced.[34]

Intricate and still little understood feedback loops connected the diverse strands of the new agricultural economy, the deteriorating climate of the height of the Little Ice Age, and the economic and social conditions that preadapted Britain for the Industrial Revolution. Some connections are obvious, but there were also more subtle consequences. Back in 1664, a Somerset clergyman named Richard Eburne had advocated mass emigration of 16,000 people a year to the colonies as a solution to the growing number of surplus poor. A century later, Britain's population was far larger, land hunger was widespread and unemployment a growing problem. Increasing numbers of artisans and farm workers chose emigration as a way to a new life, a trickle that became a flood in the nineteenth century as the steamship and railroad provided mass transportation for the first time. Tens of thousands of farm workers emigrated to North America, to Australia, South Africa, and New Zealand during the nineteenth century, where hard work and land for the taking would make them farmers in their own right. The massive land clearance that resulted had a significant effect on the carbon dioxide levels of the atmosphere and was a major factor in the global warming that began in the late-nineteenth century.

9

DEARTH AND
REVOLUTION

Not only does the land produce less, but it is less cultivated. In many places it is not worth while to cultivate it. Large proprietors tired of advancing to their peasants sums that never return, neglect the land which would require expensive improvements. The portion cultivated grows less and the desert expands. . . . How can we be surprised that the crops should fail with such half-starved husbandmen, or that the land should suffer and refuse to yield? The yearly produce no longer suffices for the year. As we approach 1789, Nature yields less and less.

—Jules Michelot

In a telling commentary on pre-industrial French agriculture, historian Fernand Braudel once compared the harvest scene in the fifteenth-century *Heures de Notre-Dame* with Vincent Van Gogh's *Harvester*, painted in 1885. More than three centuries separate the two scenes, yet the harvesters use identical tools and hand gestures. Their techniques long predate even the fifteenth century. As Britain experienced its slow agricultural revolution, millions of King Louis XIV's subjects still lived in an agricultural world little changed from medieval times. Hippolyte Taine wrote of the French poor at the eve of the Revolution in 1789: "The people are like a man walking in a pond with water up to his mouth: the slightest dip in the ground, the slightest ripple, makes him

lose his footing—he sinks and chokes."[1] His remarks apply with equal force to the fifteenth through seventeenth centuries.

The remarkable transformation in English agriculture came during a century of changeable, often cool climate, interspersed with unexpected heat waves. As farms grew larger and more intensive cultivation spread over southern and central Britain, famine episodes gave way to periodic local food dearths, where more deaths came from infectious diseases due to malnutrition and poor sanitation than from hunger. Britain grew less vulnerable to cycles of climate-triggered crop failure, even during a century remarkable for its sudden climate swings. France, by contrast, where farming methods changed little, continued to suffer through repeated local famines during the century.

Wine harvests reflect the vagaries of seventeenth-century climate. These annual events were of all-consuming importance to those who lived from the grape or drank wines regularly. They provide at least general information on good and bad agricultural years over many generations.

The date of the wine harvest was always set by public proclamation, fixed by experts nominated by the community, and carefully calibrated with the ripeness of the harvest.[2] For instance, on September 25, 1674, the nine "judges of the ripeness of the grape" at Montpellier in the south of France proclaimed that "The grapes are ripe enough and in some places even withering." They set the harvest "for tomorrow." In 1718, the harvest date everywhere was earlier, around September 12. Every year was different, and heavily dependent on the summer temperatures that surrounded the vines between budding and the completion of fruiting. The warmer and sunnier the growth period, the swifter and earlier the grapes reached maturity. If the summer was cool and cloudy, the harvest was later, sometimes by several weeks. Of course, other factors also intervened, as they do today. For example, producers of cheap wines had little concern for quality and tended to harvest as

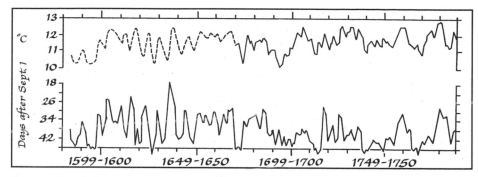

A generalized diagram of the time of wine harvests in southern Europe, 1599–1800, showing number of days after September 1 (bottom) and temperature curve (top). Data compiled from Emmanuel Le Roy Ladurie, *Times of Feast, Times of Famine: A History of Climate since the Year 1000,* translated by Barbara Bray (Garden City, N.Y.: Doubleday, 1971); and Christian Pfister, et al., "Documentary Evidence on Climate in Sixteenth-Century Central Europe," *Climatic Change* 43(1) (1999): 55–110

early as possible. Harvest dates can vary from variety to variety. High quality wines often benefited from deliberately late harvests, a risky but potentially profitable strategy widely practiced after the eighteenth century. Still, the main determinants were summer rainfall and temperature.

Generations of historians have mined meteorological records, ecclesiastical and municipal archives, and vineyard files to calculate the dates of wine harvests from modern times back to the sixteenth century. Le Roy Ladurie has calculated the dates of the wine harvest for the eastern half of France and Switzerland from 1480 to 1880. Christian Pfister and other Swiss and German historians are developing highly precise harvest records for areas to the east.[3] Though incomplete, especially before 1700, these records are sufficient to show a telling pattern, especially when you compare these dates with the cereal harvests in the same years. Late wine harvests, from cold, wet summers, often coincided with poor cereal crops. Bountiful vintages and good harvests indicate warm, dry summers. Writes Ladurie: "Bacchus is an ample provider of climatic information. We owe him a libation."[4]

The wine harvests tell us that the seventeenth century was somewhat cool until 1609. The years 1617 to 1650 were unusually changeable, with a predominance of colder summers and relatively poor harvests. Such

shifting climate patterns severely affected peoples' ability to feed themselves, especially if they were living from year to year, to the point that they were in danger of consuming their seed for the next planting in bad years. A cycle of poor harvests meant catastrophe and famine. France was coming under increasing climatic stress in the late seventeenth century. Unlike the Dutch and English, however, the French farmer was much slower to adapt.

France's rulers, like England's Tudors, were well aware of their country's chronic food shortages. Nor were they short of advice as to what to do. At least 250 works on agriculture appeared in France during the sixteenth century (compared with only forty-one in the Low Countries and twenty in Britain), most of them aimed at increasing and diversifying agricultural production. Some developed ways of classifying soils and methods of treating them. Others advocated new crops like turnips, rice, cotton and sugarcane. Praising the humble turnip, one Claude Bigottier was even moved to verse:

> As for me I will chant the virtues of my compatriots
> The glories of my country and of my beloved turnips.
> If this threefold subject appears ridiculous to the reader,
> Let him recall that often times great things are hidden behind
> The apparently insignificant.

But for all the literary activity, most of France remained at near-subsistence level.

There were pockets of innovation, especially in areas close to the Low Countries. Market gardeners on the Ile-de-France near Paris planted peas, beans, and other nitrogen-rich plants, which eventually eliminated the fallow. Elsewhere, specialized and highly profitable crops such as pastel and saffron were intensively cultivated. With the end of the religious wars in 1595, France entered a period of economic revival, no-

tably under King Henry IV, who did much to encourage agricultural experimentation and the widespread draining of wetlands to create new farmland. He was strongly influenced by the Calvinist Olivier de Serres's masterful *Le théâtre d'agriculture*, published in 1600, which described how a country estate should be run and suggested innovations such as selective cattle breeding, that would not be adopted for over 150 years.

Serres opposed the leasing of land to tenants, whom he considered unreliable and likely to diminish the land's value. He believed an owner should manage his own land and supervise the workers himself to ensure maximum profit. This would be good insurance against bad years and reduce the risk of famine and sedition. Serres also had much to say about labor relations. He believed in harmony on the farm. A landowner, the *pater familias*, should be industrious and diligent, provident and economical. He had an obligation to treat his workers and their families charitably and with respect, especially in times of famine or food shortages. He should have no illusions about wage laborers, who had to be kept at work constantly, as they were generally brutish and often hungry.

Although Serres's work was widely read during the seventeenth century, few people followed its recommendations. Most land was leased out to tenants and sharecroppers, who worked it with the help of their families and hired help. French agriculture was far from stagnant, but the indifference of many landowners and the social chasm between those of noble birth, the rich generally, and the poor made widespread reform a virtual impossibility. The chasm stemmed from historical circumstance and ancient feudal custom, from preconceived notions about labor, and from fear of the poor, who were thought to live "like beasts."

A huge stratum of subsistence farmers persisted into the eighteenth century, increasingly taxed and deprived of the use of common lands by an absent and uncaring nobility. Like their medieval predecessors, most of these farmers lived from harvest to harvest, at the mercy of the weather and a despotic government. The peasants' fear of starvation was regularly renewed. Subsistence crises were part of the political landscape, and bread riots were put down with brutal severity.

ᗒᗕ

Louis XIV, the Roi Soleil, the Sun King, reigned over Europe's most pow-
erful nation for seventy-two years, from 1643 to 1715, with a magnifi-
cence that became a near cult.[6] He was an absolute monarch, symbol of
his age, the epitome of the purest form of supreme kingship. "The State,
it is I," he is said to have once proclaimed, and he seems to have believed
it. Louis brooked no opposition, ruled without any form of central legis-
lature, and used his talent for publicity to foster an illusion of perfect au-
thority. His great palace at Versailles near Paris was the stage for dazzling
spectacles meant to convey an image of near supernatural power. Royal
balls, ballets, concerts, festivals, hunts and firework displays tied his no-
bles to his service and that of the state. "Self aggrandizement is the most
worthy and agreeable of sovereigns' occupations," the king wrote to the
Marquis de Villars in 1688.[7] Louis used it with great effect.

Louis XIV and his successors, Louis XV (reigned 1715–74) and XVI
(1774–93), were intelligent men, but not rulers of initiative or innovative
ideas. The byzantine intrigues of the king's closest associates militated
against major economic and political reform. More resolute leaders than
even the Sun King would have had trouble reforming a system that
thrived on intrigue and privilege, especially when those with the king's
ear had a vested interest in the status quo. In theory, the king's authority
passed down to *intendants*, provincial officials who reported to the central
government. The mechanisms of government were simple, but obfus-
cated by the inefficiency, vacillation, and lethargy of more than 50,000
venal and corrupt royal officials. Most of the nobility, the Second Estate,
had little interest in farming except as a source of revenue, much of it ac-
quired from ancient feudal rights, some of them as arcane as the right to
display weather vanes or to gather acorns in forests.

Even had the nobility been closely involved, French agriculture was in
trouble. Bread was a merciless tyrant that held producers, middlemen,
transporters and consumers in economic slavery. For the most part, the
French peasantry turned up their noses at potatoes and other new foods
and relied on cereal crops and vines for survival—the cereals to eat, their
grapes for some cash.

The king's ministers took a great interest in textiles and other manufactures, also in foreign trade, but they usually neglected agriculture. Their only concern was to prevent social disorder and stifle dissent with low bread prices, maintained, if necessary, by importing grain. At the same time, the king taxed his subjects heavily to support his vast expenditures and constant military campaigns. Between 1670 and 1700, Louis XIV waged almost continuous war on his neighbors, during years when the cooler, unpredictable weather caused frequent poor harvests and agricultural production declined.

The bitterly cold winters of the late seventeenth century found France ill prepared for food shortages. Agricultural production declined seriously after 1680, then tumbled disastrously during the cold and wet years between 1687 and 1701. Several severe subsistence crises ensued, as grain prices rose to the highest levels of the seventeenth century. An apocalyptic famine descended on much of northern Europe and France in 1693/94, the worst since 1661. England suffered little, because of higher agricultural productivity, crop diversity, well-organized grain import networks from the Baltic, and advances in farming technology and farming. Most French peasants were still firmly wedded to wheat, which is notably intolerant of heavy rainfall. Nor could Flemish methods and fodder crops be adopted in the warmer, drought-prone south. Having lived through a long period of relatively benign climate, cereal farmers were not equipped for cold, wet seasons when grape harvests came as late as November. With each bad harvest, grain shortages made themselves felt immediately. Many poor subsisted on bread made from ground nut shells mixed with barley and oat flour. Wrote an official in Limousin prophetically: "People will be hungry after Lent."[8] The rootless population of beggars and unemployed mushroomed. Provinces and parishes held on to grain stocks to fulfill constant army requisitions while entire communities went hungry. There were bread riots, but few peasants related their hunger to the actions of their rulers. This indifference was an authoritarian government's strongest weapon.

In the end, a tenth of Louis XIV's subjects perished from famine and its attendant epidemics in 1693/94. The glittering life at Versailles continued unaffected. No one, whether monarch, noble, or peasant, gave much thought to broadening the diet or of encouraging new farming methods in the face of real declines in productivity. Regular food short-

ages were as much a reality of life as the changes in seasons and the venality of petty officials.

Yet the kingdom was weakened by famine, malnutrition and disease, and undermined by constant war. Thousands of hectares of land had been abandoned, towns were depopulated, and trade suffered badly. The troubled times frightened many of the nobility, who were well aware of the "Glorious Revolution" of 1688 across the Channel, which had toppled the Stuart monarchs, brought William of Orange to the throne and a true form of democracy to England. For the first time, deference and conformity gave way to the first stirrings of dissent and independent political thought among nobles and intellectuals.

The death of Louis XIV in 1715 brought to an end an era when neither the king nor his advisers wasted any time listening to popular critics. No official body like the English Parliament served as a focus for public political debate. The Estates General had last met in 1614, at a gathering more remarkable for the quarrels between its members than any opposition to the king. During Louis XV's reign, loud opposing voices were heard from many quarters—the church, provincial courts, and writers of many political convictions. This was the Age of Enlightenment, when hallowed orthodoxies were challenged at every turn, when the king and his advisers became increasingly irresolute in the face of more vociferous opposition. Occasionally, a powerful minister would advocate new ideas such as agricultural reform or financial reorganization of government in response to the constant barrage of political agitation in books, broadsheets, pamphlets, and speeches. Invariably the reform foundered on the hesitation of the monarch and the petty rivalries of his courtiers. Government became increasingly vulnerable in the face of public opinion. Growing tensions within French society and the emergence of powerful rivals such as Britain, Prussia, and the Russian Empire began to undermine the supreme authority of the Bourbon monarchs—the *ancien régime*. And the entire superstructure of the state rested on highly insecure economic foundations, which, far more than in Britain, were at the mercy of sudden climatic shifts. But no one concerned with political change in France paid much attention to the peasantry, who fed them and bore the brunt of poor harvests.

For the earlier part of Louis XV's reign, climatic conditions were favorable. Between 1730 and 1739, the North Atlantic Oscillation was in a high mode, with a pronounced westerly circulation that brought mostly mild, damp winters and cooler, dry summers. Frontal system after frontal system crossed the North Atlantic, dumping ample rainfall on western Europe. The winters were the mildest for a generation, as much as 0.6°C above normal for England and as much as 1.3°C warmer in Holland. Memories of savage winters faded rapidly. From 1735 to 1739, seasonal temperatures in the Low Countries were higher than those for the entire period from 1740 to 1944.[9]

The sudden cold of 1739 to 1742 came as a shock. In early 1740, Paris suffered through seventy-five days of frost, causing "a great dearth of all provisions."[10] Peasants throughout France lived on the verge of starvation. Many died of accident hypothermia and hunger-related diseases. Northern France had such primitive housing conditions that thousands of children perished from cold. When the thaw came, "great floods did prodigious mischief," as rivers rose far beyond their banks and inundated thousands of hectares of arable land. The cool, dry spring of 1740 delayed planting as much as six weeks. Throughout much of Europe, excessive rainfall then damaged growing cereal crops and vineyards. As prices climbed and food became scarce, alarmed bureaucrats started referring in their correspondence to earlier, well-remembered famines.

From two and a half centuries' distance, the signs of environmental stress and population pressure in late eighteenth-century France are easy to discern. Under such circumstances, preindustrial states, especially those in some political and social disorder, are extremely vulnerable to partial or total collapse.

There are ample precedents from earlier history.[11] Ancient Egyptian civilization almost disintegrated in 2180 B.C., when El Niño–caused droughts reduced the Nile to a trickle and the central government was unable to feed starving villagers. Only the efforts of able provincial governors saved the day. Maya civilization in Central America offers another sobering analogy. By A.D. 800, the Maya city-states of the southern Yucatán were living on the edge of environmental disaster. An ambitious elite, living in a world of frenzied competition and warfare, was oblivious

to the impending environmental crisis in the surrounding countryside. Their escalating demands for food and labor from the common people came at a time of environmental stress, when the land was showing dangerous signs of exhaustion and growing population densities meant that the Maya had literally eaten up their environment. A series of catastrophic droughts in the following century helped bring disaster to a society already in political and social turmoil.

Eighteenth-century France was not on the verge of environmental collapse, but the links between land shortage, population growth, growing vulnerability to poor harvests, and sudden climatic shifts made for a volatile countryside that would have been unimaginable in earlier times.

Until 1788, the plight of the farmer figured little in the volatile political equations of eighteenth-century France. During the second half of the eighteenth century, between 75 and 80 percent of France's population were still peasants. Four million of them owned their land; the rest, some 20 million, lived on someone else's and paid rent. The larger scale farmers were mostly in the north and northeast, many of them renting hectarage from absentee landlords. A small number of landowning peasants survived on smaller properties, but most were settled on tiny rented plots, supplementing their incomes by outside work, and marginally self-sufficient in the best of years. The landless formed the lowest tier of the peasantry: several million people living off casual labor, on rare plots of common land, or as vagrants. By the late eighteenth century, increasing rural populations, and complex inheritance laws that led to ever tinier subdivisions, had created a chronic land shortage. There were pressures to enclose land, intensive competition for vacant properties, and an inevitable rise in the destitute vagrant population.[12]

Over the country as a whole, an averaged-sized family needed about 4.8 hectares to support itself at a basic subsistence level. Most did not have this. Depending on the region, 58 to 70 percent of the peasants, including day laborers, had access to two hectares or less. In some heavily populated regions, 75 percent of the peasants owned less than a hectare.

The British farming author Arthur Young, who traveled widely in France on the eve of the Revolution, summarized the situation in terse words: "Go to districts where the properties are minutely divided, and you will see great distress, even misery, and probably very bad agriculture. Go to others, where such subdivision has not taken place, and you will find a better cultivation and infinitely less misery."[13] Compared with England or the Low Countries, most French agriculture was astoundingly backward. Farm buildings were primitive and poorly arranged, intensive cultivation that was now routinely practiced in England or Holland was unknown in most areas. Few peasants had enough feed or forage for their livestock, so they slaughtered many head of cattle when drought struck, in the autumn, or when the hay harvest was poor. They left their fields fallow one year out of three, sometimes for two out of three. As much as a quarter of the low-yielding annual crop yield went for seed rather than food. Many farmers did not even have iron plows.

In the rich agricultural country near Payrac in southwestern France, Young wrote, "All the country, girls and women, are without shoes or stockings; and the ploughmen at their work have neither sabots nor feet to their stockings. This is a poverty that strikes at the root of national prosperity."[14] Much of France was on the subsistence edge.

With appalling poverty so widespread, even a minor increase in bread prices caused immediate agitation. The French diet was almost entirely cereal based, comprising either rye or oat bread and various gruels and broths. Only the affluent consumed wheaten loaves. Poorer French people consumed up to a kilogram of bread a day in the years before 1789, spending about 55 percent of their earnings on loaves alone. Better off folk like minor tradespeople and artisans might earn as much as thirty to forty sous a day, but when bread cost more than two sous a half kilogram, even their hunger margin was small indeed.

Rising population densities made the situation worse. Between 1770 and 1790 alone, France acquired an additional 2 million people. Wrote the villagers of La Caure in the Châlons region: "The number of our children plunges us into despair. We do not have the means to feed or clothe them; many of us have eight or nine children."[15] By the late 1780s, people were frantically searching for land. The poor had already taken over the commons, and were overrunning forests and marshlands. In an at-

mosphere of chronic deprivation, distrust ran rampant. Farmers no longer trusted millers and bakers, even their neighbors. Towns began to live in fear of violent attacks by their rural neighbors. Every wanderer in the countryside was seen as a brigand. Inevitably, a wave of complaints against wealthy landowners rose as the crisis intensified. Many demanded the sale and free distribution of the king's estates or the subdivision of the great estates into small holdings.

The land-hungry needed work to feed their families in a rural economy where employment opportunities were relatively limited, except for rural craftspeople and such folk as millers, tavern-keepers, or quarrymen. Most rural poor sought work on the great estates, but little was available, except at harvest time or when the grapes were gathered, and that at very low wages. During the quiet winter months, rural unemployment was virtually universal. The average worker was doomed to perpetual hunger and grinding poverty, even when cottage industries like weaving and spinning provided derisory wages. Pay was no better in the towns. Declared a town council in northern France: "It is certain that a man who earns only twenty sous a day cannot feed a large family; he who has only fifteen sous a day is poor indeed."[16]

For centuries, peasants had enjoyed the right to glean in harvested fields, to gather the standing stubble left by the sickles. They used the straw for repairing roofs and covering stable floors. They were also permitted under ancient law to graze their cattle on fallow land and on fields after the second harvest. These rights were progressively usurped by landowners and nobles during the second half of the eighteenth century. The peasants resisted desperately, for they knew they could not survive without these cherished rights. They already bore a heavy burden of taxation to the Church and State and also to their parishes, to say nothing of other services and payments such as the *corvée*, paid in labor or cash.

After 1770, climatic swings became more extreme, with many poor harvests interspersed with good ones. The weather fluctuations removed stability from the marketplace. Rents climbed and revenues fell, as produce markets swung between abundance and scarcity. In 1778 there was a complete failure of the vintage, but by the early 1780s there was a wine glut. In 1784 and 1785, a year after the Laki eruption in Iceland, which caused a cold summer in western Europe, hay was in such short supply

that thousands of cattle and sheep were slaughtered at knockdown prices.[17] Hail fell in Brittany at the end of April, and there were floods followed by a long drought.

Such conditions were disastrous to farmers still using the simplest farming technology. Harvesting methods were still so primitive that threshing was carried out laboriously with hand flails, meaning that grain only became available gradually through the winter. Lack of barn space meant that much harvest corn stood in the open in stooks, where it could easily rot. If the harvest was bad, granaries were empty long before the next ripening. There was never enough grain in reserve, especially when merchants emptied their storehouses to sell the crop elsewhere. Deeply conservative and suspicious of innovation, the peasants opposed any measures that increased hay crops or hectarage devoted to orchards. All that mattered was grain. The ravages of marauding armies and constant warfare merely compounded the situation. The soldiery raided the land and emptied granaries. Officials constantly demanded even more taxes to pay for the armies.[18]

Even in good times, beggars wandered the countryside—the unemployed, the disabled, and the sick. Official relief was almost nonexistent, except at the parish level, and that only for the locally resident poor. Begging became a trade. Even large families who had some land sent their children to beg for bread. Quite apart from the regular ebb and flow of migrant workers at harvest time, villagers and the urban unemployed were both constantly on the move trying to earn a living. These vagrants were a constant source of fear. During the bad harvest of 1788, beggars gathered in bands and took to knocking on farmhouse doors at night. They would wait until the men of a household had gone to the fields, then descend asking for charity. If they considered it too meager, they would help themselves. No one dared turn them away for fear of vandalism or reprisal—fruit trees cut down, cattle mutilated, crops burnt. The situation was worst at harvest time, when corn was cut at night before it was barely ripe and mobs of wanderers descended on the field to glean. Wrote an observer near Chartres: "The general temper of the population is so highly charged . . . it may well feel itself authorized to ease its poverty as soon as the harvest starts."[19] Rural crime rose as bands of brigands intimidated farmers and robbed them. Fear generated by hunger haunted the countryside long before the disastrous climatic shift of 1788.

ᖉC

The spring of 1788 was dry. Classic anticyclone conditions during the summer produced widespread crop failures due to drought and especially thunderstorms, always a hazard for French agriculture. A catastrophic hailstorm developed over the Paris region on July 13. According to British Ambassador Lord Dorset, some of the hailstones were forty centimeters in diameter. "About 9 o'clock in the morning the darkness at Paris was very great and the appearance of the heavens seemed to threaten a dreadfull Storm." The clouds dissipated, as thunderstorms, hail, and heavy rain descended on the surrounding countryside. The king himself, out hunting, was obliged to take shelter in a farmhouse. Huge trees were uprooted, crops and vineyards flattened, even some houses beaten to the ground. "It is confidently said that from four to five hundred Villages are reduced to such great distress the inhabitants must unavoidably perish without the immediate assistance of Government; the unfortunate Sufferers not only lose the crops of the present year but of three or four years to come."[20] In a later report, the ambassador estimated that 1,200 to 1,500 villages were damaged, many badly, over an area from Blois to Douay. "The noise which was heard in the air previous to the falling of the immense hail-stones is said to have been beyond all description dreadfull."[21] The wheat harvest may have been more than 20 percent lower than the average over the previous fifteen years.

Inevitably, food shortages developed, not only because of the immediate bad harvest but because the government had not foreseen a dearth.[22] In 1787, a good harvest year, the debt-laden government had responded by encouraging the export of large amounts of grain and removed all restrictions on the corn trade to encourage agriculture. When 1788 brought dearth instead of plenty, a need for imports rather than exports, the unprepared authorities imported far too little to alleviate the shortages. The shortfall was not entirely their fault. The external political situation was volatile, because Turkey had just declared war on an alliance of Austria and Russia. Sweden and other nations were poised to join in, creating unsafe conditions for shipping in the Baltic and a drop in grain imports at a critical moment.

Almost simultaneously, Spain forbade the import of French cloth, throwing hundreds of weavers out of work. Then women's fashions

changed. Fine lawn came into favor and silks went out of fashion, a catastrophe for the silk makers of Lyons. Grain prices rose rapidly in an economic environment already depressed by a long recession, which had reduced wine prices by a half. By July 1789, a loaf of bread cost four and a half sous in Paris and as much as six sous elsewhere. Inevitably, following the predictable pattern of crisis years, there were disturbances. Mobs forced bakers and shopkeepers to sell grain and bread at popularly established prices, destroyed feudal documents that bound peasants to the land, and burned their masters' chateaux.

The poor harvest could not have come at a worse moment. France had entered into an unfavorable trade treaty with England in 1776. The pact reduced import duties on English goods, the notion being to encourage French manufacturers to mechanize production in response to enhanced competition. A flood of cheap imports from across the Channel overwhelmed the cloth industry. Cloth production alone fell by 50 percent between 1787 and 1789. The 5,672 looms in Amiens and Abbeville in 1785 were down to 2,204 by 1789. Thirty-six thousand people were put out of work, throwing many poor workers onto city streets at a time when hungry peasants were flocking to urban centers in search of food. The rural crisis might have been short-lived had not urban unemployment mushroomed at the same time. In Paris, the government subsidized bread prices out of fear of the mobs, but to no avail. The situation was soon out of control.

Many political agendas seethed in France in 1788, but the poor, who had no interest in politics, had one primary concern—bread. And bread came from grain, whose abundance in turn depended on good harvests or generous imports. The weather of 1788 was not, of course, the primary cause of the French Revolution. But the shortage of grain and bread and the suffering resulting from dearth contributed in large measure to its timing. The weakness of the French social order, born of generations of chronic hunger, contributed to the outbreaks of violence before the historic events of the summer of 1789, when "the Great Fear of 1789" gripped much of France in mass hysteria and revolution and cast the peasantry into the political arena.

In the bitterly cold winter of 1788/89, heavy snowfall blocked roads, major rivers froze over, and much commerce came to a standstill. The spring thaw flooded thousands of hectares of farming lands. Bread riots broke out in March in Brittany, then in Flanders and elsewhere, with ri-

oters fixing prices in shops and marketplaces. In April the disturbances spread to Paris, where people were anxious about the lean months between the exhaustion of one year's crops and the harvesting of the next in late summer. Bread riots continued sporadically through the summer in towns large and small, where peasants attended weekly markets. Hungry day laborers were only too glad to join in riots over food prices. Rumors of widespread disorders spread like wild fire through the countryside. Desperate families stopped grain wagons and seized their cargoes, paying the appropriate price or simply helping themselves. Only the largest convoys had military escorts: there was insufficient manpower for comprehensive protection. Everyone distrusted and feared everyone else. The towns lived in constant fear of mobs of ransacking peasants. Farmers became apprehensive that a surge of townspeople would come and rob their granaries. Every beggar, vagrant, and rioter became a "brigand." Inevitably, too, rumors swept the countryside that the aristocrats were forging an alliance against all commoners.

With bread prices higher than they had been in almost twenty years, many people expected even larger hungry mobs to take to the streets. When the riots did come, they were triggered by a chance remark by a wallpaper manufacturer named Reveillon, who said in a public meeting that the government should lower grain prices so that wages could be limited to fifteen sous.[23] Rumors of impending wage reductions swept the restless capital. The disturbances were old fashioned bread riots, but they came as the Estates-General was about to meet. Political events soon overtook the disturbances, as the popular minister reformist Jacques Neckar, who had taken frantic measures to import grain to the capital, was dismissed by the king. On July 12, Neckar left office. Two days later came the storming of the Bastille.

The bread riots and harsh security efforts that tried to expel vagrants from Paris and other centers heightened the anxiety. Everyone believed the aristocrats would forge an alliance with brigands and wage war against the poor. In fact, the alleged alliance was a rumor propagated by revolutionaries who saw an aristocratic plot at every turn. Bands of peasants armed themselves throughout the country.

Hunger, hope, and fear drove the rural crisis of 1789. But what made the crisis different from earlier ones were political expectations arising

from an impending election of deputies, in which each peasant would have an individual vote and a chance to state a grievance in a *cahier*. Many were naive enough to believe that the writing of a *cahier* would produce an immediate addressing of the complaint—the reduction of tithes, an easing of taxation, and so on. When nothing happened, the peasants started refusing to pay taxes and feudal dues. After July 13, there were widespread disturbances in the countryside, directed especially at seignorial castles and manor houses. The insurgents searched for grain stores and especially for legal documents establishing feudal rights, which were promptly burned. In some cases, lords were forced to sign declarations that they would not reimpose them in the future. The disturbances were remarkably orderly except when lords or their agents offered violence. Then there was bloodshed and burnings. Some bands were led by men who even bore orders said (falsely) to have come from the king himself.

The trail of destruction and reports of widespread rural insurrection soon reached Paris, where the National Assembly turned its immediate attention to feudal privilege and to the needs of the peasants. On August 4, 1789, deputies of the more liberal aristocracy and clergy surrendered their feudal rights and fiscal immunities. In triumph, the Assembly claimed that "the feudal regime had been utterly destroyed," a misleading statement, for they merely surrendered some lasting remnants of serfdom, while other privileges were only redeemable by purchase. Four years later, the insistence and militancy of the peasants led to the cancellation of all debts.

A prolonged drought now added to the chaos. Rivers dried up and watermills came to a standstill, resulting in a flour shortage and another surge in food prices. By mid-September, the women of the markets were leading the agitation that led to the famous march to Versailles on October 5. Two columns of protesters marched in the rain to the palace to present their demands to Louis XVI. He promptly gave orders to reprovision the capital and sanctioned the National Assembly's August decrees and the all-important Declaration of Rights of Man and Citizen, which was to form a partial basis for the new Constitution. The royal family was forced to accompany the crowd back to Paris and the *ancien regime* collapsed.

The Great Fear was, in the final analysis, the culmination of a subsistence crisis that had brewed for generations, of a chronic food dearth triggered by draconian land policies and sudden climatic shifts that pushed

millions of French peasants across the fine line separating survival from deprivation. The panic was followed by a violent reaction, when the countryside turned against the aristocracy, unifying the peasants and making them realize the full extent of their political power. There would probably not have been a French Revolution if hate for outmoded feudal institutions had not unified peasant and bourgeois in its attempted destruction. The events of 1789 stemmed in considerable, and inconspicuous, part from the farmer's vulnerability to cycles of wet and cold, warmth and drought. As Sébastian Mercier wrote prophetically in 1770: "The grain which feeds man has also been his executioner."[24]

1 0

The Year Without
a Summer

This was succeeded, for nearly an hour, by a tremulous motion
of the earth, distinctly indicated by the tremor of large win-
dow frames; another comparatively violent explosion occurred
late in the afternoon, but the fall of dust was barely percepti-
ble. The atmosphere appeared to be loaded with a thick
vapour: the Sun was rarely visible, and only at short intervals
appearing very obscurely behind a semitransparent substance.
—*A British resident of Surakarta, eastern Java, on the Mount*
Tambora eruption, April 11, 1815

On April 11, 1815, the island of Sumbawa in eastern Java sweltered
under a languid tropical evening. Suddenly, a series of shocks, like can-
non fire, shattered the torpid sunset and frightened the inhabitants, still
jittery about gunfire. Napoleon's representative to the Dutch East Indies
had only recently been driven from the islands and the British were ad-
ministering the region. The garrison at Jogjakarta sent out a detachment
of troops to check on nearby military posts. As the sun set, the fusillade
seemed to grow louder. By chance, the British government vessel *Benares*
was in port at Makasser in the southern Celebes. She set sail with a force
of troops to search the islands to the south and flush out any pirates.
Finding none, the *Benares* returned to port after three days. Five days
later, on April 19, the explosions resumed, this time so intense that they
shook both houses and ships. The captain of the *Benares* again sailed

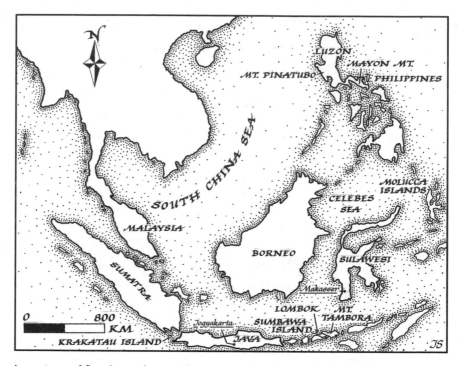

Locations of Southeast Asian volcanoes

southward to investigate, under a sky so dark with ash he could barely see the moon. Complete darkness mantled the region, cinders and ash rained down for days on villages and towns. Mount Tambora, at the northern tip of Sumbawa, had erupted with catastrophic violence.

After three months of violent convulsions, Mount Tambora was 1,300 meters lower. Its summit had vanished in a cloud of lava and fine ash that rose high into the atmosphere. Volcanic debris smothered the British resident's house sixty-five kilometers away and darkened the sky over a radius of five hundred kilometers. The British lieutenant governor of Java, Sir Thomas Stamford Raffles, wrote: "The area over which tremulous noises and other volcanic effects extended was one thousand English miles [1,600 kilometers] in circumference, including the whole of the Molucca Islands, Java, a considerable portion of Celebes, Sumatra, and Borneo. . . . Violent whirlwinds carried men, horses, cattle, and whatever came within their influence, into the air."[1] At least 12,000 people on Sumbawa died in the explosion, and another 44,000 from famine caused by falling ashes on the neighboring island of Lombok. Floating trees covered the

ocean for kilometers. Fierce lava flows surged downslope into the Pacific and covered thousands of hectares of cultivated land. Floating cinders clogged the Pacific to a depth of six meters over an area of several square kilometers.

Volcanologists have fixed the dates of more than 5,560 eruptions since the last Ice Age. Mount Tambora is among the most powerful of them all, greater even than the Santorini eruption of 1450 B.C., which may have given rise to the legend of Atlantis. The ash discharge was one hundred times that of Mount Saint Helens in Washington State in 1980 and exceeded Krakatau in 1883. Krakatau, the first major eruption to be studied at all systematically, is known to have reduced direct sunlight over much of the world by 15 to 20 percent. The much larger Tambora event, coming during a decade of remarkable volcanic activity, had even more drastic effects at a time when global temperatures were already lower than today.

At least three major volcanic eruptions occurred between 1812 and 1817: Soufriere on Saint Vincent in the Caribbean erupted in 1812, Mayon in the Philippines in 1814 and Tambora a year later. This extraordinary volcanic activity produced dense volcanic dust trails in the stratosphere. The Krakatau event provides scientists with a baseline index for measuring the extent of volcanic dust veils. If 1883 is given an index of 1,000, 1811 to 1818 is roughly 4,400. Another set of powerful eruptions between 1835 and 1841 produced an index of 4,200 and further colder weather.

Dense volcanic dust at high altitudes decreases the absorption of incoming solar radiation by reducing the transparency of the atmosphere, which leads to lower surface temperatures. The effects can be gauged by worldwide measurements taken after the Krakatau eruption of 1883, when the monthly average of solar radiation fell as much as 20–22 percent below the mean value for 1883–1938. While an increase in scattered light and heat (diffuse radiation) compensates for some of the depletion, a fluctuation of only 1 percent in the solar energy absorbed by the earth can alter surface temperatures by as much as 1°C. In a marginal farming area like northern Scandinavia, this difference can be critical.

A decrease in solar radiation leads to a weakening of zonal circulation in northern latitudes and pushes the prevailing westerly depression tracks southward toward the equator. The subpolar low moves southward. Cooler and duller spring weather arrives in northern temperate latitudes,

bringing more storms than usual. Sustained volcanic activity can have a powerful effect. The great eruptions of 1812 to 1815 helped move the subpolar low of midsummer down to 60.7° north, a full six degrees farther south than it was in the Julys between 1925 and 1934.

The years 1805 to 1820 were for many Europeans the coldest of the Little Ice Age. White Christmases were commonplace after 1812. The novelist Charles Dickens, born in that year, grew up during the coldest decade England has seen since the 1690s, and his short stories and *A Christmas Carol* seem to owe much to his impressionable years. Volcanoes were the partial culprit. The Tambora ash, lingering in the atmosphere over much of the world for up to two years, produced unusual weather. A two-day blizzard in Hungary during late January 1816 produced brown and flesh-colored snow. The inhabitants of Taranto, in southern Italy, were terrified by red and yellow snowflakes in a place where even normal snow was a rarity. Brown, bluish, and red snow fell in Maryland in April and May. Everywhere, the dust hung in a dry fog. Wrote an English vicar: "During the entire season the sun rose each morning as though in a cloud of smoke, red and rayless, shedding little light or warmth and setting at night behind a thick cloud of vapor, leaving hardly a trace of its having passed over the face of the earth."[2]

The year 1816 acquired immediate notoriety on both sides of the Atlantic as "the year without a summer." Heavy rain accompanied abnormally low temperatures in western and central Europe throughout the vital growing months. The monthly temperatures for that summer were between 2.3 and 4.6°C colder than the mean. Northern England experienced the coldest July in 192 years of record keeping. Hailstorms and violent thunder showers battered growing crops. On July 20, the London *Times* remarked that "should the present wet weather continue, the corn will inevitably be laid and the effects of such a calamity and at such a time cannot be otherwise than ruinous to the farmers, and even to the people at large."[3] In Kent, one of the warmer parts of England, a poor wheat

harvest ended on October 13, compared with the usual September 3. The crop was in "so damp a condition, as to be unfit for immediate use."[4]

Europe was still reeling from a generation of war and economic blockade. Widespread industrial unemployment from the scaling down of war-related manufacturing and the demobilization of thousands of men from armies and navies had already created hunger for many poorer families. The meager harvest soon drove cereal and bread prices beyond these families' reach. English wheat yields in 1816 were the lowest between 1815 and 1857, at a time when food and drink consumed two-thirds of a laboring family's budget. Fortunately, large grain reserves from the previous year kept English cereal prices reasonably low for a while.

In France, "you could not eat the bread, it stuck to the knife."[5] In the country as a whole, the crop yielded half the normal grain after a cold summer marked by widespread flooding and hailstorms. The wine harvest began on about October 29, the latest date in years. In Verdun, the grapes failed to ripen at all. More sophisticated transportation facilities than a generation earlier eased the threat of hunger in many areas. There was a food dearth rather than a famine. French prices rose sharply in rural areas, but politically mandated subsidies in Paris kept bread prices there low.

Conditions rapidly worsened in remoter and mountainous areas. Southern Germany suffered a complete harvest failure in 1816, such that by the following winter there was "a true famine . . . so far as this is still possible in the state of civilization in which we find ourselves." Carl von Clausewitz, who wrote those words, described poor villages and remote towns where "ruined figures, scarcely resembling men, prowling around the fields searching for food among the unharvested and already half rotten potatoes that never grew to maturity."[6]

The mean summer temperature in Geneva, where the English poet Lord Byron had taken up residence in the Villa Diodati after abandoning his wife in London, was the lowest since 1753. Byron's lakeside refuge was filled with houseguests, among them Percy Bysshe Shelley and his wife Mary. The cold weather kept the party indoors, so they entertained each other with stories. Mary's invention became the classic horror novel *Frankenstein*. The tourists were surrounded by famine. Grain and potato prices had tripled, and more than 30,000 Swiss were breadless and with-

out work. The poor ate sorrel, Iceland moss, and cats. The streets of
Zurich swarmed with so many begging adults and children that 1817 be-
came known as the "year of the beggars." "They are supported by private
and public charities, and distributions of economic soup."[7] In response,
government imported grain from as far away as Lombardy and Venice.
All too often, bandits intercepted the precious cargo in mountain passes
or on Lake Como. Offenders convicted of arson or robbery were be-
headed, robbers whipped. Three women were decapitated for infanticide,
and the number of suicides rose rapidly.

Inevitably, the widespread hunger brought a surge in religious devo-
tion, mysticism, and prophecies of the imminent demise of the world.
Baroness Julie de Krüdener of Baden, expelled from Baden in southern
Germany for her missionary zeal, distributed charity at every opportunity
through a fund supported by the sale of her jewels, income from her es-
tates, and donations from wealthy supporters. "The Lady of the Holy Al-
liance" caused a great uproar in Switzerland by proclaiming that "The
time is approaching when the Lord of Lords will reassume the reins. He
himself will feed his flock. He will dry the eyes of the poor. He will lead
his people, and nothing will remain of all the powers of darkness save de-
struction, shame, and contempt."[8] Baroness Krüdener's protests over the
treatment of beggars and her claimed miracles caused her to be banished
from several towns.

Social unrest, pillaging, rioting, and criminal violence erupted across
Europe in 1816, reaching a climax the following spring. For centuries,
the popular reaction to poor harvests and famine had been fervent prayer
and civil disturbances. The latter followed a well-established pattern—
demonstrations in front of bakers' shops and in market squares, accompa-
nied by arson, looting, and riots. Whenever a food dearth and high grain
prices loomed, the working poor took to the streets, as they did in re-
sponse to poor harvests in France and other countries throughout the
eighteenth century. But the grain riots of 1816/17 were marked by a level
of violence unknown since the French Revolution.

Trouble came first on the English side of the Channel, when, following
excess rainfall in East Anglia during May 1816, grain prices rose rapidly
and rural employment opportunities shrank. Marauding crowds of farm-
workers attacked the houses of those who offended them, burned barns

and grain stocks, and marched around armed with iron-studded sticks and flags bearing the words "Bread or Blood." They demanded a reduction in bread prices until the militia confronted them and read the Riot Act, which threatened the death penalty. The summer was quiet until the poor harvest and renewed price rises brought more trouble. A crowd of 2,000 in Dundee, Scotland, plundered more than a hundred food shops, then looted and burned a grain merchant's house. Once again, the militia had to be called in to restore order.

The British disturbances had far more than merely the food dearth as an agenda. Stagnation in trade and manufacturing, widespread unemployment, and the social stresses of rapid industrialization and emerging class consciousness were major forces behind the rioting and behind the accompanying Luddite movement. In March 1817, for example, a meeting of 10,000 Manchester weavers resolved to send a hunger march of 600 to 700 protestors, each with a blanket on their backs, to petition the Prince Regent for measures to relieve the depressed cotton trade. The pathetic march, though apparently apolitical, was soon dispersed. Only one "blanketeer" eventually reached London.

The food shortages were even more severe in Ireland, a country now heavily dependent on the potato. Hundreds of smallholding families in County Tyrone abandoned their homes in spring 1817 and lived by begging. They searched for nettles, wild mustard, and cabbage stalks. Food was so scarce that "seed potatoes were taken up from the ground and used for the support of life; nettles and other esculent vegetables *eagerly* sought after to satisfy the cravings of hunger. . . . The whole country was in motion."[9] At least 65,000 people perished despite urgent relief efforts.

Bread riots afflicted France by late 1816. In November, an enraged Toulouse crowd, incensed by price increases, prevented shipments of wheat from leaving the town and imposed a "fair" price of 24 francs a hectoliter. Although there were no grain shortages in the region, the people were afraid of what would happen if all stocks were exported elsewhere. A company of dragoons eventually dispersed the rioters. Policemen and soldiers protecting grain wagons on their way to market in the Loire Valley found themselves fighting with hungry villagers. By midwinter 1817, many magistrates had given up searching for thieves. Serious disturbances broke out around Paris, where grain imports and subsidies

kept prices down, while those outside the city worried about food depri-
vation. Thousands of immigrants from the countryside poured into the
city in search of cheaper food. An 1817 census classified no less than 11.5
percent of Parisians as "destitute" out of a total population of 713,966.
Large vagrant bands wandered the countryside, seizing control of the
town of Château-Thierry, emptying the food storehouses, and intercept-
ing grain barges along the Marne river. When the military took control of
the town, the rebellion spread to the countryside amidst rumors of an im-
pending Napoleonic coup.

The subsistence crisis triggered massive emigration throughout Europe.
A quarter-century of war had pent up a generation of potential émigrés.
Tens of thousands of people journeyed down the Rhine from the German
states into Holland, hoping to cross to America. Conditions in Amster-
dam were so deplorable that many would-be immigrants tried to return
home. Hundreds begged for ship berths. Even those with money for the
fare could not find space. The authorities tried returning the destitute to
their homelands and stopping them at the frontier, with little success.

Even the emigrants' home countries worried about the exodus.
Switzerland, already famous for its watches and textiles, and fearful of los-
ing vital industrial secrets, had frowned on emigration in 1815. But in-
creasing pauperization and high food prices caused thousands to leave.
Tens of thousands of Englishmen, mainly from Yorkshire, migrated to the
United States between 1815 and 1819 for the same reason, as did 20,000
Irish in 1818. How many of these people were specifically fleeing hunger
rather than general deprivation is unclear, but it is certain that more than
20,000 Rhinelanders emigrated to North America between 1815 and
1830 to escape a miserable life of subsistence farming on highly frag-
mented land holdings where the margin of risk was simply too high and
wage earning opportunities were too rare.

During the summer of 1816, Professor Jeremiah Day, President of Yale
College in New Haven, Connecticut, was responsible for maintaining
temperature records at the university, a continuous weather chronicle that

dated back to 1779. The task involved rising at 4:30 each morning to read the instruments, even in the dead of winter. Day's readings for June 1816 are astoundingly low, averaging 18.4°C, about 2.5°C lower than the mean for 1780 to 1968. New Haven was no warmer that month than Quebec City in Canada. It was the coldest June ever known.

Spring had been dry and late that year, with frosts in mid-May. Nevertheless, crops were planted and beginning to grow when three unseasonable cold waves swept down rapidly from Canada and spread over New England. For five days between June 5 and 10, bitterly cold winds blasted the region. Eight to fifteen centimeters of snow fell in northern New England before the weather moderated. Vermont was pounded with heavy rain, which turned to snow on June 9. The snowfall blanketed the hills and stranded dozens of sheep. Farmer Hiram Harwood of Bennington, Vermont, wrote in his journal of fields stiff with frost, of weather so cold that he wore mittens in the fields until midday. By June 10, his corn was "badly killed and was difficult to see."[10] Hundreds of freshly shorn sheep perished in the cold. In Concord, New Hampshire, guests at the Inauguration Address of Governor William Plumer battled strong winds and snow flurries on their way to the meeting. Once seated, wrote guest Sarah Anna Emery: "our teeth chattered in our heads, and our feet and hands were benumbed."[11] A friend's "troublesome tooth" ached unbearably in the cold.

New York and southern New England fared little better. The Catskill Mountains were dusted with snow. Thousands of migratory birds fled their frozen country forests and flocked to New York City, where they dropped dead in the streets. In South Windsor, Connecticut, the Reverend Thomas Robbins, who farmed part time, preached to his congregation on the parable of the fruitless fig tree (Luke 13:6–9). A vineyard owner came to pluck fruit from the fig tree on his property, found none, and ordered his laborer to cut it down. The worker urged him to leave it alone and to cut it down the next year if it did not bear fruit. In other words, be patient, for this affliction will pass.

The cold wave passed and farmers throughout New England planted anew. Just under a month later, a second, but less severe, cold spell brought heavy frost to Maine. Many lakes in southern Canada were still iced over. Widespread crop damage prompted fears of insufficient hay for

the coming winter. Newspapers urged farmers to replant yet again and discussed possible substitutes, like potato tops, as winter fodder. The remainder of July and early August were warm and summerlike, except for a prolonged drought. The indefatigable Thomas Robbins thanked Providence for the wonderful change, but worried about rain. On August 20, he conducted a "solemn and interesting season of prayer" for rain. A shower fell the next day, coinciding with a sharp, unseasonal frost, which effectively ended any chance of a decent corn crop. Had the frost come two weeks later, the harvest would have been excellent. Despite the unusual weather, many farmers fared reasonably well. The Vermonter Hiram Harwood mowed his hay in early August, had his winter wheat in by August 23 and his oats a few days later, "as fine a crop of oats as is rarely seen."[12]

In New Haven, the last spring frost came on June 11, twenty days later than any other year of the decade. The earliest fall freeze came thirty-five days early, on August 22. Ignoring the freak July frost, 1816's growing season was fifty-five days shorter than the usual 155, in large part because of the Tambora eruption on the other side of the world.

While many farmers salvaged fruit and vegetable crops, the real casualty of the summer was maize, the staple of nineteenth-century New England. No more than a quarter of the 1816 corn harvest was fit for human consumption. The rest was unripe and moldy, barely good enough for cattle or pigs. Money was always scarce in small rural communities, and the poor harvest compounded the cash shortage as winter descended. Many parishes in Quebec ran out of bread and milk. According to the *Halifax Weekly Chronicle*, poor farmers in Nova Scotia supported "a miserable existence by boiling wild herbs of different sorts which they eat with their milk; happy those who have even got milk and have not yet sacrificed this resource to previous pressing wants."[13] In Saint John's, Newfoundland, nine hundred potential immigrants were sent back to Europe because there was little food in the town. The governor of New Brunswick forbade grain export or distillation of cereals into spirits of any kind.

Prices for food of all kinds skyrocketed. Seed corn from sheltered farms in northern New England commanded up to four dollars a bushel—and farmers were glad to obtain it at that outrageous price. Maine potatoes rose from forty cents a bushel in spring 1816 to seventy-five cents the fol-

lowing year. Thomas Jefferson's finances were stretched so thin by the poor corn harvest at Monticello, in Virginia, that he was forced to borrow $1,000 from his agent, an enormous sum at the time. Even further south, crop yields in North and South Carolina were a third of normal in places.

The effects of the cold of 1816 rippled on for years. While the federal government did little to ameliorate the crisis, the New York legislature recognized the need for improved transportation systems for moving food to and from rural areas, at the time accessible only by the crudest of cart tracks. The Erie Canal, which linked the Hudson River with Lake Erie, was begun in April 1817. On October 25, 1825, the entire 523 kilometer-long canal was opened with great public fanfare. Canal boats were a slow and cumbersome way of transporting goods or food, so the waterway was soon superseded by railroads.

The subsistence crisis of 1816/17, triggered by catastrophic harvest failures in 1816, was the last truly extensive food dearth in the Western world. Its effects ranged from the Ottoman Empire, to parts of North Africa, large areas of Switzerland and Italy, western Europe, and even New England and eastern Canada. The crisis was due not only to failed harvests but also to soaring food prices at a time of continued political and social unrest after the Napoleonic wars.

In the west, more deaths resulted from social conditions than from actual hunger caused by a cycle of very cold years. In Switzerland, the death rate in 1816 was 8 percent higher than in 1815; a year later it was 56 percent higher. In England and France, the rises were more moderate, because some effective steps were taken to curb rising food prices. As in 1740, most deaths resulted from infectious diseases fostered by malnutrition. Historian Alexander Stollenwerk quotes from a contemporary journal: "Many individuals have died, if not of hunger, at least of the insufficiency and bad quality of the food. . . . Such vegetables as grow wild in the fields might afford great relief; but the idea of eating grass like animals appears dreadful to these people."[14] The large numbers of beggars in Italy, Switzerland, and Ireland contributed to a high mortality in those coun-

tries, largely from typhus and the diseases of famine and hunger. "It is horrible to see emaciated skeletons with voracious appetites gulping down the most loathsome and unnatural foods—carcasses of dead animals, cattle fodder, leaves of nettles, swine food."[15]

The harvest failure of 1816 brought on typhus and relapsing fever epidemics in Britain. Glasgow witnessed 3,500 deaths from these infections in 1818, and some 32,000 cases in a population of 130,000. An outbreak of typhus in autumn 1816 among Spitalfields silk workers in London spread rapidly to the poor districts of the city. Poorhouses were overflowing with "half starved beings, many of them deriving their sole claim to relief from having slept in the streets of the parish, and who were already seized with fever." Thomas Bateman, the medical superintendent of the London House of Recovery, theorized that the epidemic was a barometer of economic conditions, that "deficiency of nutriment is the principal source of epidemic fever."[16]

When the cold spring, summer, and fall weather and constant rain saturated peat and firewood, making hearths hard to keep alight, the Irish poor crowded together for warmth in filthy hovels and at soup kitchens, passing typhus-bearing body lice feces among them. The desiccated and infected fecal dust clung to woolen fabrics such as cloaks and blankets, which were often the only source of warmth for people. In 1817/18, 850,000 people in Ireland were infected by the epidemic.

Bubonic plague, a frequent companion of earlier famines, appeared here too. A severe plague outbreak had begun during a famine in central and northwestern India in 1812. By 1813, the plague was widespread in southeastern Europe, killing over 25,000 people in Bucharest. Strict quarantine regulations were imposed in Adriatic and Mediterranean ports, but outbreaks continued until 1822, with the Balearic Islands in the western Mediterranean losing 12,000 people in 1820. The plague never affected western Europe, despite the poor harvests and widespread hunger, partly because of strict quarantine measures at eastern frontiers and Mediterranean ports, but also because of critical improvements in domestic hygiene such as the widespread use of masonry, brick, and tile instead of wood, earth, and straw in towns and cities.

A well-founded fear of fire had prompted the change. After the great fire of London, 9,000 brick houses replaced 13,200 wooden dwellings

destroyed by the conflagration. Other cities like Amsterdam, Paris, and Vienna slowly followed suit. The changeover also helped improve hygienic conditions by providing less favorable living conditions for fleas and rats. Straw floor coverings disappeared, while private grain storage bins gave way to better-built and -maintained public facilities, again providing a less favorable environment for insects and rodents. It was no coincidence that plague epidemics continued to ravage eastern Europe and much of southwestern Asia, where most people continued to live in earthen and timber dwellings. Clean, rat-free buildings were a key to plague-free environments in cities. Today, bubonic plague is predominantly a disease of rural populations in areas like South America, where housing conditions are often still appalling.

The cold years of 1812 to 1820 coincided with a cycle of poor grain and potato harvests, food scarcities, and rapidly rising commodity prices in societies that were already unsettled by changing economic conditions at the end of the Napoleonic wars. Western commodity markets spun in confusion as agricultural productivity fell rapidly. Real incomes declined. Prices fluctuated wildly as a result of the cold weather, poor harvests, and impulsive economic decisions about which crops to plant sometimes made on the spur of the moment. Consumer demand shifted away from industrial goods as people struggled to pay for food. Unemployment levels rose sharply, throwing the working poor onto the streets as purchasing power shrank.

As the cost of living climbed beyond most working people's reach, thousands became dependent on public or private charity or were reduced to begging. Some became vagrants, others tried to emigrate to Eastern Europe or North America. Thousands more took to the streets and turned to rioting and crime. Marriages and births declined. All this happened at a time when Jacobin France was a more recent memory than the Vietnam War is today. Governments were acutely aware of the danger of revolution, of massive peasant rebellions. The threat of social disorder and epidemic disease forced governments to take measures to provide

public relief. The same threats frightened several European govern-ments—like that of France—into conservative, even repressive, policies. In the long term, there emerged a new commitment to rudimentary poli-cies of social welfare that tried to offer basic security to the distressed in times of economic crisis. These policies were the greatest legacy of the Tambora eruption.

I I

AN GHORTA MÓR

Ireland is famed for its crops of potatoes. . . . The culture of
this plant has been longer practiced there than with . . . any
other European nation. . . . The Irish have always, very judi-
ciously, looked upon this article as an object of the greatest im-
portance.

> —*Austin Bourke,* 'The Visitation of God'?
> The Potato and the Great Irish Famine, *1993*

The [sedan] chairmen, porters, coalheavers in London, and
those unfortunate women who live by prostitution, the
strongest men and the most beautiful women perhaps in the
British dominions, are said to be . . . from the lowest rank of
people in Ireland, who are generally fed from this root. No
food can afford a more decisive proof of its nourishing quality,
or its being particularly suitable to the health of the human
constitution.

> —*Adam Smith,* The Wealth of Nations, *1776,*
> *on the Irish and potatoes*

Thanks to the Gulf Stream, Ireland enjoys a damp, moderate climate
with generally mild winters and springs. For centuries, the Irish subsisted
off butter, curds and whey in summer and off the fall oat crop in winter.
Raising cereals had never been easy, even when combined with cattle
farming. Excessive rainfall in spring and summer regularly damaged

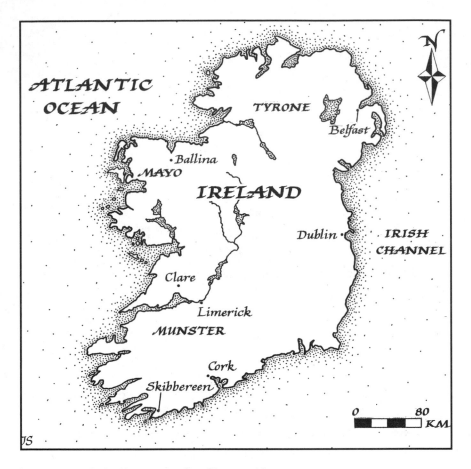

Locations in Ireland mentioned in Chapter 11

growing crops. Famines were commonplace and invariably followed by plague and pestilence, which often killed more people than hunger. Both high and low NAO indices could spell trouble for Irish farmers. A low index brought unseasonably cold winters and frosts; high indices the constant threat of heavy rain during the growing season. Here the link between excessive rainfall, poor oat crops, and winter hunger was brutally direct.

No one knows exactly when the potato came to Ireland, but it appears to have been during the last fifteen years of the sixteenth century.[1] Irish farmers soon noticed that the strange tuber thrived in their wet and often sunless climate. Potatoes produced their greatest yields in years when oats were decimated by the rain from repeated Atlantic depressions. Planted in

well-drained, raised fields, potatoes were highly productive and reliable, even on poor soils. Ireland's long growing season without temperature extremes was ideal for the early European potato, which sprouted growth and flowers during long summer days and tubers in frost-free autumns, conditions very similar to those in many parts of the Andes. Unlike cereals, the tubers were remarkably immune to sudden climatic shifts. This was true almost anywhere in northern Europe, but in Ireland the wet climate especially favored the potato. While other crops rotted above ground, potatoes quietly grew below the surface. Easy to cook and store, they seemed an ideal food for the Irish poor. Above all, they were an effective famine food. The potato-cereal combination offered a safeguard against the failure of either crop. As long as a balance was maintained between the two, the Irish had a reasonably reliable safety net against hunger.

At first the potato was merely a supplement to the Irish diet, except throughout Munster in the south, where the poorest country people embraced it as a staple very early on. Wrote an observer in 1684: "Ye great support of ye poore sortes of people is thire potatoes." They were a winter food, consumed between "the first of August in the autumn until the feast of Patrick in the spring."[2] The harvest was so casual that many farmers simply left the tubers in the ground and dug them out when required. They learned the hard way that a hard frost would destroy the crop in short order.

Potato cultivation increased twentyfold over the next half century, despite a terrible famine in the exceptional cold of 1740 and 1741, when both the grain and potato crops failed; 1740–1 became known as *Blaidhain an air,* "the year of the slaughter." An unusually long spell of cold weather destroyed both grain and potato crops and killed livestock, even seabirds. By this time, the poor of the south and west were depending almost entirely on potatoes and were especially vulnerable to crop failure. The government intervened aggressively, prohibiting grain exports and deploying the army to provide famine relief. There was little excess food in Europe, partly because of poor harvest and also because of the War of Austrian Succession. Instead, "large supplies of provisions arrived from America."[3] Both local landlords and gentry, and members of the Anglican church organized large scale charity relief in the form of free food, subsidized grain, and free meals. This generosity was sparked more by fear of

social disorder and epidemic disease than by altruism. Despite the assistance, large numbers of the poor took to the roads to beg for relief or to move to the towns in search of food, employment, or a departing ship. Between 300,000 and 400,000 people perished of dysentery, hunger, and typhus in a famine that foreshadowed the great tragedy of the 1840s. In the end, at least 10 percent of Ireland's population perished of starvation and related medical ills. The famine demonstrated that neither potatoes nor oats were a complete panacea to Ireland's farming problems, partly because stored potatoes only kept about eight months in the damp climate.

As memories of the famine faded, the explosion in potato farming continued. The late eighteenth century was the golden age of the Irish potato, "universally palatable from the palace to the pig-sty."[4] Potatoes formed a substantial part of the diet of the wealthy and the entire diet of the poor. The excellent Irish strains developed during these years were admired and planted throughout northern Europe not only for human use but as animal fodder. By the 1790s, farmers were throwing out large numbers of surplus potatoes each year, even after feeding their cattle and pigs. "They left them stacked in heaps at the back of ditches, piled them in the gaps of fences, used them as top dressing, buried them, or stacked them in fields and burned them."[5]

Visitor after visitor remarked on the healthy looks of Irish countryfolk, and their cheerful demeanor, and their constant dancing, singing, and storytelling. By the end of the eighteenth century, physicians were recommending potatoes "as a supper to those ladies whom providence had not blessed with children, and an heir has often been the consequence."[6] John Henry wrote in 1771 that where "the potato is most generally used as food, the admirable complexions of the wenches are so remarkably delicate as to excite in their superiors very friendly and flattering sensations."[7] In 1780, traveler Philip Lucksome observed that the poorer Irish lived on potatoes and milk year round "without tasting either bread or meat, except perhaps at Christmas once or twice."[8]

Everyone grew potatoes in rectangular plots separated from their neighbors' by narrow trenches. Each tract was about two to three meters wide, fertilized with animal dung, powdered shell, or with seaweed in coastal areas. Using spades called *loys,* ten men could turn over and sow 0.5 hectare

with potatoes in a day. To sow a cereal crop of the same area in the same time would take forty. The Irish "raised fields," sometimes called "lazy beds," could produce as many as seventeen tons of potatoes a hectare, an astounding yield when compared with oats. The potato had obvious advantages for land-poor farmers living in complete poverty. With the vitamins from their tubers and milk or butter from a few head of cattle, even the poorest Irish family had an adequate, if spartan, diet in good harvest years.

Oblivious of the potential dangers from weather and other hazards, Ireland moved dangerously close to monoculture. Grain was no longer part of the diet in the south and west of the country and had become predominantly a cash crop in the north. The beauty of the potato was that it fed the laborers who produced oats and wheat for export to bread-hungry England. The illusion of infallible supply caused a growing demand for Irish potatoes in northeast England to feed the growing populations of rapidly industrializing Liverpool and Manchester.

In 1811, at the height of the Napoleonic Wars, a writer in the *Munster Farmers' Magazine* called potatoes "the luxury of the rich and the food of the poor; the chief cause of our population and our greatest security against famine."[9] But for all their advantages, potatoes were not a miracle crop. Unusually wet or dry summers and occasional exceptionally cold winters subjected the country to regular famine. The combination of rain and frost sometimes killed both cereals and potatoes. Even in plentiful years, thousands of the poor were chronically unemployed and dependent on aggressive government intervention for relief. Many Irish workers, including many skilled linen workers, emigrated to distant lands to escape hunger. In 1770 alone, 30,000 emigrants left four Ulster ports for North America. They departed in the face of rapid population growth, archaic land tenure rules that subdivided small farming plots again and again— and the ever-present specter of famine.

The periodic food shortages that plagued Ireland between 1753 and 1801 were mostly of local impact, with relatively low mortality.[10] A serious food

shortage developed in 1782/83, when cold, wet weather destroyed much of the grain crop at the height of a major economic slump. Private relief efforts and aggressive intervention by the Irish government averted widespread hunger. The Earl of Carlisle, at the time the lord lieutenant of Ireland, disregarded the lobbying of grain interests, embargoed food exports to England and made £100,000 available as bounty payments on oat and wheat imports. Food prices fell almost immediately. When the severe winter of 1783/84 prolonged the food crisis, the lord lieutenant once again intervened. He assumed control over food exports and made money available for relief at the parish level in affected areas. Within ten days, the parish scheme brought generous rations for the needy: a pound of bread, a herring and a pint of beer daily. The number of deaths was much lower than it had been during the disaster of 1740–42. Government's priorities were clear and humane, and were matched by rapid response to needs.

An Act of Union joined England and Ireland in 1800. Ireland lost her political and legislative autonomy and her economic independence. The decades after 1800 saw Britain embark on a course of rapid industrialization that largely bypassed Ireland, where competition with their neighbor's highly advanced economy, the most sophisticated in Europe, undermined many nascent industries. By 1841, 40 percent of Britain's male labor force was employed in the industrial sector, compared with only 17 percent of Irishmen. Much of the deindustrialization in the famed Irish linen industry came from the adoption of labor-saving devices. New weaving machinery and steam power had transformed what had been a cottage industry into one concentrated in large mill facilities centered around Belfast in the north. Until the factories came along, thousands of small holders had subsisted off small plots of land and weaving and spinning. Now, having lost an important source of income, they were forced to depend on their tiny land holdings, and above all on the potato. And in lean years, the authorities in London were less inclined to be sympathetic than their Irish predecessors.

Irish commercial agriculture, which generated enough cattle and grain exports to feed 2 million people, required that as much as a quarter of Ireland's cereals and most livestock be raised for sale abroad. Ireland had become a bread basket for England: Irish oats and wheat kept English bread prices low, while most of the Irish ate potatoes raised on rented land and

lived at a basic, and highly vulnerable, subsistence level. Nowhere else in Europe did people rely so heavily on one crop for survival. And the structure of land ownership meant that this crop was grown on plots so small that almost no tenant could produce a food surplus.

Potatoes were an inadequate insurance against food shortages. More than 65,000 people died of hunger and related diseases in 1816, the "year without a summer." They died in part because the British authorities chose not to ban grain exports, an effective measure in earlier dearths. Chief Secretary Robert Peel justified this on the specious grounds that private charity givers would relax their efforts if the government assumed major responsibility for famine relief. In June 1817, he issued a fatuous proclamation to the effect that "persons in the higher spheres of life should discontinue the use of potatoes in their families and reduce the allowance of oats to their horses."[11]

By 1820, the potato varieties that had sustained the Irish in earlier times were in decline. Black, Apple, and Cup potatoes were outstanding varieties, especially the Apple with its deep green foliage and roundish tubers, which produced a rich-flavored, mealy potato likened by some to bread in its consistency. These hardy and productive strains began to degenerate due to indiscriminate crossbreeding in the early nineteenth century. They gave way to the notorious Lumper, or horse potato, which had originated as animal fodder in England. Lumpers were highly productive and easily raised on poor soil, an important consideration when people occupied every hectare of land. By 1835, coarse and watery Lumpers had become the normal staple of Irish animals and the poor over much of the south and west. Few commentators had anything polite to say about them. Henry Dutton described them as: "more productive with a little manure . . . but they are a wretched kind for any creature; even pigs, I am informed, will not eat them if they can get other kinds."[12]

The agricultural writer Arthur Young, touring through Ireland in 1779, had written glowingly of the potato and its ability to feed people. But as the population soared and yields dropped, the potato's disadvantages be-

came apparent. Lumpers did not keep from one year to the next, so one could not rely on the previous year's crop as a cushion against a poor harvest. Ireland's poor, already living on an inferior potato with dubious nutritional value, thus had no food reserves. They were also running out of land. Ireland's population had risen rapidly until it was over one-half the combined population of England and Wales. The rapid rise put severe pressure on farming land even as larger farmers increasingly converted their land to grain or stock raising for export. The conversions forced poor potato growers higher into the hills and on to ever less fertile land. Inevitably, crop yields fell. During the often hungry summer months, people were tempted to consume their seed potatoes, even to dig up their new crops as soon as the tubers formed. Year after year, as the distress intensified, thousands of Irish migrated to North America to escape increasingly difficult circumstances at home. Many commentators on both sides of the Irish Channel became voices of doom. "The condition of Ireland becomes worse and worse," wrote John Wiggins in *The Monster Misery of Ireland*, published in 1844. Ireland was "a house built upon sand . . . and must inevitably fall the moment that the winds blow and the waves rage, or even with the first and slightest gale."[13] He urged immediate action.

But it was too late. A tiny fungus bred on the other side of the Atlantic was already on its way to Europe. Another observer, Dr. Martin Doyle, wrote in his letters on the state of Ireland that "should a dearth of provision occur, famine and pestilence will set in together, and rid us probably of a million."[14] The disaster, waiting to happen, was compounded by indifference and inertia. A series of Parliamentary Commissions examined the state of Ireland but did nothing. In the memorable words of Austin Bourke: "Each in turn lifted the lid of the cauldron, looked helplessly into the mess of injustice, prejudice, starvation, and despair, and quietly put the lid on again."[15]

Potatoes, like all crops, are susceptible to disease. Outbreaks of a viral disease called curl came in 1832–4 and were followed by a dry rot epidemic. Neither did lasting damage. Then, in 1843, an outbreak of potato blight,

phytophthora infestans, sometimes called "late blight," attacked growing crops in the hinterland of major eastern United States ports. Extremely fast moving, its spores germinated on the leaves and stems of the potato plant or in the surrounding soil. The disease first appeared as black spots, then as a furry growth. The plant soon decayed and the growing tubers became discolored, pulpy messes. A distinctive smell was often the first sign that blight had struck. Over the next two years the disease spread rapidly from the New York–Philadelphia area both into the southeastern United States and westward into the Great Lakes region and Canada. Inevitably, the spores crossed the Atlantic. No one knows how, from where, or when the blight spread to Europe. Some authorities believe it arrived in potatoes imported from Peru, on ships carrying guano fertilizer (fertilizer from bird droppings) as early as 1844. Others point to Mexico or North America as sources. Once established, the blight spread rapidly, helped by the prevailing weather conditions.

The summer of 1845 was cold, sunless and wetter than normal, but by no means unusual for the mid-nineteenth century. Shallow, thundery depressions with highly variable winds penetrated into the Continent. The damp, chill weather and shifting winds favored the transport of blight spores in all directions. At the time, potato crops throughout Europe were extremely susceptible to blight, and the Lumper was even more so than most. The disease worked through plots of growing Lumpers with terrifying rapidity, sometimes rotting the tubers almost overnight.

Blight was first reported in Belgium in July 1845. By August, infected foliage appeared in fields around Paris and in the Rhineland; southern England and the Channel Islands were affected at about the same time. There was no effective antidote. Botanists and learned societies scrambled for an explanation of the unknown infection, attributing it to the unusually cool and gray summer, to progressive degeneration of the potato, or even to "some aerial taint originating in outer space." Meanwhile, the blight spread inexorably. At the end of August, the first reports of infection were reported from the Botanic Gardens in Dublin.

At first, the Irish newspapers played down the significance of the infestation, appearing as it did at harvest time. Public panic set in during October, when millions of ripe tubers turned rotten in the fields. "Where will Ireland be in the event of a universal potato rot?" asked Dr. John

Lindley, the editor of the widely read *Gardener's Chronicle*.[16] The crop losses were heaviest in areas where the summer had been wettest. The mean loss from tuber rot in Ireland in 1845 was about 40 percent and the threat of famine immediate.

At first, potatoes were in plentiful supply. People hastened to sell their sound tubers or to eat them at once. The famine did not truly begin until five or six months later, when every fragment of potato had been consumed. Relief measures were complicated by the lack of good roads and by the chronic insolvency of many Irish landlords, who were virtually powerless to help their tenants. In London, Prime Minister Sir Robert Peel responded to the reports of crop failure by appointing a Scientific Commission to diagnose the problem, report on the extent of the damage, and recommend an antidote. The Commission estimated that as much as half of the crop was destroyed or rotting in storage, failed to diagnose the cause, and raised such an alarm that Peel ordered the immediate importation of £100,000-worth of maize from the United States. Peel intended this measure not as a way of feeding the starving potato farmer but as a way of controlling grain prices cheaply, without any danger of the government being accused of interfering in the cereal marketplace.

By April 1846, the House of Commons learned that people were eating their seed potatoes. About a third less hectarage of potatoes was planted as a result, making scarcity inevitable. The spring was cold and wet, but May and June turned warm and dry. Hopes ran high. The growing potatoes looked luxuriant in the fields. Then in early August, the blight appeared a full two months earlier than the previous year, progressing east and northeastward on the wings of the prevailing winds at a rate of about eighty kilometers a week. Almost every potato was lost. Father Mathew, a celebrated temperance advocate of the day, wrote how he had traveled from Cork to Dublin on July 27: "This doomed plant bloomed in all the luxuriance of an abundant harvest. Returning on the third instant I beheld with sorrow one wild waste of putrefying vegetation. In many places the wretched people were seated on the fences of their decaying gardens, wringing their hands and wailing bitterly the destruction that had left them foodless."[17] For hundreds of miles, the fields were black as if ravaged by fire. The stench of rotting potatoes filled the air.

In 1845, the distress had been severe but not overwhelming, thanks to an above average harvest and at least partially effective relief efforts. This time, the failure was complete. There were not even any freshly harvested potatoes to tide over the hungry. Every scrap of clothing and other possessions, even bedding, had already been pawned or sold for food. Not a green potato field could be seen from Limerick to Dublin. Torrential rain fell, violent thunderstorms ravaged the blackened fields, and dense fog hovered over the blighted land. On September 2, the London *Times* called the potato crop a "total annihilation."

Poor cereal crops made 1846 a year of widespread food shortages in Europe, forcing countries to bid against one another for cargoes of food imports from the Mediterranean and North America. France and Belgium paid high prices, England was outbid, and Irish relief suffered. Private merchants bought up stocks avidly for Ireland, but they were the worst kind of traders, who sold grain in tiny lots at enormous prices to relief organizations and those few individuals who could afford it. Official indifference compounded the problem. High British government officials knew less of Ireland and its economics than they knew about China. Irish peasants were told to eat grain instead of potatoes, but at the same time the government did nothing to curb the export of grain from the starving country. Free-trade doctrines prevailed, whereby the exporting of grain would provide money for Irish merchants to purchase and import low-priced food to replace the potato. No one in the impoverished west of Ireland knew anything about importing food, nor did the infrastructure exist to get it there.

By late September, the situation was desperate. People were living off blackberries and cabbage leaves. Shops were empty. Troops were sent to protect wagons carrying oats for export. Even if the exported food had been kept in the country, the people would not have been much better off, for they had no money to buy it. Proposals for public works to employ the hungry were stalled in Whitehall, then delayed by protests over task work and low wages. Even the government's payments to the destitute workers were irregular because of a shortage of silver coin. The fields, combed by emaciated families, contained not even a tiny potato. Children began to die. The weather turned cold at the end of October, and

fifteen centimeters of snow fell in County Tyrone in November. Adding
to Ireland's troubles, the North Atlantic Oscillation flipped into low
mode, bringing the most severe winter in living memory.

Ireland's winters are normally mild and the poor normally spent them
indoors, where peat fires burned. This time they had to work out of doors
to survive. By November, over 285,000 poor were laboring on public re-
lief works for a pittance. Many died of exposure. Thousands more poured
into towns, abandoning their hovels in ditches and near seashores. In-
evitably, farm work was neglected, with few tilling the soil, partly because
the peasants feared, with reason, that landlords would seize their harvests
for rent. A Captain Wynne visited Clare Abbey in the west and confessed
himself unmanned by the extent of the suffering: "witnessed more espe-
cially among the women and little children, crowds of which were to be
seen scattered over the turnip fields like a flock of famished crows, de-
vouring the raw turnips, mothers half naked, shivering in the snow and
sleet, uttering exclamations of despair, while their children were scream-
ing with hunger."[18] Even the dogs had been eaten.

Magistrate Nicholas Cummins of Cork visited Skibbereen in the west-
ern part of the country, entered a hovel that appeared deserted, and found
"six famished and ghastly skeletons, to all appearances dead . . . huddled
in a corner on some filthy straw, their sole covering what seemed to be a
ragged horsecloth, their wretched legs hanging about, naked above the
knees. I approached with horror, and found by a low moaning they were
alive—they were in fever, four children, a women and what had once
been a man."[19] Within minutes, Cummins was surrounded by more than
two hundred starving men and women. Rats were devouring corpses ly-
ing in the streets. The government in London argued that relief was the
responsibility of "local relief committees." None existed, and food was
plentiful in Skibbereen market. But the poor had no money to buy it.

Disease followed inevitably in the wake of hunger. Rural hospitals and
clinics were few, the medical infrastructure grossly inadequate, the work-
houses overwhelmed with dying victims. Patients lay on the ground. The
government provided tented hospitals and other relief measures, but too
little too late. Ten times more people died of fevers than of starvation it-
self, just as they had in Europe in 1741.

Despite a glorious summer and healthy crops, the famine continued into 1847. A shortage of seed potatoes meant that only about a fifth of the normal hectarage was planted, so the harvest, although superb, was inadequate to feed the people. Nor could the poor buy food, now a third cheaper than the year before: there was no employment to be had, nor wages to be earned. The British government, believing firmly in the sanctity of the free market, pursued the ideology of minimal intervention that dominated many European governments of the day. Ministers believed that poverty was a self-imposed condition, so the poor should fend for themselves. They were motivated mainly by fear of social unrest and a concern not to offend politically powerful interests such as corn merchants and industrialists. A financial crisis in England caused by sharply falling grain prices and wild speculation in railway shares gave the government an excuse to provide no more relief funding for Ireland, where corpses lay by roadsides because no one was strong enough to bury them. People died at the gates of workhouses, landlords were assassinated by their desperate tenants. As violence broke out, the authorities called in the military. By the end of 1847, 15,000 troops were billeted in a country pauperized by starvation and fever, where employment was nonexistent.

The spring of 1848 was cold, following heavy snow in February. People were optimistic that the cold winter would prevent the reappearance of blight and made every sacrifice to plant potatoes everywhere they could. The weather was favorable through May and June but turned cool and very wet in July. The blight struck almost overnight. By August, the extent of the new disaster was becoming apparent as heavy rain also damaged wheat and oat crops. The failure of the 1848 potato crop was as complete as that of 1846. Thousands defaulted on their rents and were evicted from their lands by landlords, who were themselves heading toward insolvency because of overwhelming debt. Everyone who could scrape together the money contemplated emigration. Not only the poor left, but farmers, some of considerable property, whom the country could ill afford to lose. The countryside was becoming deserted. Thousands of hectares of land around Ballina in County Mayo in the northwest looked like a devastated battlefield. In Munster, the landlords could not deal with the abandoned farms. Paupers squatted on empty arable land, too

weak to cultivate it, living in ditches. Trade ground to a standstill all over the country. Shops were boarded up and "thousands are brought to the workhouse *screaming* for food and can't be relieved."[20] Nearly 200,000 people crowded into workhouses designed for 114,000. Jails became a refuge. Desperate young men committed crimes so they could be sentenced to transportation. Barrister Michael Shaughnessy reported that many poor children "were almost naked, hair standing on end, eyes sunken, lips pallid, protruding bones of little joints visible." He asked: "Am I in a civilized country and part of the British Empire?"[21]

The final casualty figures from An Ghorta Mór, "The Great Hunger," will never be known. The 1841 census records 8,175,124 people living in Ireland. In 1851, the number had fallen to 6,552,385. The Census Commissioners of the day calculated that, with a normal rate of increase, the total should have been just over 9 million. Two and a half million people were lost, a million to emigration, the remainder, mostly in the west, to famine and associated disease. These estimates are probably conservative. A combination of highly unpredictable climate, overdependence on a single crop, and official indifference killed over a million people in a Europe that, thanks to greatly improved infrastructures, was becoming increasingly isolated from the ravages of hunger.

Thus the Little Ice Age ended as it began, with a famine whose memory resonated through generations. Ireland changed radically as a result. The population continued to decline for the remainder of the nineteenth century due to emigration, delayed marriages, and celibacy. Emigration rates remained high, reaching a peak in 1854. Ninety thousand people still left annually in the 1860s, a level reached by no other country until Italy after the 1870s. By 1900 Ireland's population was half the prefamine level, making it unique among European nations. The population decline did not reverse until the 1960s.

Blight mostly disappeared by 1851, but the destruction wrought by the famine continued. The lasting physical effects among the survivors included a high incidence of mental illness. Disease and mortality re-

mained high among the poor. Irish society now contained high proportions of the old and the very young, contributing to social conservatism and torpor. But the huge loss of population, tragic as it was, brought some long-term advantages. There was less competition for employment, while remittances from emigrants kept many stumbling farms in the west alive. The structure of Irish agriculture changed radically: land holdings became larger and more streamlined, and farming more commercial. Livestock replaced grain as farmers adjusted to the realities of a far smaller workforce.

The living standards of the poor remained very low. In the west, many continued to subsist on potatoes. Crop yields dropped considerably, partly because of less intensive use of fertilizer, because of much waste land and occasional local outbreaks of blight. The Lumper gave way to more palatable potato strains. Peoples' diets gradually became more diverse as the market economy grew and railroads spread through the country. But they were still vulnerable to occasional food shortages that brought scenes like those of the 1840s, though never on the same scale. Death from starvation was unusual. But the poor harbored deep resentments against the wealthier farming neighbors, who shared little of their prosperity with their laborers. Memories of the Famine, fears of starvation and eviction, were profound political realities for the remainder of the nineteenth century. The psychological scars of the Famine and hate of the English still run deep in Irish society.

An Ghorta Mór was not the last European famine. Catastrophic food shortages owing to crop failures and cold weather developed in Belgium and Finland in 1867/68. The politically driven Volga famine of 1921 and the terror famine of the Ukraine in 1932/33 dwarf the Irish disaster. But for sheer shame, the Great Hunger has no rivals.

As the Irish starved, warming conditions in the far north kept pack ice away from Icelandic coasts. Warmer water brought by the Irminger Current led to a short boom in cod fishing off western Greenland between 1845 and 1851. Meanwhile, Europe was somewhat colder, as blocking

anticyclones brought the easterly winds and harsh winters that plagued the Irish poor. By 1855, the North Atlantic Oscillation had switched again, and ice returned to Icelandic coasts. The prevailing westerlies over the North Atlantic strengthened, bringing a milder climate to Europe and the beginnings of sustained glacial retreats. The summer of 1868 was exceptionally hot, with a record temperature of 38.1°C at Tunbridge Wells, south of London, on July 22 and many days with readings over 30°. The following winter was very mild, with a mean temperature closer to that of warmer and more oceanic Ireland. The warmer years continued through the 1870s, except for occasional cold Februaries and very wet summers from 1875 onward.

Another cold snap in 1879 brought weather that rivaled that of the 1690s. December 1878 and January 1879 saw weeks of below-freezing temperatures in England, followed by a cold spring and one of the wettest and coldest summers ever recorded. In some parts of East Anglia, the 1879 harvest was still being gathered after Christmas. Coming at a time of general agricultural decline, when Britain's grain market was flooded with cheap North American wheat from the prairies, 1879's disaster caused a full-grown agricultural depression. Farmers in the northwest turned from grain to beef, but even livestock soon proved unprofitable when frozen beef entered the country from Argentina, Australia, and New Zealand. Thousands of unemployed farm laborers left the land for the towns and emigrated to Australia, New Zealand, and other countries with greater opportunities. The late 1870s were equally cold in China and India, where between 14 and 18 million people perished from famines caused by cold, drought, and monsoon failure. Glaciers advanced in New Zealand and the Andes, and Antarctic ice extended much further north than in Captain Cook's time a century earlier. Sailing ships traversing the Roaring Forties along the clipper route from Australia to Cape Horn regularly sighted enormous tabular icebergs, with some seen as far north as the mouth of the River Plate, just 35° south latitude.

The cold snap persisted into the 1880s, when hundreds of London's poor died of accident hypothermia. As late as 1894/95, large ice floes formed on the Thames in the heart of winter. Then prolonged warming began. Between 1895 and 1940, Europe enjoyed nearly a half-century of relatively mild winters. Only the winters of 1916/17 and 1928/29 were

colder than usual, but they certainly never witnessed the prolonged sub-zero temperatures of the Little Ice Age.

By this time, human activities were leaving their mark on global climate, not only through the discharge of carbon dioxide into the atmosphere but through pollution. The coldest European winter of the twentieth century was 1963, with a winter mean of $-2°C$ and a January mean of $-2.1°C$. Such air temperatures were cooler than many of the seventeenth and eighteenth century, when Londoners held frost fairs on the frozen Thames. This time, the river waters never fell below about 10°C and ice never formed. A constant spew of industrial waste and other pollutants kept the water at artificially high temperatures. Climatologist Hubert Lamb remarks: "The progress of urbanization suggests . . . the pastimes in future cold winters will be to skate on the Thames at Hampton Court—at the western limit of the metropolis—and then swim in it to Westminster pier!"[22]

THE MODERN
WARM PERIOD

People in every generation . . . have found their joys and happiness. Those in middle latitudes have thanked their gods for the green Earth, the lilies of the field and the golden corn, those in other latitudes for the beauty of the polar and mountain snows, the shelter of the northern forests, the great arch of the desert sky, or the big trees and flowers of the equatorial forest. How many of our present problems arise from not understanding our environment and making unrealistic demands upon it?"

—*Hubert Lamb,*
Climate, History and the Modern World, *1982*

12

A WARMER
GREENHOUSE

In the year 2060 my grandchildren will be approaching seventy; what will their world be like?
—*Sir John Houghton,* Global Warming:
The Complete Briefing, *1997*

While writing this book, I found myself looking at paintings differently, from a climatic perspective. Look beyond the central theme of a painting and you can explore house interiors and country landscapes, find details of implements of tillage and cooking utensils, admire fine musical instruments and watch a kaleidoscope of changing gentlemen's and ladies' fashions. These fashions were perhaps influenced by persistent cold winters. Women's fashions "exposed the person" somewhat daringly in postrevolutionary France, but as the grip of cold weather increased, designers created warm underwear for their clients, including a "bosom friend," which warmed the chest and hid cleavage that a few years earlier had been daringly exposed.[1]

Then there are the clouds. In a fascinatingly esoteric piece of research, Hans Neuberger studied the clouds shown in 6,500 paintings completed between 1400 and 1967 from forty-one art museums in the United States and Europe.[2] His statistical analysis revealed a slow increase in cloudiness between the beginning of the fifteenth and the mid-sixteenth centuries, followed by a sudden jump in cloud cover. Low clouds (as opposed to fair-weather high clouds) increase sharply after 1550 but fall

again after 1850. Eighteenth- and early nineteenth-century summer artists regularly painted 50 to 75 percent cloud cover into their summer skies. The English landscape artist John Constable, born in Suffolk in 1776 and a highly successful painter of English country life, on average depicted almost 75 percent cloud cover. His contemporary Joseph Mallord William Turner, who traveled widely painting cathedrals and English scenes, did roughly the same.

After 1850, cloudiness tapers off slightly in Neuberger's painting sample. But skies are never as blue as in earlier times, a phenomenon Neuberger attributes to both the "hazy" atmospheric effects caused by short brush strokes favored by impressionists and to increased air pollution resulting from the Industrial Revolution, which diminished the blueness of European skies.

The changes were not mere artistic fashion but probably accurate depictions of increased cloud cover. The closing decades of the Little Ice Age brought the usual unpredictable climatic shifts. The 1820s and 1830s saw warmer springs and autumns, with 1826 bringing the warmest summer between 1676 and 1976. In the exceptionally cold and wet August of 1829, by contrast, rain fell in the Scottish lowlands on twenty-eight of the month's thirty-one days. Floods washed out bridges, ruined crops and changed river courses. In the same year, Lake Constance in Switzerland froze over for the first time since 1740; it would not do so again until the exceptional cold of 1963. The winter of 1837/38 was so harsh in Scandinavia that ice linked southern Norway with the port of Skagen at the northern tip of Denmark, and extended far west out of sight of land.

The 1840s perpetuated the same unpredictable swings, with several cold winters and cool summers. Warmer summers such as 1846 saw long periods of calm, humid weather as anticyclone after anticyclone built over Europe. Heat waves extended from the west deep into Siberia, where the skipper of a Russian survey vessel on the Lena River had difficulty finding the main channel in the midst of a rapidly thawing, flooded landscape. Tree trunks and huge lumps of peat cascaded alongside as he found his way by listening to the roaring and rushing of the stream. Suddenly, the flood waters carried alongside the boat a perfectly preserved mammoth

head, released from the permafrost that had refrigerated it for thousands of years since the Ice Age. The crew had just enough time to examine the hairy cranium with stunned astonishment before it vanished into the muddy torrent. After 1850, the climate warmed slowly and almost continually, as a new climatic player took the stage—humanity.

When an austere and humorless missionary named Samuel Marsden landed at Oihi in New Zealand's Bay of Islands on Christmas Day, 1814, he brought "horses, sheep, cattle, poultry, and the gospel." With a finely developed sense of occasion, he preached to the curious Maori on the text, "Behold I bring you glad tidings of great joy." Within half a century, his tidings had changed Maori society and New Zealand's environment beyond recognition.[3]

By 1839, Christianity had a strong foothold in the country and tribal wars had virtually ceased. In that year, the missionaries claimed 8,760 Maori as regular churchgoers. A large part of their success came from agriculture. In 1824, a missionary farmer named Davis had founded a model farm at Waimate, where he introduced up-to-date English agriculture and stock-raising practices. His methods were already spreading among the Maori when a flood of European settlers arrived, sponsored by the New Zealand Colonization Company in London. By 1843, 11,500 Europeans lived in New Zealand, most of them in the heavily forested North Island. The settlers pushed inland, cutting down trees and clearing land for intensive European-style farming. The effects on Maori culture were disastrous. Between 1860 and 1875, as more than 4 million hectares of Maori land passed into settler ownership, thousands of hectares of forest and woodland fell before the farmer's axe.

New Zealand was not alone. Mid-nineteenth century immigration brought tens of thousands of land-hungry farmers to Australia, North America, South Africa, and elsewhere. The newcomers felled millions of trees as they cleared their farmlands or provided firewood and lumber for the growth of cities and the spreading Industrial Revolution. The long-term environmental effects for earth were profound.

A standing forest can contain as much as 30,000 metric tons of carbon per square kilometer in its trees, and still more in its undergrowth.[4] When the trees are felled, much of this carbon enters the atmosphere.

Similarly, virgin grassland soils have an organic content of up to 5,000 metric tons per square kilometer, half of which may be lost within six months when it is cultivated. One estimate has the twenty-year global burst of pioneer agriculture and land modification between 1850 and 1870 raising the carbon dioxide level in the atmosphere by about 10 percent, even allowing for absorption by the world's oceans. Isotopic levels in tree rings from long-living California bristlecone pines chronicle a rise in carbon dioxide levels during these very years, at a time when the discharge from fossil fuel burning was still relatively small.

This change may have been one of the mechanisms that gradually raised global temperatures during the late nineteenth century, ending the Little Ice Age by about 1850. The pioneer agricultural explosion, fueled by large-scale emigration, railroads, and ocean steamships, was the first human activity that genuinely altered the global environment. The second came from coal, already a significant air polluter in large cities.

"In the third week of November, in the year 1895, a dense yellow fog settled down upon London. From the Monday to the Thursday I doubt if it were ever possible from our windows in Baker Street to see the loom of the opposite houses." Thus Arthur Conan Doyle keeps Sherlock Holmes pacing restlessly at home, impatient for action, watching "the greasy, heavy brown swirl still drifting past us and condensing to oily drops on the window panes."[5] The choking "pea soupers" of the great detective's London came from factory chimneys and millions of coal fires pouring smoke into still, cold air. I remember a day in the early 1960s when you could not see your hand in front of your face, and everyone wore masks to protect their lungs. The advent of smokeless fuels has mercifully consigned the pea souper to historical oblivion.

By the sixteenth century, England's forests had shrunk drastically in the face of rising rural populations and an insatiable demand for construction lumber and firewood. Londoners turned to coal instead and choked in clouds of coal smoke hovering over streets and crowded roofs.

Global temperature anomalies since 1860. Note the pronounced warming trend, which accelerates after the 1970s.

During a cold spell in January 1684, diarist John Evelyn complained of the "fuliginous steame of the Sea Coal," which filled Londoners' lungs with "grosse particles." King Charles II contemplated ways of abating London's smog, which was later made worse by the Industrial Revolution with its coal-powered steam engines, railroads, and factories.[6] You can see the nineteenth century's air pollution in the work of London artists. Sailing ships, tugs, and freighters work their way against the Thames tides in a yellowy or pink-gray light; sunsets over Saint Paul's Cathedral glow with a hazy red that was unknown in earlier centuries.[7]

Industrial and domestic coal burning not only choked passers by, it released enormous concentrations of atmospheric carbon dioxide. In the early twentieth century, the mass-produced automobile and a shift from coal to oil and gas poured even more carbon dioxide into the atmosphere. Antarctic and Greenland ice cores have trapped air bubbles that date back long before the Industrial Revolution and show that carbon dioxide levels in the atmosphere have risen sharply since 1850. Other greenhouse gases, such as methane, have increased at the same time, as global human populations rise and engage in ever more intense rice paddy agriculture and

cattle herding. It is surely no coincidence that global temperatures have gradually and inexorably risen over the past 150 years.

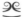

The first half of the twentieth century was not unusual by Little Ice Age standards. At first, the warming matched that between the late 1600s and the 1730s, when full twentieth-century warmth was attained for a decade. The eighteenth-century warm spell ended with the harsh winter of 1739/40. Unpredictable climatic shifts continued for the next century and three-quarters, with no significant longer term trends except for cycles of cold caused by volcanic activity. Europe also enjoyed twenty years of warmth in the 1820s and 1830s, but again nothing like the sustained warming that began between 1890 and 1900 and continues, with one short interruption, to this day.

The period 1900 to 1939 saw a high incidence of westerly winds and mild winters, characteristic of a high North Atlantic Oscillation condition. The strong pressure gradient between the Azores high and the Icelandic low helped maintain the westerlies. Air temperatures over the globe reached a peak in the early 1940s, after decades of strong atmospheric circulation. Locations near the edge of the Arctic like Iceland and Spitzbergen experienced warming even more extreme than that in Europe. The area of the north covered by pack ice shrank between 10 and 20 percent. Snow levels rose on northern mountains. Ships could now visit Spitzbergen for over seven months a year, compared with three months before 1920. The distribution and variability of rainfall altered over much of the world as well. Northern and western Europe experienced more rainfall, as mud-bound troops on the Western Front in 1916 found to their cost. My father, who fought on the Western Front, complained in his diary of "constant rain, grey skies, and mud everywhere. We sink into it up to our knees, sloppy dreadful stuff that rots our feet. No one fights in either side, we just suffer silently in the wet."[8]

The additional precipitation continued into the 1920s and 1930s as subpolar cyclones became larger and spread their wind circulation further

into the Arctic. The warming increased the length of the growing season in western Europe by as much as two weeks compared with the mid-nineteenth century, as the last spring frost came earlier and the first autumn freeze later. After 1925, Alpine glaciers disappeared from valley floors up into the mountains. Equivalent stronger westerlies over the Pacific extended the arid wind shadow of the Rocky Mountains far eastward, bringing the disastrous droughts of the Oklahoma Dust Bowl era in the 1930s. Changes in atmospheric circulation brought much more reliable monsoon winds to India. There were only two partial monsoon failures in the thirty-six years between 1925 and 1960, a dramatic contrast to the catastrophic failures of the late nineteenth century, when millions of Indian villagers perished in terrible famines.[9]

By the 1940s, scientists were talking of the persistent warming trend, which had begun to transcend the familiar climatic swings. At first they focused their attention on the most obvious sign of global warming, retreating Arctic sea ice. What would happen if the ice pack vanished by the end of the twentieth century? Would it be possible to grow food even further north, to settle lands closer to the Arctic than even the valleys and hill slopes farmed during the Medieval Warm Period? The climatologists had few research tools to draw on, working as they were before an era of computer modeling, satellites, and global weather tracking. Their researches were also hampered by the sheer variability of rainfall and temperature, which tended to obscure longer term trends, and by a lack of properly organized long-term meteorological data.

Just as climatologists were pondering a half-century or more of gradual warming, changes in the atmospheric circulation regime in the 1950s brought a lowering of the global average temperature to about the level of 1900–1920. This cooling endured longer than any other downward temperature trend since 1739–70. The NAO was now in a low phase, with the westerlies weakened and shifted southward. Western Europe became colder and generally drier during the winter months. The winter of 1962/63 was the coldest in England since 1740. I remember skating on the River Cam near Cambridge for kilometers, after having rowed on it a few days earlier in water so cold that the spray froze to our oars. The Baltic Sea was completely ice covered in 1965/66. In 1968, Arctic sea ice

surrounded Iceland for the first time since the exceptional winter of 1888. The effects of the circulation changes were also felt elsewhere. Between 1968 and 1973, prolonged drought in the Sahel zone, on the southern margins of the Sahara, killed thousands of people and decimated cattle herds. In 1971/72, eastern Europe and Turkey experienced their coldest winter in 200 years. The Tigris River froze over for the only time in the century. Record low winter temperatures in 1977 over the Midwest and eastern United States convinced many people that another Ice Age was imminent. *Time* magazine ran a story on the repetitive cycles of Ice Ages. Cold was fashionable again.

Then, suddenly, the NAO index flipped to high. The warming resumed and seemed to accelerate. In 1973/74, the Baltic was virtually ice-free. England enjoyed its warmest summer since 1834. Record heat waves baked England, the Low Countries, and Denmark in 1975/76. More weather extremes, a higher incidence of hurricanes, and drought after drought: the world's climate seemed very different from that of a century (or even a decade) earlier.

Few scientists were actively studying long-term climatic change at the time. They worked far from the limelight until June 1988, when a searing two-month heat wave settled over the Midwest and eastern United States. Weeks of dry, record heat reduced long stretches of the Mississippi River to shallow streams. Barges ran aground on mud banks and were stranded for weeks. At least half the barley, oats, and wheat crops on the northern Great Plains were lost. The drought ignited destructive wild fires over 2.5 million hectares of the west, engulfing much of Yellowstone National Park. The dry spell was caused by a relatively common meteorological event: a blocking high that kept heat hovering over the Midwest and east. But a single Senate hearing in which everyone sweltered was sufficient to turn global warming from an obscure scientific concern into a public policy issue.[10]

On June 23, 1988, climatologist James Hansen testified before a hearing of the Senate Energy and Natural Resources Committee on a day when the temperature in Washington D.C. reached a sweltering 38°C. The heat wave was an appropriate backdrop for some startling climatic testimony. Hansen had impressive data from 2,000 weather stations

around the world, which documented not only a century-long warming trend but a sharp resumption of warming after the early 1970s. Four of the warmest years of the past 130 had occurred in the 1980s. The first five months of 1988 had brought the highest temperatures yet. Hansen flatly proclaimed that the earth was warming on a permanent basis because of humanity's promiscuous use of fossil fuels. Furthermore, the world could expect a much higher frequency of heat waves, droughts, and other extreme climatic events. His predictions thrust global warming into the public arena almost overnight.

We live on a benign planet, protected by the heat absorbing abilities of the atmosphere, the so-called "greenhouse effect." Energy from the sun heats the surface of the earth and so drives world climate. The earth, in turn, radiates energy back into space.[11] Like the glass windows of a greenhouse, atmospheric gases such as water vapor and carbon dioxide trap some of this heat and re-radiate it downward. Without this natural greenhouse effect, earth's temperature would be about −18°C instead of the present comfortable +14°. But the effect is no longer purely natural. Atmospheric concentrations of carbon dioxide have now increased nearly 30 percent since the beginning of the Industrial Revolution; methane levels have more than doubled; and nitrous oxide concentrations have risen by about 15 percent. These increases have enhanced the heat-trapping capabilities of the atmosphere.

Ozone depletion is another consequence of human industrial activity. The earth's atmosphere is divided into several layers, the troposphere extending from the surface to about ten kilometers, the stratosphere from ten to about fifty kilometers. Most airline traffic travels in the lower part of the stratosphere. Most atmospheric ozone is concentrated in a layer in the stratosphere about fifteen to fifty kilometers, where it absorbs a portion of solar radiation, preventing it from reaching the earth's surface. Most importantly, it absorbs ultraviolet light that causes harm to some crops, some forms of marine life, and causes skin cancers and other med-

ical complications in humans. Ozone molecules are constantly formed and destroyed in the stratosphere, but the total ozone level stays relatively stable and has been measured over several decades. Over the past half-century, intensive use of chlorofluorocarbons (CFC) as refrigerants and for many other applications has damaged the protective ozone layer, resulting in ozone depletion, reflected in the famous annual ozone "hole" over Antarctica and a fall in ozone levels of up to 10 percent over many parts of the world.

Global mean surface temperatures have risen between 0.4 and 0.8°C since 1860 and about 0.2 to 0.3°C since 1900 in some parts of the world. If the present levels of emission release continue, carbon dioxide concentrations may be *30 to 150 percent higher* than today's levels by the year 2100. Some estimates place the potential temperature rise between 1.6 and 5.0°C in different parts of the world, an unprecedented climb by post–Ice Age standards. With this rise would come major environmental changes: decreased pack ice and snow cover in the Arctic and Northern Hemisphere, further climbs in sea level, beyond the ten- to twenty-five-centimeter rise of the past century (the largest over the past 6,000 years), which would threaten many coastlines and low-lying nations like the Bahamas and many Pacific islands; perhaps a higher frequency of exceptional storms and extreme weather events; and severe droughts in places like tropical Africa. Many of these environmental changes carry potentially catastrophic political and social consequences.

Since Hansen's 1988 testimony, temperatures have risen to their highest levels since at least A.D. 1400 and show no signs of cooling off. The 150-year warmup is now the most prolonged in 1,000 years. One record after another has toppled. January to September 1998 was the second warmest period on record in North America, exceeded only by 1934. September 1998 was the warmest September ever globally for over a century, more than 0.6°C above the long-term mean for 1880–1997. Blistering heat enveloped much of the American south during spring and summer that

year. Del Rio, Texas, suffered through a record sixty-nine days with temperatures above 38°C.

No less than 67 percent of all winters since 1980 have been warmer than the long-term average. The winter of 1999/2000 was by a huge margin the warmest in the United States in 105 years of record keeping, 0.3°C higher than the previous record, set in 1998/99. Europe has also seen a series of unusually mild winters. Over the Northern Hemisphere as a whole, both land and ocean winter temperatures were the sixth warmest on record, only slightly cooler than the record years of 1997/98 and 1998/99.[12] Summer temperatures are now equal to the means of the Medieval Warm Period. Globally, minimum temperatures have been increasing about twice the rate of maximum temperatures since the 1950s, which is lengthening frost-free seasons over much of the Northern Hemisphere.

Are the record temperatures of the 1990s simply part of the endless cycling of cooler and warmer climate that has gone on since the end of the Ice Age? Or do they result, at least in part, from unwitting human interference with global climate? On the face of it, the rising temperatures of the past decade seem to bear out James Hansen's predictions. But computer models have their limitations. Long-term climatic projections require models of mind-boggling complexity, based on as complete data as possible from every corner of the world. While these models improve from year to year, they are no better than the technology and software that ran them, or the data fed into them. They are obviously statistical estimates based on geographically incomplete information.

Still, they show some disturbing trends. For example, the North Atlantic Oscillation's current high mode has endured for several decades longer than usual, and brought significant winter warming of nearby Northern Hemisphere land masses. Numerical models of the climate system show that the NAO's stability from the 1960s to early 1990s is outside the range of normal variation.[13] Does this mean that recent temperature changes are the result of human-generated greenhouse gases? The statistical odds that they are rank in the 90th percentile, but we will not have anything approaching a definitive answer to this question for another three decades.

Part of the reason we don't know to what extent our present climate change is natural has to do with the sun. The sun has always been a dynamic player in global climate change, but the extent of its influence is still a mystery. Research has hardly begun. A helioseismograph based on an orbiting observatory named SOHO 1.6 million kilometers in space sends sound waves toward the sun, which bounce back from the layers that form its interior. The waves acquire high-quality observations without the interference caused by atmospheric "noise" and have located two parallel gas layers about 225,000 kilometers beneath the solar surface that speed up and slow down in a synchronous pattern in regular twelve- to sixteen-month cycles. This "tachcline" is where the turbulent outer region of the sun meets the orderly, interior radiative core. The tachcline may be the source of powerful magnetic fields that produce solar flares and solar winds, and create the eleven-year cycle of sunspots.[14] The effects of these cycles on global climate are still unknown.

Another solar phenomenon may also be at play. A group of astronomers and climatologists has studied solar "corona," literally holes in the sun's outer atmosphere through which streams of charged particles flow into space to engulf the entire planetary system. They believe this solar wind activity has a direct connection to climatic change on earth: charged particles hitting the earth's atmosphere affect the properties of clouds and the percentage of them covering the globe. When numerous coronae cover the solar surface, the increased solar winds produce greater terrestrial cloud cover, and average temperatures drop. The importance of this effect is still unknown.[15]

Solar radiation is never constant, making it a possible cause of climate change, and a factor in the current warming. Over the past twenty years, space-based measurements of solar radiation, the first accurate data on these fluctuations, have revealed eleven-year cycles that correspond to the well-known eleven-year cycle of sunspots. Solar intensity is greater at times of higher sunspot activity. Proxy measurements from tree rings and ice cores chronicle these cycles and longer term fluctuations in earlier centuries. We know solar activity was high during the twelfth and thirteenth centuries, the height of the Medieval Warm Period. Present levels of solar irradiance are higher than periods of unusually low sunspot activity during the Sporer (1425–1575), Maunder (1645–1715), and Dalton Min-

ima (1790–1820). Solar activity increased steadily during the first half of the twentieth century but has changed little since 1950, beyond the usual eleven-year cycles. In computer climate simulations, the surface temperature warming resulting from the known fluctuations in solar radiation between 1600 and the present amount to only 0.45°C. Less than 0.25°C can be attributed to the period 1900 to 1990, when surface temperatures rose 0.6°C.[16] Changes in solar radiation appear to account for less than half of twentieth-century warming.

Solar activity is currently at a high level relative to the record of the past 8,000 years, which suggests that future impacts of solar radiation on global climate will be much smaller than those stemming from greenhouse gases. Even during sunspot minima, reduced solar luminosity probably accounted for no more than half a degree Centigrade of cooling. Solar radiation is large enough to shape global warming, but not to dominate it.

Even if the sun does significantly influence climate change on earth, humanly generated greenhouse gases, virtually absent during the Little Ice Age, are almost certainly the major agents of the current sustained warming. Prudence suggests that we plan for an entirely new era of climate change.[17]

What form will this change take? One school of thought, popular with energy companies, is serenely unfazed by global warming. Gradual climate change will bring more benign temperatures. Sea levels will rise slightly, there may be some extreme weather events, but within a few centuries we will emerge into a more uniform, warmer regimen of shrunken ice sheets, milder winters, and more predictable weather—much like earth in the time of the dinosaurs. Humanity will adjust effortlessly to its new circumstances, just as it has adjusted to more extreme changes in ancient times.

The record of history shows us that this is an illusion. Climate change is almost always abrupt, shifting rapidly within decades, even years, and entirely capricious. The Little Ice Age climate was remarkable for its rapid changes. Decades of relatively stable conditions were followed by a sudden shift to much colder weather, as in the late seventeenth century, 1740/41, or even the 1960s. The same pattern of sudden change extends back as far as the Great Ice Age of 15,000 years ago, and probably to the very beginnings of geological time. Given this history, we would be rash

to assume that sudden climate change will miraculously give way to a more uniform warming trend. The exact opposite seems more likely. In all probability the dinosaurs lived through short-term climatic shifts that were just as unpredictable as those of the past 10,000 years, if for no other reason than that large-scale volcanic activity was just as prevalent then as it is today. The Little Ice Age reminds us that climate change is inevitable, unpredictable, and sometimes vicious. The future promises exactly the same kinds of violent change on a local and global scale. If the present, unusually prolonged high mode of the North Atlantic Oscillation is indeed due to anthropogenic forcing, then we must also assume that global warming will accentuate the natural cycles of global climate on the largest and smallest scales. Some of these potential cycles of change are frightening to contemplate in an overpopulated and heavily industrialized world.

This concern has ample historical precedent. Eleven thousand years ago, long before the Industrial Revolution, humanity experienced a fast climate change that came as a complete shock. After some three millennia of global warming, rising sea levels, and shrinking ice sheets at the end of the Great Ice Age, a massive influx of fresh glacial meltwater into Arctic waters shut down the downwelling that carried salt water into the deep ocean. The warm conveyor belt that had nourished natural global warming in the north abruptly stopped. The warming itself ceased perhaps within a few generations, plunging Europe into near-glacial cold for a thousand years. Glaciers advanced, pack ice spread far south for much of the year, and forests retreated southward. Rainfall zones shifted, and intense drought settled over southwestern Asia, causing many Stone Age bands to turn from foraging to farming. The millennium-long "Younger Dryas" event, named after a polar flower, ended as rapidly as it began, when the downwelling switch abruptly turned on again and warming resumed.

Younger Dryas Europe was sparsely populated by hunter-gatherer groups that were mobile enough to adapt to rapidly changing environmental conditions. What would happen today if northern downwelling were to slow down or cease and plunge Europe into near-glacial cold? Anthropogenic global warming could easily flip the switch. Models of ocean circulation patterns hint that even a modest increase in fresh meltwater inflow into arctic seas could choke off downwelling in the North At-

lantic. The pulse of fresh water would float atop the dense, salty Gulf Stream, just as it did 11,000 years ago, forming a temporary "lid" that would effectively prevent the Gulf Stream water from cooling and sinking. A sea ice cap could form in short order, preventing the Gulf Stream from starting up again, and trigger an intensely cold regimen in Europe within perhaps a few years. No one can predict how long such a cold snap would last. A few unusually warm summers might melt the ice and expose the Gulf Stream, allowing downwelling to resume and milder climate to return. Or evaporation of water vapor in the tropical Atlantic far from the ice sheets could cause such a buildup of salt water that downwelling would begin at the edges of the ice zone, far from the traditional spots, again causing a rapid warmup of European climate.

The consequences of a Younger Dryas–like event to industrial agriculture alone, though truly frightening to contemplate, are not beyond the grounds of possibility. The chance is remote, but Europe's planners factor it into their scenarios for the climatic long-term future.

The short-term climatic future is relatively easy to predict. If warming continues on its present trajectory, growing seasons in Europe will lengthen, vineyards will again be established in central England, and farms will be cleared closer to the Arctic Circle. Northern Europe and much of North America may prosper from the warmth, but southern Europe, much of tropical Africa, and Central and South America will suffer more frequent water shortages and greater heat, as well as diminished agricultural capacity. Confrontations over water rights will flare in countries like Egypt, which depend on river flow from across national borders. People will adapt as they always have, but drier tropical regions with at least 400 million people subsisting in overpopulated marginal environments will make that adaptation difficult.

What of the longer term, if global warming accelerates? Sufficient reserves of fossil fuel exist to cause a continued growth in atmospheric carbon dioxide levels well into the twenty-second century. If this growth continues unchecked, the climate changes on earth will probably be very large

indeed and extremely unpredictable. But many scientific uncertainties remain. Recently, James Hansen and a group of his colleagues have argued that the rapid warming of recent decades has in fact been driven mainly by non-CO_2 gases such as chlorofluorocarbons. Fossil fuel burning CO_2 and aerosols have both positive and negative climatic forcing effects, which tend to cancel each other out. Hansen and his team point out that the growth rate of non-CO_2 gases has declined over the past decade and could be reduced even further. This, combined with a slowing of black carbon and CO_2 emissions, could lead to a decline in the rate of global warming.[18] Much more research is needed to confirm this hypothesis.

Optimists assume that we will adapt comfortably. We humans do have a striking ability to adapt to changing environmental circumstances at the local level. Witness the agricultural revolution in Flanders, the Low Countries, then Britain during the climatically unpredictable sixteenth and eighteenth centuries.

Yet optimism fades in the face of demographic reality. Six billion of us now inhabit earth, with hundreds of millions still subsisting from harvest to harvest, from rainy season to rainy season, just as many European peasants once did. For Europe and North America, with their industrial-scale agriculture and elaborate infrastructures for moving food over long distances, famine is remote. But subsistence farmers on other continents still live with the constant threat of hunger. As I write this, more than 2 million cattle herders in northeast Africa face starvation because of severe drought. Such numbers are hard for us to comprehend in the prosperous West. They will become still harder to comprehend if global temperatures rise far above present levels, when rising seas inundate densely populated coastal plains and force millions of people to resettle inland, or far more severe droughts settle over the Sahel and the less well watered parts of the world? I have avoided discussing wars in this book—it would be simplistic to say that wars or other complex political events were *caused* by climatic change—but it's implausible to suppose that famines and massive dislocations of poor populations will be unaccompanied by civil unrest and disobedience. We can only imagine the potential death toll in an era when climatic swings may be faster, more extreme, and completely unpredictable because of human interference with the atmosphere. The French Revolution or the Irish potato famine pale into insignificance.

Even if the present warming is entirely of natural origin, greenhouse warming in the future could be accentuated by fossil fuels. We would be rash to ignore even theoretical scenarios, for we and our descendants are navigating uncharted climatic waters. In that respect we are no different from medieval farmers or eighteenth-century peasants, who took the weather as it came. Today we can forecast the weather and model climatic change, but globally we are still as vulnerable to climate as were those who endured the famine of 1315 or the great storms of the Spanish Armada, simply because there are so many of us and we are so closely linked, environmentally, economically, and politically. Fortunately, we now have, or will shortly have, the scientific data that document the full extent of the danger. We also know what has to be done, and have many of the tools to make significant changes. But to implement countermeasures to reduce greenhouse gasses and minimize the impact of climatic extremes on an increasingly crowded world community will require a new altruism, and a desire to work for the global rather than the national good, for the welfare of our grandchildren and great-grandchildren rather than to satisfy short-term, often petty, goals. Political bickering, selfish national interests and the intense lobbying of international business have so far militated against broad agreement as to the path ahead.

Over a century ago, Victorian biologist Thomas Huxley urged us to be "humble before the facts." The facts stare us in the face, yet we do not display sufficient humility. As British diplomat Sir Crispin Tickell recently remarked: "Mostly we know what to do but we lack the will to do it."[19] The vicissitudes of the Little Ice Age remind us of our vulnerability again and again. In a new climatic era, we would be wise to learn from the climatic lessons of history.

NOTES

The literature surrounding the Little Ice Age is diffuse, enormous, and profoundly contradictory, much of it in extremely obscure, specialized journals. To fully reference this book would festoon it with hundreds of footnotes. Instead, I have elected to provide a guide to further reading among the citations, footnoted at a general level to the text. The reader will find comprehensive bibliographies in most of the works cited below, which will provide an entry into the technical literature.

PREFACE

The quote from George Philander is from *Is the Temperature Rising?* (Princeton: Princeton University Press, 1998), 3.

PART ONE WARMTH AND ITS AFTERMATH

The Chaucer quote is from the *Canterbury Tales,* edited by John Coghill (Baltimore: Pelican Books, 1962), 17.

The German chronicler of 1315 is quoted in William Chester Jordan's *The Great Famine* (Princeton: Princeton University Press, 1996), 20.

CHAPTER 1

The excerpt from *Hafgerdinga Lay* ("The Lay of the Breakers") is quoted in Magnus Magnusson and Hermann Pálsson, eds., *The Vinland Sagas* (Harmondsworth, England: Penguin Books, 1965), 52.

1. H. H. Lamb, *Climate, History and the Modern World* (London: Methuen, 1982), 165. Lamb's work is an excellent, thorough summary. M. L. Parry, *Climatic Change, Agriculture, and Settlement* (Folkstone, England: Dawson, 1978) covers expansion and contraction of agricultural activity, especially in Scotland.

2. Both quotes in this paragraph from Jean Grove, *The Little Ice Age* (London: Routledge, 1988), 21–22. Grove's monograph is one of the few book-length studies of the Little Ice Age and is seminal, if, inevitably, outdated in places. Hermann

Flohn and Roberto Fantechi, *The Climate of Europe: Past, Present, and Future* (Dordrecht, Germany: D. Reidel, 1984) offers another technical analysis.

3. Magnusson and Pálsson, *The Vinland Sagas*, 78.

4. Kirsten A. Seaver, *The Frozen Echo: Greenland and the Exploration of North America, ca. A.D. 1000–1500* (Stanford: Stanford University Press, 1996), 46. This work is an authoritative study of the early settlement of the north during the warmer centuries. For the Vikings generally, see the lavishly illustrated volume: William W. Fitzhugh and Elisabeth A. Ward, eds., *Vikings: The North Atlantic Saga* (Washington, D.C.: Smithsonian Institution Press, 2000).

5. The term "Gothic" was coined by Renaissance scholars, who considered the style the epitome of grotesque savagery. Subsequently, contempt has turned to admiration and near adoration.

6. Until the eighteenth century, farmers were described with a variety of terms that denoted their status in the community rather than their occupation. In the sixteenth century, for example, most people were engaged in some form of farming as well as other occupations at the same time. For instance, almost all country clergymen were farmers, since much of their living came in the form of land. Craftspeople, miners, and many other combined these occupations with seasonal work on the land. For the purposes of this book, I use the term farmer generically, as the context of its use is usually obvious.

7. Norman Davies, *Europe: A History* (New York: Oxford University Press, 1996), 356. John Mundy, *Europe in the High Middle Ages, 1150–1309*, 2nd ed. (New York and London: Longman, 1991) is another useful source.

CHAPTER 2

The excerpt from Johan Huizinga, *The Autumn of the Middle Ages,* is translated by Rodney J. Payton and Ulrich Mammitzsch (Chicago: University of Chicago Press, 1996), 1–2.

1. Quote from the *Annals of London* from M. L. Parry, *Climatic Change, Agriculture, and Settlement,* 34. The literature on the North Atlantic Oscillation is enormous and hard to track. Here are some useful references with bibliographies: Edward R. Cook et al., "A Reconstruction of the North Atlantic Oscillation using tree-ring chronologies from North America and Europe," *The Holocene* 8(1) (1998): 9–17; Jürg Luterbacher et al., "Reconstruction of monthly NAO and EU indices back to A.D. 1675," *Geophysical Research Letter,* September 1, 1999: 2745–2748; M. J. Rodwell and others, "Oceanic forcing of the wintertime North Atlantic Oscillation and European climate," *Nature* 398: 320–323.

2. Cooling in the Arctic and the subsequent unpredictable conditions are well covered by Hubert Lamb, *Climate, History and the Modern World.* The best source on the famine of 1316 is William Chester Jordan's *The Great Famine* (Princeton: Princeton University Press, 1996), which offers a comprehensive analysis and an im-

pressive bibliography. I have relied on this important work extensively in this chapter. Barbara W. Tuchman's *A Distant Mirror: The Calamitous 14th Century* (New York: Alfred A. Knopf, 1978) is a sweeping account of the century, which I also drew on here. The quotes in this paragraph are as follows: "E Floribus chronicum, etc., auctore Bernardo Guidonia," Martin Bouquet, et al., eds., *Recuil des Historians des Gaules et de la France*, 24 vols. (Paris, 1738–1904). 21;725 "Excerpta e memoriali historiarum Johannis a sancto Victore," Bouquet et al., eds., *Recuil des Historians*, 21, 661. "Extraits de la chronique attribuee à Jean Desnouelles," Bouquet et al., eds., *Recuil des Historians*, 21, 197. I am deeply grateful to Professor William Jordan of Princeton University for kindly researching and translating these quotes for me.

3. Isaiah 5:25.

4. Henry S. Lucas, "The Great European Famine of 1315, 1316, and 1317," *Speculum* 5(4) (1930): 357.

5. Salzburg chronicler quoted from Jordan, *The Great Famine*, 18.

6. Ibid., 24.

7. Quotes from J. Z. Titow, "Evidence of weather in the account rolls of the Bishopric of Winchester," *Economic History Review* 12 (1960): 368.

8. The Neustadt vineyard research was the work of nineteenth-century German antiquarian Friedrich Dochnal. Quoted and discussed by Jordan, *The Great Famine*, 34–35.

9. Lucas, op. cit. (1930), 359.

10. Both quotes in this paragraph from Jordan, *The Great Famine,* 147. Abbott Gilles le Muisit: Henri Lemaître, ed., *Chronique et Annales de Gilles le Muisit, abbé de Saint-Martin de Tournai (1272–1352)* (Paris: Ancon, 1912).

11. Guillaume de Nangis quoted from Henry S. Lucas, "The Great European Famine," 359.

PART TWO COOLING BEGINS

The excerpt from the *Second Towneley Shepherd's Play* is from John Spiers, *Medieval English Poetry: The Neo-Chaucerian Tradition* (London: Faber and Faber, 1957), 337. For the construction of the cycle itself, see John Gardner, *The Construction of the Wakefield Cycle* (Carbondale, Ill.: Southern Illinois University Press, 1974).

The quote by Jan de Vries is from his "Measuring the Impact of Climate on History: The Search for Appropriate Methodologies," in Robert I. Rotberg and Theodore K. Rabb, *Climate and History* (Princeton: Princeton University Press, 1981), 22.

CHAPTER 3

The quote by François Matthes is from his "Report of Committee on Glaciers," *Transactions of the American Geophysical Union* 21 (1940): 396–406.

1. François Matthes, "Report of Committee on Glaciers," *Transactions of the American Geophysical Union* 20 (1939): 518–523. For a general essay on climate change, the interested reader can do no better than George Philander's *Is the Temperature Rising?* (Princeton: Princeton University Press, 1998). See also Hubert Lamb's monumental *Climate Present, Past, and Future*, 2 vols. (London: Methuen, 1977).

2. Quotes in this paragraph from Hubert Lamb and Knud Frydendahl, *Historic Storms of the North Sea, British Isles and Northwestern Europe* (Cambridge: Cambridge University Press, 1991), 93. I. B. Gram-Jenson, *Sea Floods* (Copenhagen: Danish Meteorological Institute, 1985) is a short, more technical work on the subject from the Danish perspective. See also A. M. J. De Kraker, "A Method to Assess the Impact of High Tides, Storms and Sea Surges as Vital Elements in Climatic History," *Climatic Change* 43(1) (1999): 287–302.

3. Quoted from Jordan, *The Great Famine*, 24.

4. Christian Pfister, "The Little Ice Age: Thermal and Wetness Indices, in Rotberg and Rabb, *Climate and History*, 85–116.

5. A brief summary of tree-ring curves can be found in Keith R. Briffa and Timothy J. Osborn, "Seeing the Wood from the Trees," *Science* 284 (1999): 926–927.

6. Wallace S. Broecker, "Chaotic Climate," *Scientific American*, January 1990: 59–56, discusses the Great Ocean Conveyor Belt.

7. For deep water production theories, see Wallace S. Broecker, Stewart Sutherland, and Tsung-Hung Peng, "A Possible 20th-Century Slowdown of Southern Ocean Deep Water Formation," *Science* 286 (1999): 1132–1135.

CHAPTER 4

The excerpt from *Kongugs Skuggsjá (The King's Mirror)* is from Kirsten Seaver, *The Frozen Echo* (Stanford: Stanford University Press, 1996), 112.

1. See ibid., also Fitzhugh and Ward, eds., *Vikings: The North Atlantic Saga*. The lavishly illustrated Fitzhugh and Ward volume, published to coincide with a major museum exhibit, is a superb compilation of essays on all aspects of Viking and Norse archaeology and history for the general reader. There are excellent articles on recent archaeological finds at both Norse settlements.

2. Seaver, *The Frozen Echo*, 237.

3. This passage draws on Lamb and Frydendahl, *Historic Storms*.

4. Seaver, *The Frozen Echo*, 104.

5. A seminal, multidisciplinary paper on Norse abandonment of the Western Settlement and Nipaatsoq can be found in L. K. Barlow et al., "Interdisciplinary Investigations of the end of the Norse Western Settlement in Greenland," *The Holocene* 7(4) (1997): 489–500.

6. Joel Berglund, "The Farm Beneath the Sand," in Fitzhugh and Ward, *Vikings: The North Atlantic Saga*, 295–303.

7. The literature on cod is enormous. Mark Kurlansky, *Cod: A Biography of the Fish that Changed the World* (New York: Walker, 1998). Harold A. Innis, *The Cod Fisheries: The History of an International Economy* (Toronto: University of Toronto Press, 1954) is still authoritative.

8. Discussion in Grove, op. cit. (1988), Chapter 12.

9. Mark Kurlansky's *The Basque History of the World* (New York: Walker, 1999) discusses the Basque expansion.

10. E. M. Carus Wilson, "The Iceland Trade," in Eileen Power and M. M. Postan, eds., *Studies in English Trade in the Fifteenth Century* (London: Routledge and Kegan Paul, 1933), 180.

11. Herring fisheries are discussed by Jan de Vries and Ad van der Woude's definitive *The First Modern Economy: Success, Failure, and Perseverance of the Dutch Economy, 1500–1815* (Cambridge: Cambridge University Press, 1997).

12. Doggers: see Wilson, "The Iceland Trade," also Seán McGrail, *Ancient Boats in N.W. Europe: The archaeology of water transport to A.D. 1500* (New York: Longmans, 1987), a useful summary of early seafaring. For medieval shipping, see Richard W. Unger, *The Ship in the Medieval Economy* (Montreal: McGill-Queens University Press, 1980), and the same author's *Ships and Shipping in the North Sea and Atlantic, 1400–1800* (Brookfield, Vt.: Ashgate Variorum, 1997). I am grateful to Professor Unger for background information on Dutch doggers.

13. Wilson, "The Iceland Trade," 180.

14. Ibid.

15. Albert C. Jensen, *The Cod* (New York: Thomas Crowell, 1972), 87.

16. Ibid., 89.

CHAPTER 5

The quote by Fernand Braudel is from his *The Structures of Everyday Life* (New York: Harper and Row, 1981), 49.

1. For this chapter, I have drawn extensively on Emmanuel Le Roy Ladurie's classic *Times of Feast, Times of Famine: A History of Climate since the Year 1000*, translated by Barbara Bray (Garden City, N.Y.: Doubleday, 1971). The Semur-en-Auxois window is described there and is well worth a visit.

2. My account of French peasant life is derived from Emmanuel Le Roy Ladurie, *The French Peasantry 1450–1600*, translated by Alan Sheridan (Berkeley: University of California Press, 1987).

3. Analyses of the Black Death abound. A good account used here: Robert S. Gottfried, *The Black Death: Natural and Human Disaster in Medieval Europe* (New York: Free Press, 1983). See also William H. McNeill, *Plagues and People* (New York: Anchor Books—Doubleday, 1977); Graham Twigg, *The Black Death: A Biological Reappraisal* (London: Batsford Academic and Educational, 1984) argues that the

Black Death that hit England may in fact have been the first, and lethal, appearance of anthrax and not bubonic plague. Contributors to Robert I. Rotberg and Theodore K. Rabb, eds., *History and Hunger* (Cambridge: Cambridge University Press, 1985) discuss the complex relationship between food production, population, and disease. The graphical presentations between pages 305 and 308 are especially valuable.

4. Gottfried, *The Black Death*, 58–59.

5. Ibid., 67.

6. Ibid., 70. Such processions were already commonplace in earlier centuries.

7. Lamb, *Climate Present, Past, and Future*, 479.

8. Ladurie, *The French Peasantry 1450–1600*, 48.

9. Ladurie, *Times of Feast, Times of Famine,* discusses wine harvests in depth.

10. Ibid., 66–67.

11. Gilles de Gouberville is well portrayed by Ladurie, using primary sources in his *The French Peasantry 1450–1600*, 199–230. The brief quotes in this section come from this work.

12. Quoted by Ladurie, *The French Peasantry 1450–1600*, 229.

13. The discussion of glacial history which follows is drawn from Ladurie, *Times of Feast, Times of Famine*, which is based primarily on historical sources, and on Grove, op. cit. (1988).

14. Ladurie was unable to establish the modern equivalent for *journaux* of land.

15. Christian Pfister et al., "Documentary Evidence on Climate in Sixteenth-Century Central Europe," *Climatic Change* 43(1) (1999): 55–110.

16. Behringer, Wolfgang, "Climatic Change and Witch-Hunting: The Impact of the Little Ice Age on Mentalities," *Climatic Change* 43(1) (1999): 335–351.

17. Quotes and analysis from Lamb and Frydendahl, *Historic Storms*, 38–41.

18. Lamb, op. cit. (1977), 478.

19. W. G. Hoskins, "Harvest fluctuations and English economic history 1620–1759," *Agricultural History Review* 68 (1968): 15–31.

20. Proverbs 11:26.

21. David W. Stahle et al., "The Lost Colony and Jamestown Droughts," *Science* 280 (1998): 564–567. I am grateful to Dr. David Anderson for letting me read his unpublished paper "Climate and Culture Change in Prehistoric and Early Historical Eastern North America" (1999), from which the comment about English and Spanish is taken.

PART THREE THE END OF THE "FULL WORLD"

The quote by François Matthes is from his "Report of Committee on Glaciers" (1939): 520.

CHAPTER 6

The French government official at Limousin is quoted in Ladurie, *Times of Feast, Times of Famine,* 177.

1. Ladurie raises this point in his *Times of Feast, Times of Famine*, whereas Lamb's thesis is closely argued in his *Climate, History and the Modern World*.

2. The best general source on the agricultural revolution in Britain is Mark Overton's *Agricultural Revolution in England: The Transformation of the Agrarian Economy 1500–1850* (Cambridge: Cambridge University Press, 1996). For references on France and Ireland, see Chapters 9 and 11.

3. Quoted from Richard Verstegan's *A Restitution of Decayed Intelligence* (Antwerp: 1605) in Lamb, *Climate Present, Past, and Future*, 463.

4. I am grateful to Professor Prudence Rice for the opportunity to consult her unpublished paper "Volcanoes, earthquakes, and the Spanish colonial wine industry of southern Peru" (1999), upon which this passage is based. For ancient volcanoes generally, see G. Heiken and F. McCoy, eds., *Volcanic Disasters in Human Antiquity* (Washington, D.C.: Geological Society of America Special Paper, 2000), also T. Simkin, and K. Fiske, *Krakatau: the Volcanic Eruption and its Effects* (Washington D.C.: Smithsonian Institution, 1993).

5. Shanaka L. De Silva and Gregory A. Zielinski, "Global Influence of the A.D. 1600 eruption of Huanyaputina, Peru," *Nature* 393 (1998): 455–458.

6. K. R. Briffe et al., "Influence of volcanic eruptions on Northern Hemisphere summer temperature over the past 600 years," *Nature* 393 (1998): 450–455.

7. F. G. Delfin et al., "Geological, 14 C and historical evidence for a 17th century eruption of Parker Volcano, Mindanao, Philippines," *Journal of the Geological Society of the Philippines* 52 (1997): 25–42.

8. This section is based in part on Overton, op. cit. (1996), and on Robert Trow-Smith, *Society and the Land* (London: Cresset Press, 1953). I also drew heavily on A. H. John, "The Course of Agricultural Change 1660–1760," in L. R. Presnell, ed., *Studies in the Industrial Revolution* (London: Athlone Press, 1960), 125–155. For the Netherlands, see de Vries and van der Woude, *The First Modern Economy*.

9. Quotes from Charles Wilson, *England's Apprenticeship 1603–1763*, 2nd ed. (London and New York: Longman, 1984), 27.

10. Quoted from Walter Blith, *The English Improver* (1649) by Wilson, ibid., 28.

11. Trow-Smith, *Society and the Land*, 96.

12. Overton, op. cit. (1996), 203.

13. The literature on enclosure is enormous and confusing to the lay person. Overton, op. cit. (1996) provides basic references and the general reader is advised to start there. Some other sources I found useful: Robert C. Allen, *Enclosure and the Yeoman* (Oxford: Clarendon Press, 1992), J. M. Neeson, *Commoners: Common Right, Enclosure and Social Change in England, 1700–1820* (Cambridge: Cambridge University Press, 1993), and J. A. Yelling, *Common Field and Enclosure in England 1450–1850* (Hamden, Conn.: Archon Books, 1977). For parliamentary enclosure, see Chapter 8.

14. Redcliffe N. Salaman's *The History and Social Influence of the Potato*, 2d ed. (Cambridge: Cambridge University Press, 1985) is the fundamental source on the history of this all-important vegetable.

15. Ibid., 86.

16. Ibid., 104–105.

17. Ibid., 115.

CHAPTER 7

The *Old Farmers Almanac* 174 (1766, p. 47) is quoted from John D. Post, *The Last Great Subsistence Crisis in the Western World* (Baltimore: Johns Hopkins University Press, 1977).

1. Lamb, *Climate, History and the Modern World* provided the data for this passage.

2. Ibid., 218.

3. A discussion of global glaciation, including New Zealand, can be found in Grove, op. cit. (1988).

4. Quoted by Grove, op. cit. (1988), 380–381.

5. Lamb, *Climate Present, Past, and Future*, 526. I also drew on this work for the data on faunal migrations that follows.

6. This section is based on John A. Eddy, "The Maunder Minimum: Sunspots and Climate in the Reign of Louis XIV," in Geoffrey Parker and Lesley M. Smith, eds., *The General Crisis of the 17th Century*, 2nd ed. (London: Routledge, 1997), 264–298. Quotes are from this paper. For more on sunspots, see G. Reid and K. S. Gage, "Influence of Solar Variability on global sea surface temperatures," *Nature* 329 (6135): 142–143.

7. Eddy (op. cit.), in Parkey and Smith (1997), 267.

8. Since 1710, the amount of solar activity has risen, but modern readings are confusing, as the 14C concentration in the atmosphere has risen sharply since the late nineteenth century due to the combustion of fossil fuels and human activity, which has introduced much higher levels of carbon dioxide into the atmosphere.)

9. Ladurie, *Times of Feast, Times of Famine*, 160.

10. Quotes in this paragraph from ibid., 170.

11. Ibid., 173.

12. Ibid., 174.

13. Ibid., 177.

14. Quotes in this paragraph from ibid., 181.

15. Grove, op. cit. (1988), 188.

16. Ladurie, *Times of Feast, Times of Famine*, 187.

17. Ibid., 196.

18. Grove, op. cit. (1988), 88.

19. Grove, op. cit. (1988), 89.

CHAPTER 8

Nathanial Kent's *General View of the Agriculture of the County of Norfolk* (1796) is quoted in Mark Overton, op. cit. (1996), 166.

1. The Great Fire of London is easily accessible to the general reader. John E. N. Hearsley, *London and the Great Fire* (London: John Murray, 1965) is a widely read source, which I drew on here. Pepys quotes are from page 15.

2. Ibid., 141.

3. Robert Latham and Linnet Latham, eds. *A Pepys Anthology* (Berkeley: University of California Press, 1988), 158.

4. Ibid., 159.

5. Hearsley, *London and the Great Fire*, 149.

6. Lamb and Frydendahl, *Historic Storms*, 50.

7. Ibid., 38.

8. Guy de la Bédoyère, ed., *The Diary of John Evelyn* (Woodbridge, England: Boydell Press, 1995), 267.

9. Lamb, *Climate Present, Past, and Future*, 488; Emmanuel Le Roy Ladurie, *The Ancien Régime*, translated by Mark Greengrass (Oxford: Blackwell, 1996), 210.

10. D. P. Willis, *Sand and Silence: Lost Villages of the North* (Aberdeen, Scotland: Center for Scottish Studies, University of Aberdeen, 1986), offers a brief description of the Culbin disaster. Quote from page 40. There is some debate as to the exact nature of the Culbin disaster, with some experts questioning whether it would be possible for a single storm to accumulate so much sand. See J. A. Steers, "The Culbin Sands and Burghead Bay," *Geographical Journal* 90 (1937): 498–523, and accompanying debate. I have chosen to use the more dramatic scenario here.

11. Willis, *Sand and Silence*, 37.

12. Daniel Defoe, *A Collection of the Most Remarkable Casualties and Disasters . . .* , 2d ed. (London: George Sawbridge, 1704), 66.

13. Ibid., 75.

14. Ibid., 94.

15. Quoted by Lamb and Frydendahl, *Historic Storms*, 60.

16. Lamb, *Climate Present, Past, and Future*, 485.

17. See, for example, discussion in ibid., 485 ff.

18. John D. Post, *Food Shortage, Climatic Variability, and Epidemic Disease in Preindustrial Europe* (Ithaca, N.Y.: Cornell University Press, 1985) provided much of the material for this section. Quote from page 58. See also F. Neman, *Hunger in History: Food Shortages, Poverty and Deprivation* (Cambridge, Mass.: Blackwell, 1990).

19. Ibid., 60.

20. Post, *Food Shortage, Climatic Variability, and Epidemic Disease*, 62.

21. Ibid., 63.

22. Ibid., 73–74.

23. Ibid., 279.

24. Ibid., 295.

25. Ibid., 210–211.

26. By coincidence, after writing this passage, I came across Charles More's *The Industrial Age: Economy and Society in Britain 1750–1995*, 2d ed. (London and New

York: Longman, 1997), which contains a discussion of the same painting in the context of agriculture. Interesting that it evoked the same reaction in an archaeologist and a historian!

27. John Walker, *British Economic and Social History 1700–1977*, 2nd ed. revised by C. W. Munn (London: Macdonald and Evans, 1979), 79. For discontent in Britain, see Frank O. Darvall, *Popular Disturbances and Public Disorder in Regency England* (London: Oxford University Press, 1934). A more complex discussion: E. P. Thompson, *The Making of the English Working Class* (London: Longmans, 1965).

28. Arthur Young is so important that he has generated a historical literature in its own right, some of which wonders just how thorough an observer he was. His two-volume *A Course in Experimental Agriculture*, published in London in 1771, is his masterpiece.

29. Parliamentary enclosure has spawned a huge literature. A good beginner's guide: Michael Turner, *Enclosures in Britain 1750–1830* (London: Macmillan, 1984).

30. Trow-Smith, *Society and the Land*, 103.

31. Ibid., 101.

32. Ibid., 41.

33. Ibid., 138.

34. Discussion of this complex issue in Wilson, *England's Apprenticeship 1603–1763*, Chapter 1.

CHAPTER 9

Jules Michelot is quoted in Ralph W. Greenlaw, ed., *The Economic Origins of the French Revolution: Poverty or Prosperity?* (Boston: D. C. Heath, 1958), 3.

1. Hippolyte A. Taine, *L'Ancien Regime*, translated by John Durand, vol. 1 (New York: Henry Holt, 1950), 338.

2. Data on wine harvests comes from Ladurie, *Times of Feast, Times of Famine*, Chapter 11, and Emmanuel Le Roy Ladurie and Micheline Baulant, "Grape Harvests from the Fifteenth through the Nineteenth Centuries," in Rotberg and Rabb, *Climate and History*, 259–268. For the complexities of studying wine harvests, see Barbara Bell, "Analysis of Viticultural Data by Cumulative Deviations," in Rotberg and Rabb, *Climate and History*, 271–278.

3. A special issue of the journal *Climatic Change*, 43(1) (1999), surveys the latest research in climatic history in Switzerland and parts of Central Europe. See also Christian Pfister, *Klimageschichte der Schweiz 1525–1860*, 2 vols. (Berlin: Verlag Paul Haupt, 1992), and the same author's *Wetternachhersage. 500 Jahre Klimavariationen und Naturkatastrophen (1496–1995)* (Berlin: Verlag Paul Haupt, 1999). Of particular interest in the special volume are: Christian Pfister and Rudolf Brázdil, "Climatic Variability in Sixteenth-Century Europe and Its Social Dimension: A Synthesis," *Climatic Change* 43 (1) (1999): 5–53; also Pfister et al., "Documentary Evi-

dence on Climate." For Alpine glacier fluctuations, see H. Holzhauser and H. J. Zumbühl, "Glacier Fluctuations in the Western Swiss and French Alps in the 16th Century," *Climatic Change* 43 (1) (1999): 223–237.

4. Ladurie, *Times of Feast, Times of Famine,* 79.

5. Quoted from Henry Heller, *Labour, Science and Technology in France, 1500–1620* (Cambridge: Cambridge University Press, 1996), 67. I also drew on this book for the discussion of Olivier de Serres.

6. Ladurie, *The Ancien Régime,* was the source for this discussion.

7. Davies, *Europe: A History,* 615.

8. Ladurie, *The Ancien Régime,* 215.

9. Lamb, *Climate Present, Past, and Future,* 452.

10. Post, *Food Shortage, Climatic Variability, and Epidemic Disease,* 211.

11. General discussion in my *Floods, Famines, and Emperors: El Niño and the Collapse of Civilizations* (New York: Basic Books, 1999).

12. Ladurie, *The Ancien Régime,* 306ff.

13. Arthur Young, *Travels in France during the Years 1787, 1788, and 1789,* edited by C. Maxwell (Cambridge: Cambridge University Press, 1950), 279.

14. Ibid., 28.

15. Georges Lefebvre, *The Great Fear of 1789,* translated by Joan White (New York: Pantheon Books, 1973), 8.

16. Ibid., 10.

17. Charles A. Wood, "The Effects of the 1783 Laki Eruption," in C. R. Harington, ed., *The Year Without a Summer? World Climate in 1816* (Ottawa: Canadian Museum of Nature, 1992), 60.

18. In writing this section, I drew on J. Newmann, "Great Historical Events That Were Significantly Altered By the Weather: 2. The Year Leading to the Revolution of 1789 in France," *Bulletin of the American Meteorological Society* 58(2) (1977): 163–168.

19. Lefebvre, *The Great Fear of 1789,* 18.

20. Oliver Browning, ed., *Diplomatic Dispatches from Paris, 1784–1790,* vol. 2 (London: Camden Society, 1910), 75–76.

21. Ibid., 82.

22. The origins of the French Revolution have been thwart with controversy since the event occurred. William Doyle, *Origins of the French Revolution,* 3rd ed. (Oxford: Oxford University Press, 1999) is an admirable starting point for the English-speaking reader and contains a discussion of the widely differing theoretical viewpoints. I drew on it here. See also Gary Kates, ed., *The French Revolution: Recent Debates and New Controversies* (London and New York: Routledge, 1998). Both these volumes have excellent bibliographies, which include comprehensive French sources.

23. Doyle, *Origins of the French Revolution,* 154.

24. Braudel, *The Structures of Everyday Life,* 133.

CHAPTER 10

The resident of Surakartais quoted in Michael R. Rampino's "Eyewitness Account of the Distant Effects of the Tambora Eruption of April 1815," in Harington, ed., *The Year Without a Summer?*, 13.

1. The Mount Tambora disaster is well described for a popular audience by Henry Stommel and Elizabeth Stommel, *Volcano Weather: The Story of 1816, The Year Without A Summer* (Newport, R.I.: Seven Seas Press, 1983). Quote is from pages 7–8. For more technical papers, see Harington, *The Year Without a Summer?*

2. Stommel and Stommel, *Volcano Weather*, 56.

3. *The Times*, London, July 20, 1816.

4. Post, *The Last Great Subsistence Crisis*, 41.

5. Ibid.

6. Ibid., 44.

7. Ibid., 99.

8. Ibid., 97.

9. Ibid., 89.

10. Stommel and Stommel, *Volcano Weather*, 30. See also Patrick Hughes, *American Weather Stories* (Washington D.C.: U.S. Department of Commerce, 1976).

11. Stommel and Stommel, *Volcano Weather*, 30.

12. Ibid., 42.

13. Ibid., 72.

14. Post, *The Last Great Subsistence Crisis*, 125.

15. Ibid., 128.

16. Ibid., 131.

CHAPTER 11

The excerpt is from Austin Bourke's *"The Visitation of God"? The Potato and the Great Irish Famine,* edited by Jacqueline Hill and Corma Ó Gráda (Dublin: Lilliput Press, 1993), 18.

1. Adam Smith, *The Wealth of Nations* (London, 1776), quoted by Peter Mathias, *The First Industrial Nation: The Economic History of Britain 1700–1914* (London: Methuen, 1990), 174.

2. Salaman, *The History and Social Influence of the Potato,* is the source for this passage.

3. Bourke, *The Visitation of God?* Both quotes from page 15.

4. Christine Kinealy, *A Death-Dealing Famine: The Great Hunger in Ireland* (London: Pluto Press, 1997), 43.

5. Bourke, *The Visitation of God?* 18. The quote is from the *Irish Agricultural Magazine*, 1798: 186.

6. Bourke, *The Visitation of God?*, 20.

7. Quoted in ibid., 24.

8. William D. Davidson, "The History of the Potato and Its Progress in Ireland," *Journal of the Department of Agriculture, Dublin* 34 (1937): 299.

9. Bourke, *The Visitation of God?*, 24.

10. Ibid., 17.

11. The literature on the great Irish potato famine is enormous and polemical; the nonspecialist navigates it at his or her peril. Cormac O. Gráda, *Ireland Before and After the Famine. Explorations in Economic History, 1800 to 1925* (Manchester, England: Manchester University Press, 1988) is a comprehensive analysis in a broad context. Christine Kinealy's *A Death-Dealing Famine* is an excellent and dispassionate summary. Austin Bourke's *Visitation of God* is definitive. Cecil Woodham-Smith's eloquent and thoroughly researched *The Great Hunger, Ireland 1845–1849* (New York: Harper and Row, 1962) was vilified by many academic reviewers, but is now regarded in a somewhat more sympathetic light and still remains an excellent account for the general reader. Arthur Gribben, ed., *The Great Famine and the Irish Diaspora in America* (Amherst, Mass.: University of Massachusetts Press, 1999) explores many aspects of the famine. For mass emigration, the following are useful, among many others: William F. Adams, *Ireland and Irish Emigration to the New World from 1815 to the Famine* (New Haven: Yale University Press, 1932) and Timothy Gwinnane, *The Vanishing Irish* (Princeton: Princeton University Press, 1997).

12. Kinealy, *A Death-Dealing Famine*, 46.

13. Bourke, *The Visitation of God?*, 18. The quote is from the *Irish Agricultural Magazine*, 1798: 186. For the history of the potato, see both this work and Salaman, *The History and Social Influence of the Potato*, which remains the definitive source, with the author charmingly remarking that "nothing short of mental instability, could excuse a lifelong attachment to the study of so banal a subject" (p. xxxi). Larry Zuckerman, *The Potato: How the Humble Spud Rescued the Western World* (London: Faber and Faber, 1998) is a popular, uncritical account.

14. Quoted by Bourke, *The Visitation of God?*, 24.

15. Quoted in ibid., 67.

16. Ibid., 69.

17. Ibid., 26.

18. Kinealy, *A Death-Dealing Famine*, 52.

19. Woodham-Smith, ibid., 91.

20. Ibid., 155.

21. Ibid., 162.

22. The closing section of this chapter is based on Lamb, *Climate, History and the Modern World*. Quote is from page 247.

PART IV THE MODERN WARM PERIOD

The quote by Hubert Lamb is from his *Climate, History and the Modern World*, 375.

CHAPTER 12

The quote by John Houghton is from his *Global Warming: The Complete Briefing*, 2nd ed. (Cambridge: Cambridge University Press, 1997), 1.

1. Lamb, *Climate, History and the Modern World*, 239–241 is the source for this passage.

2. Hans Neuberger, "Climate in Art," *Weather* 25 (2) (1970): 46–56.

3. This passage draws on Brian Fagan, *Clash of Cultures* (Walnut Creek, Calif.: Altamira Press, 1998), Chapter 16.

4. Based on Alexander T. Wilson, "Isotope Evidence for Past Climatic and Environmental Change," in Rotberg and Rabb, *Climate and History*, 215–232. See also: Richard H. Grove, *Ecology, Climate, and Empire: Colonialism and Global Environmental History 1400–1940* (Cambridge, Eng.: White House Press, 1997).

5. Sir Arthur Conan Doyle, "The Adventure of the Bruce-Partington Plans." Quotes from Sir Arthur Conan Doyle, *The Illustrated Sherlock Holmes Treasury* (New York: Avenal Books, 1984), 793.

6. Guy de la Bédoyère, ed., *The Diary of John Evelyn* (Woodbridge, England: Boydell Press, 1995), 267. An excellent biography of King Charles II: Antonia Fraser, *Royal Charles: Charles II and the Restoration* (New York, Alfred A. Knopf, 1979).

7. Neuberger, "Climate in Art," 52.

8. This passage draws on Lamb, op. cit. (1982), Chapters 13 and 14. Quote: Brian Walter Fagan, *Letters of an Ordinary Gentleman, 1914–16* (Manuscript in possession of the author dated 1921), entry for November 14, 1915.

9. Lamb, op. cit. (1982), Chapter 13.

10. William K. Stevens, *The Change in the Weather* (New York: Delacorte Press, 2000), Chapter 8, provides an account of this memorable hearing. Stevens's book offers an admirable summary of the history of global warming research.

11. The best summary of global warming effects is in Houghton, *Global Warming*.

12. Excellent information on annual temperature records for the 1990s and later can be found on the Web: www.ncdc.noaa.gov is the home page for the National Climate Data Center in Asheville, North Carolina, with links to other global data centers.

13. Timothy J. Osborn, et al., "The Winter North Atlantic Oscillation," Climatic Research Unit, University of East Anglia, 1999.

14. R. Howe, et al., "Dynamic Variations at the Base of the Solar Convection Zone," *Science* (287): 2456–2460.

15. Eric Posmentier, et al., available at www.elsevier.com/journals/newast.

16. www.csf.coloradu.edu/bioregional/99/msg00355.html.

17. Extended discussion in Houghton, *Global Warming*, Chapters 7ff.

18. James Hansen, Makiko Sato, Reto Ruedy, Andrew Lacis, and Valdar Oinas, "Global Warming in the Twenty-First Century: An Alternative scenario," *Proceedings of the National Academy of Sciences* 10 (2000):1073–1083.

19. From a BBC Broadcast. Quoted by Houghton, ibid., 151.

INDEX

Accident hypothermia, 140, 157, 196

Africa, 101–102, 210, 216

Agriculture
after famine, 80, 81
climate changes and invention of, 102
commercial, 108, 143, 186
communal, 109, 110
crop failure, 91
diversification, 85–86, 103, 107
enclosure of land, 109–110
in England, 94, 103, 107, 108–110,
 143, 149, 150
and environment, 204
European-style, in New Zealand, 203
farmers described, 220n6
fifteenth century, 83
in Flanders, 108
Greenland dairying economy, 67
high productivity in, 81
in Holland, 107, 108
in Iceland, 10
in Ireland, 103, 181–182, 184–187,
 195
landlord and tenant, 110, 143–144,
 146
landowners and, 85
land reclamation in, 107
lay farming, 106
manor farms, 67–68
of Maori society, 203

medieval, 17–18, 33–40
new economy of, 145, 147
new methods of, 106, 109, 138
in North American European colonies,
 96–97
revolution in, 97, 103, 106, 107
in rural communities, 33–34
specialization, 107, 108
subsistence, 101–103, 106
technology, 85
Younger Dryas–like event and, 215

Agriculture in France, 149–166
climate changes and, 160–161
food shortages, 151, 155–156, 162
innovation and experimentation,
 151–152
peasants and, 158–160
recovery in late fifteenth century,
 84–85
revolution, 103, 107
rural unemployment and, 160
subsistence, 151, 153
urban unemployment and, 163
wine harvests, 150–152

Aletsch glaciers, 124–125

Alexander VI, Pope, 62

Allalin glacier, 89, 125

All Saints Flood, 91

Alps, 18, 28, 86–90, 117–118,
 123–127, 207